P9-DGZ-854

SHAOLIN TEMPLE OF ZEN

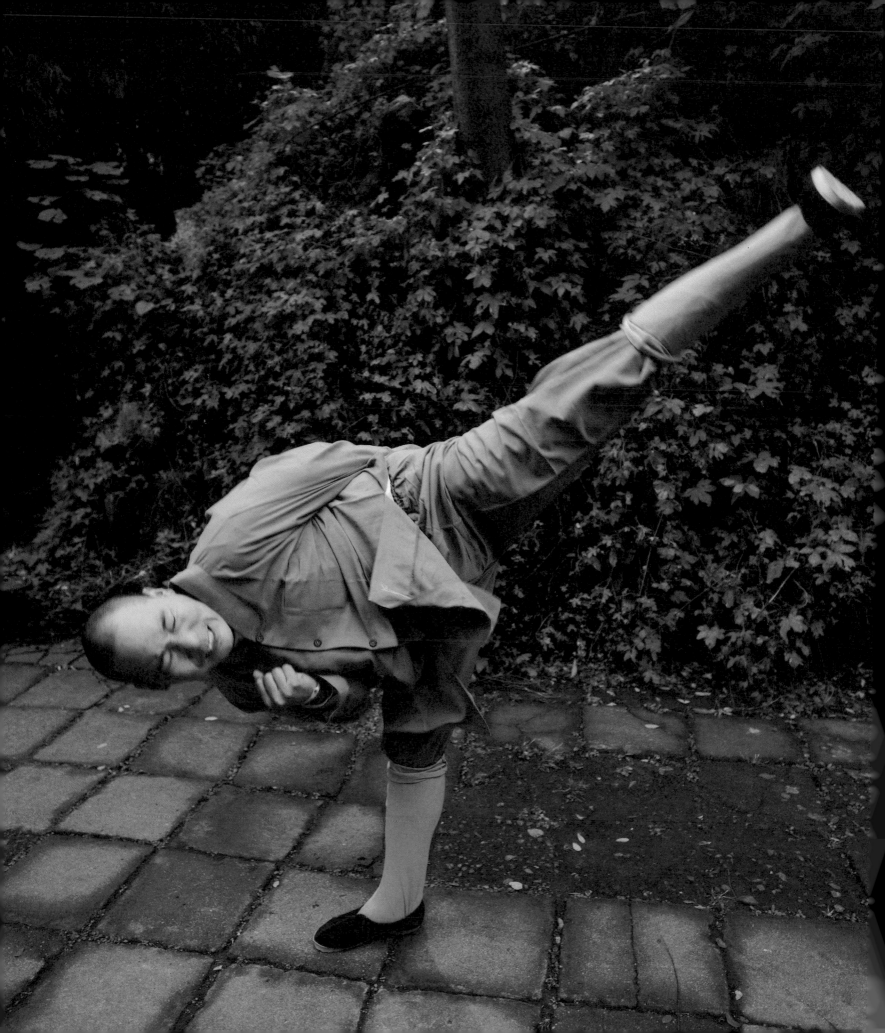

SHAOLIN TEMPLE OF ZEN

by JUSTIN GUARIGLIA

foreword by SHI YONG XIN,
Abbot of the Shaolin Temple

essay by MATTHEW POLLY

aperture

Editor: Lesley A. Martin
Designer: Lorraine Wild with Leslie Sun, Green Dragon Office, Los Angeles
Production: Matthew Pimm

The staff for this book at Aperture Foundation includes:
Ellen S. Harris, *Chief Executive Officer*; Michael Culoso, *Director of Finance and Administration*; Nancy Grubb, *Executive Managing Editor, Books*; Susan Ciccotti, *Production Editor*; Sarah Henry, *Production Manager*; Andrea Smith, *Director of Communications*; Kristian Orozco, *Director of Sales and Foreign Rights*; Diana Edkins, *Director of Exhibitions and Limited-Edition Photographs*; John Miller, Laura Cooke, *Work Scholars*

This project was made possible, in part, with the generous support of Geoffrey Lieberthal.

Compilation—including selection, placement, and order of text and images—copyright © 2007 Aperture Foundation, Inc.; photographs copyright © 2007 Justin Guariglia; essay copyright © 2007 Matthew Polly; foreword copyright © 2007 Shi Yong Xin. All rights reserved under International and Pan-American Copyright Conventions. No part of this book may be reproduced in any form whatsoever without written permission from the publisher.

The quote that appears on page 24 is excerpted from *The Zen Teachings of Bodhidharma*. Translated by Red Pine. New York: North Point Press, 1998.

Aperture Foundation books are available
in North America through:
D.A.P./Distributed Art Publishers
155 Sixth Avenue, 2nd Floor
New York, N.Y. 10013
Phone: (212) 627-1999
Fax: (212) 627-9484

Aperture Foundation books are distributed
outside North America by:
Thames & Hudson
181A High Holborn
London WC1V 7QX
United Kingdom
Phone: + 44 20 7845 5000
Fax: + 44 20 7845 5055
Email: sales@thameshudson.co.uk

First edition
Printed by CS Graphics in Singapore
10 9 8 7 6 5 4 3 2 1

Library of Congress Control Number:
2007921787
ISBN 978-1-59711-080-8

aperturefoundation
547 West 27th Street
New York, N.Y. 10001
www.aperture.org

The purpose of Aperture Foundation,
a non-profit organization, is to advance photography
in all its forms and to foster the exchange of ideas
among audiences worldwide.

Front cover:
Monk Shi De Yang practices *Nan Yuan Da Hong Quan* (Big Hong Fist).

Pages 2–3:
First light in the valley of Shaolin. Shaolin is located southwest of Beijing, an overnight train-ride from the capital.

Frontispiece:
Monk Shi Yan Lou performs a front sidekick, a standard technique in *sanda* (Chinese-style kickboxing).

Right:
The Drum Tower, one of two prominent towers within the temple complex, is characteristic of the architectural style of temples found throughout China. It burned down in 1928 and was rebuilt in 1995.

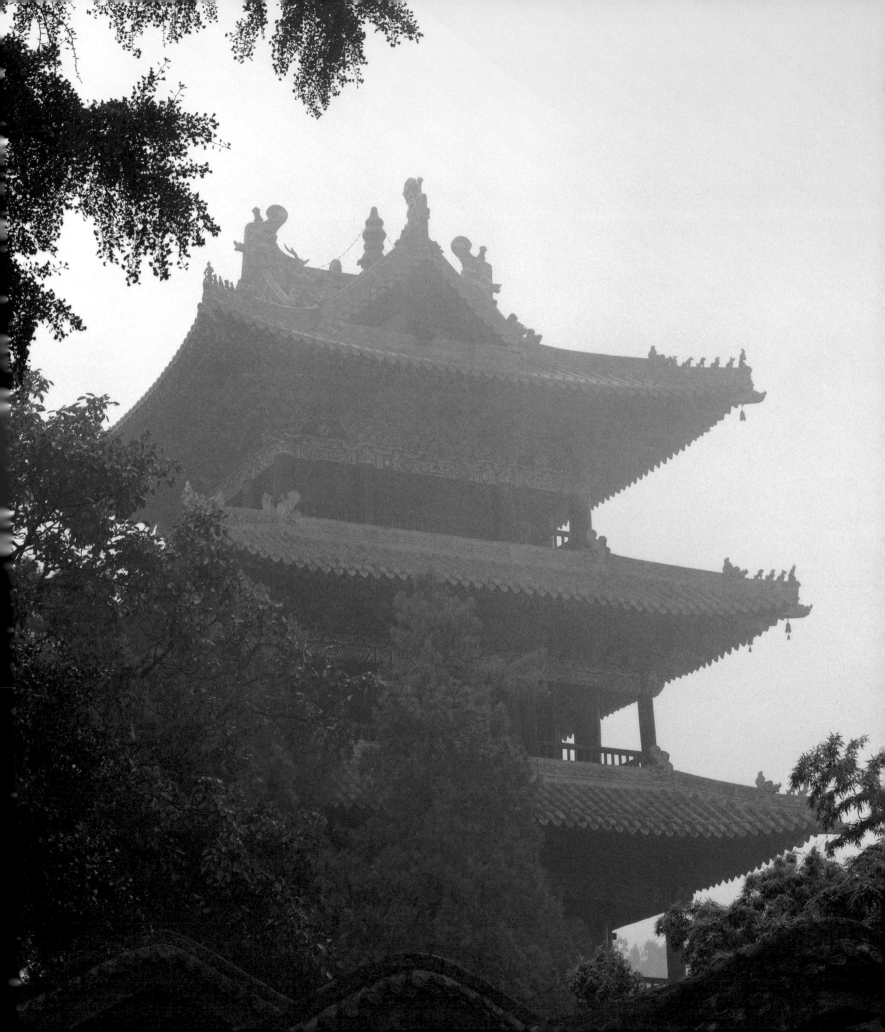

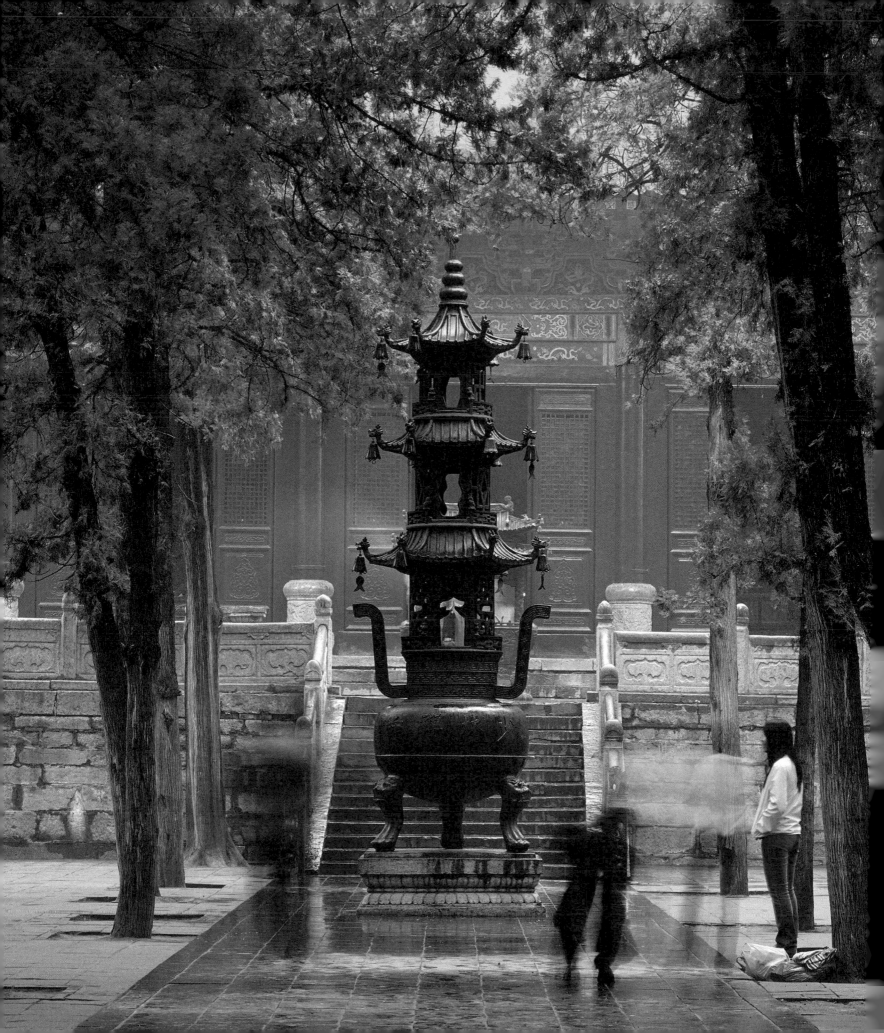

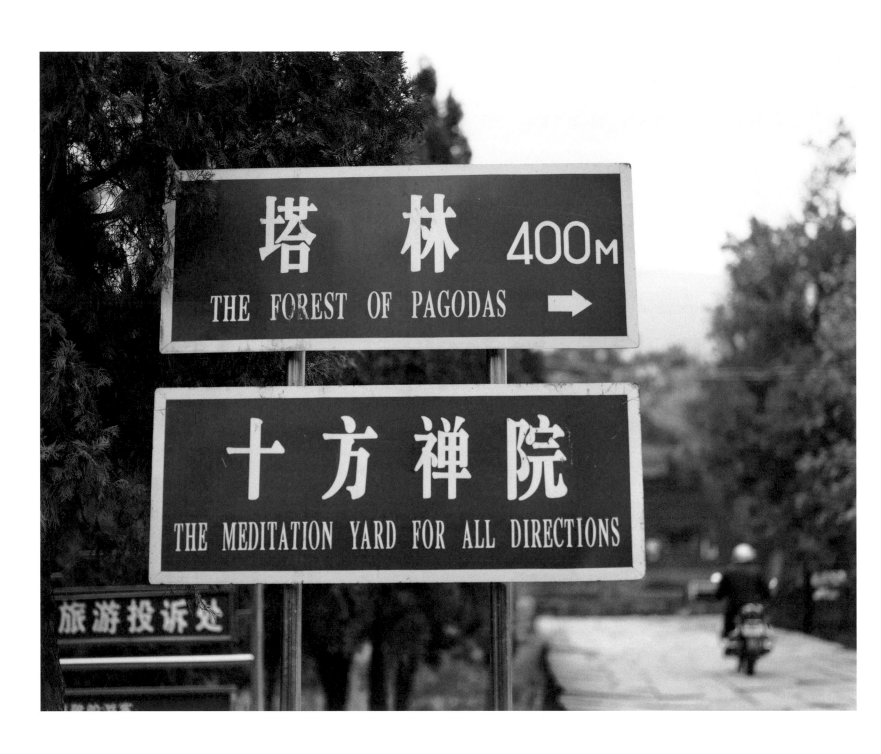

Left:
A bronze pagoda incense burner located outside
the Sutra-keeping Pavilion, which houses
over five thousand Buddhist *sutras* (scriptures).

Above:
Signs in both English and Chinese guide tourists
toward the temple and surrounding areas.

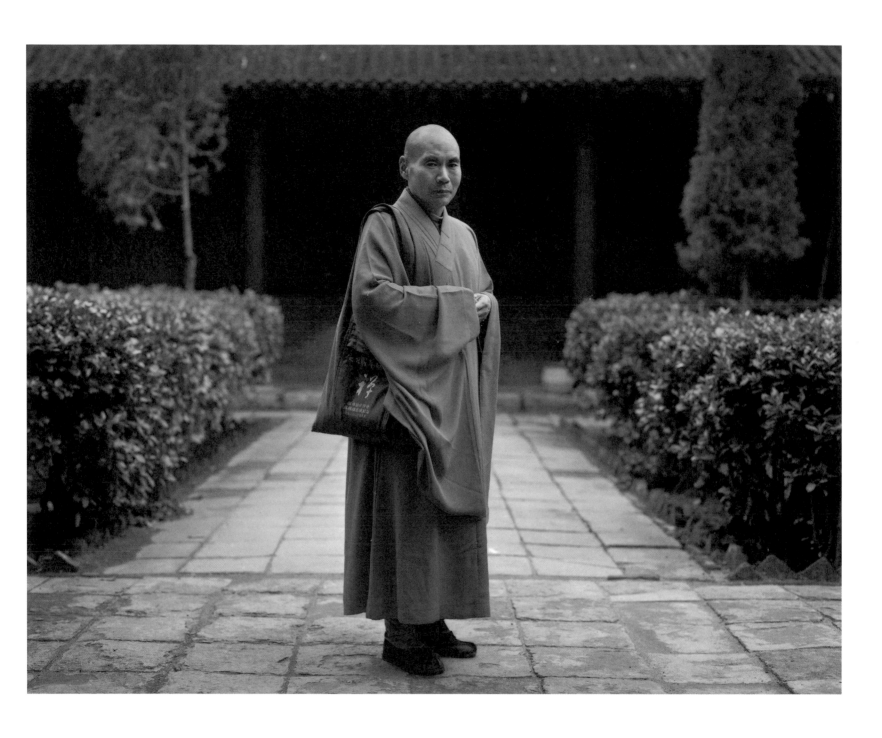

Shi Yong Cheng, a Shaolin *wenseng* (cultural or praying monk). Shaolin is not only a source for the martial arts, but is also a home for traditional herbal medicines, painting, and calligraphy.

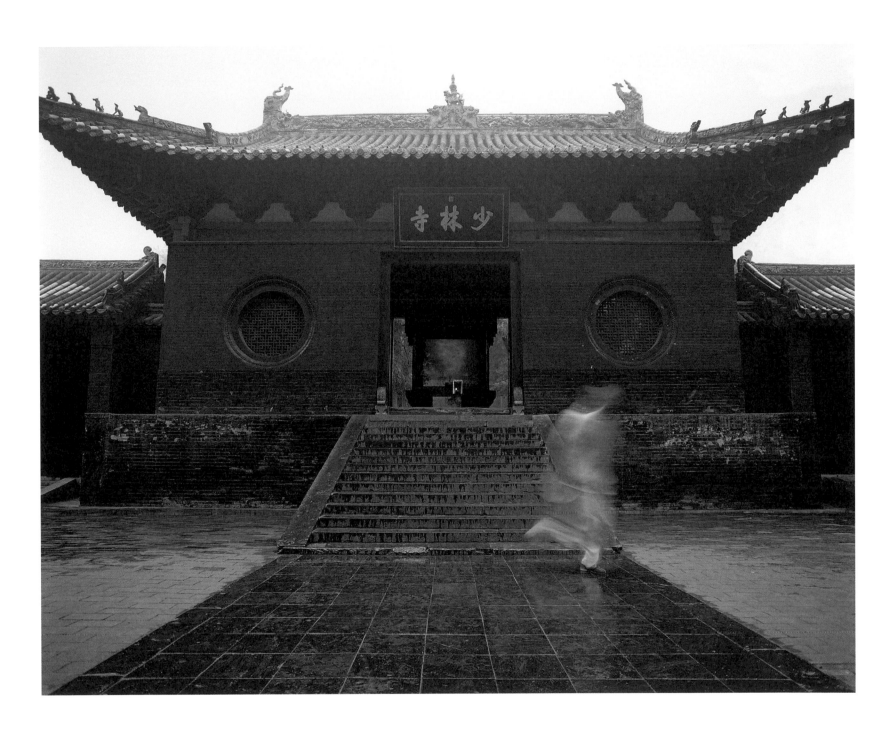

The Shaolin Temple's famous facade, with its
distinguishing twin round windows on either side
of the entrance, has been featured in countless
Hong Kong kung fu films.

Students from a local martial arts school and
tourists explore the legendary temple grounds.

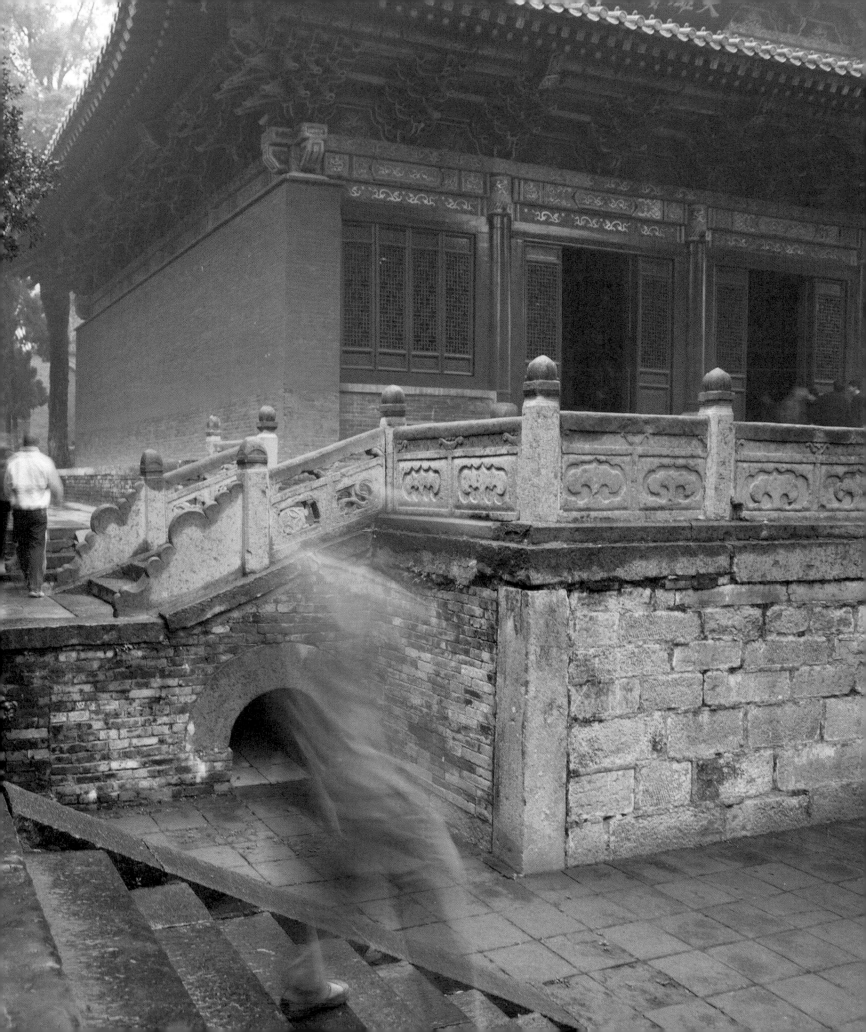

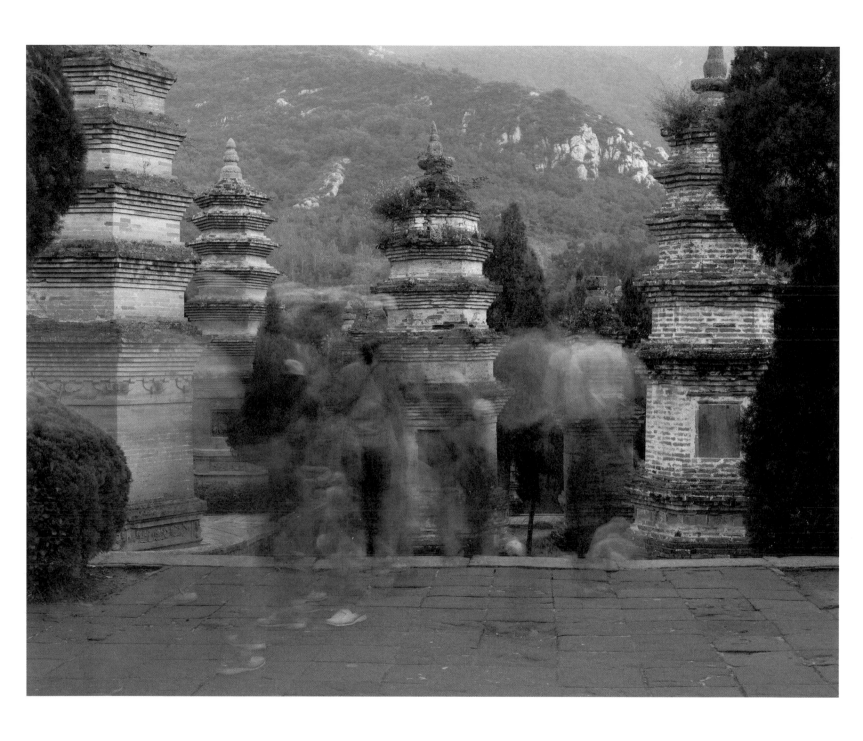

Tourists visit the Pagoda Forest, which pays
homage to past monks of great stature
and serves as their burial grounds. Only the
most respected and famous monks are
buried here.

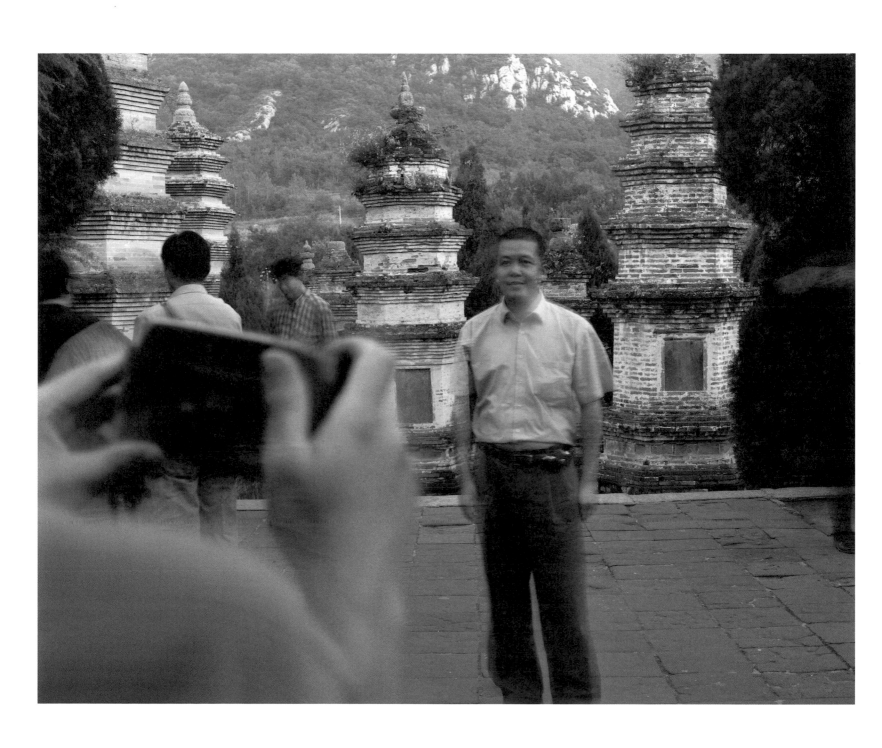

Previous spread:
Tourists pay for a peek of a stone statue of Bodhidharma, credited as the founder of Zen Buddhism, high up the slope of the sacred Mount Song Shan. The statue was built outside the cave where Bodhidharma is said to have meditated for nine consecutive years.

Right:
The wares of a local merchant litter the grounds after a tourist-heavy day. The temple has become Henan Province's most important attraction, a living museum. To protect its legacy, the temple recently applied for UNESCO World Heritage status.

18

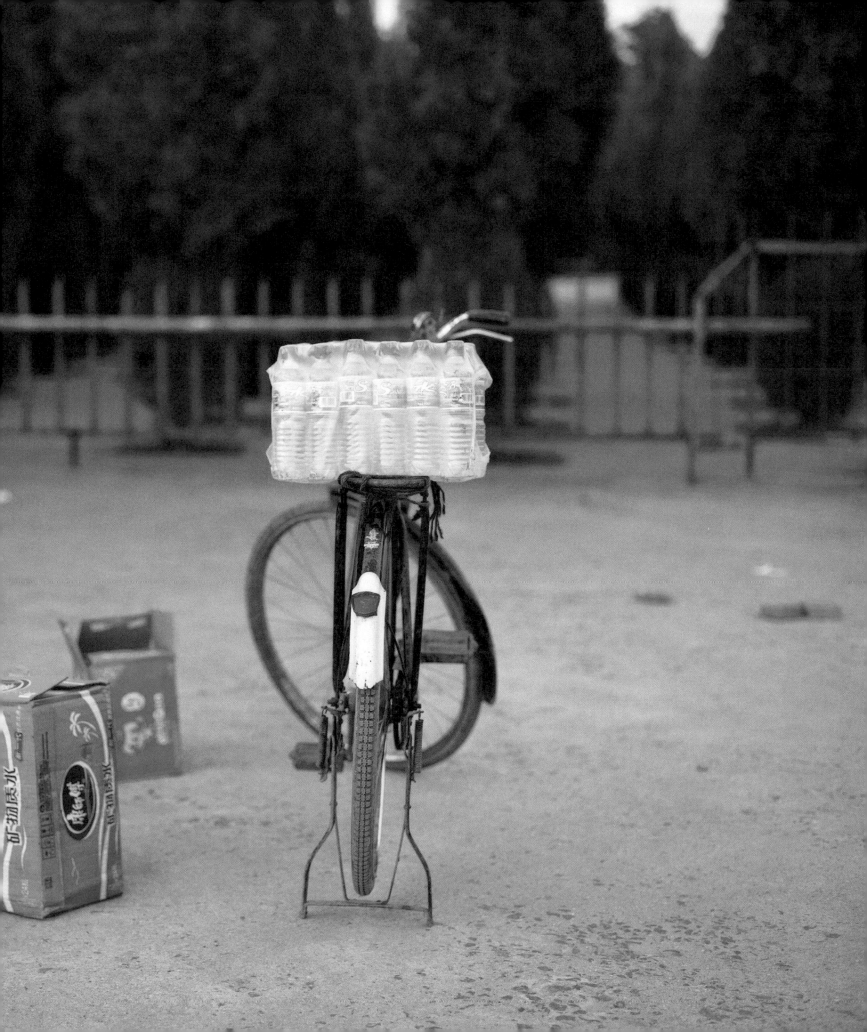

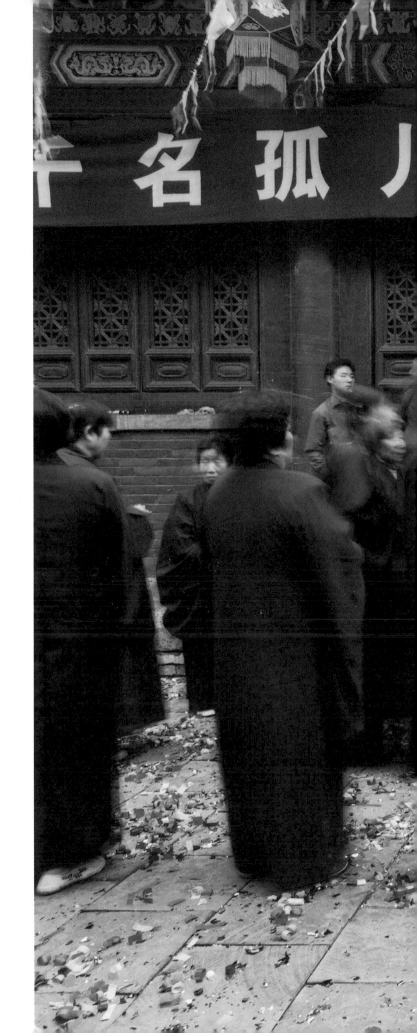

A group of Buddhist lay women pay a visit to the temple, where hundreds of Buddhist ceremonies take place every year. As the birthplace of both *Ch'an* (Zen) Buddhism and kung fu, Shaolin is the most famous monastery in China.

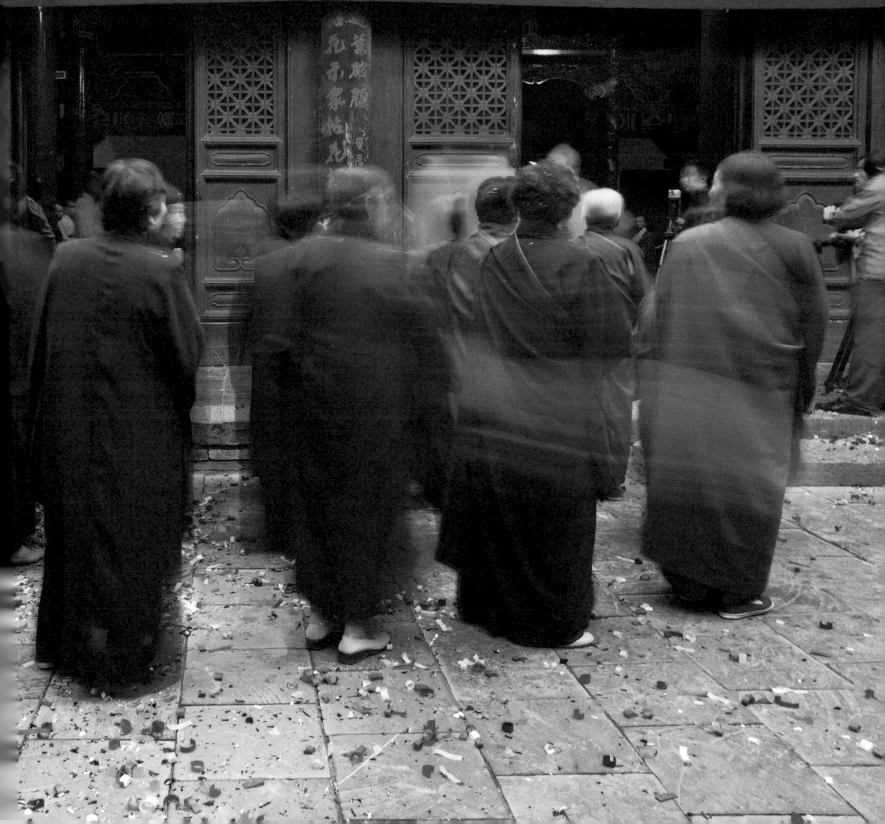

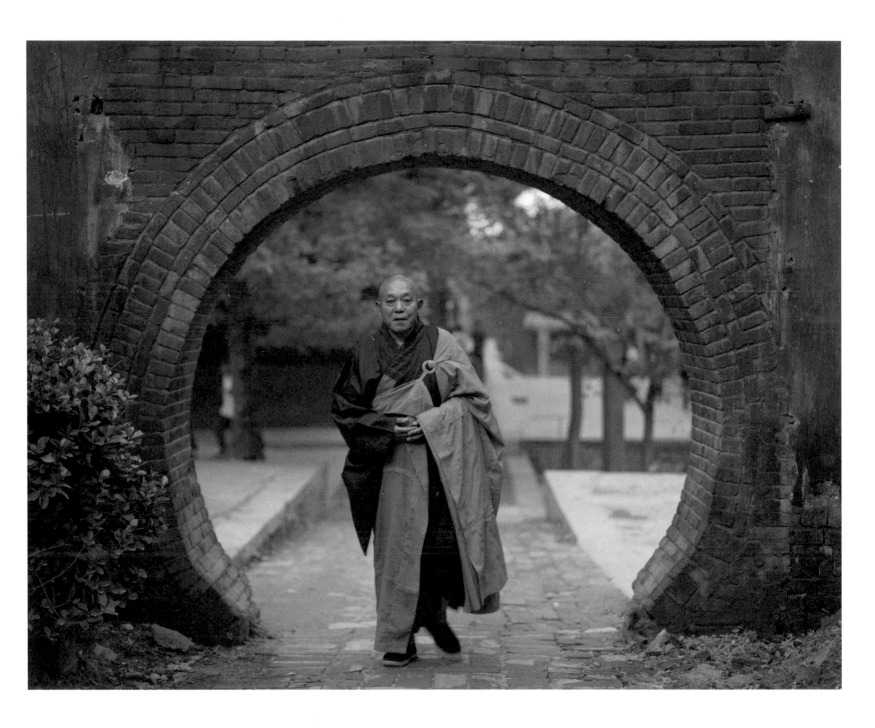

Above:
Shi Xing Zhou, 32nd generation

Right:
Shi Yan Yang, 33rd generation

The Shaolin system of apprenticeship assigns
a new Buddhist name to each student who is
accepted as a monk. The names indicate which
"generation" a monk belongs to, a centuries-long
legacy leading back to the founding generation.

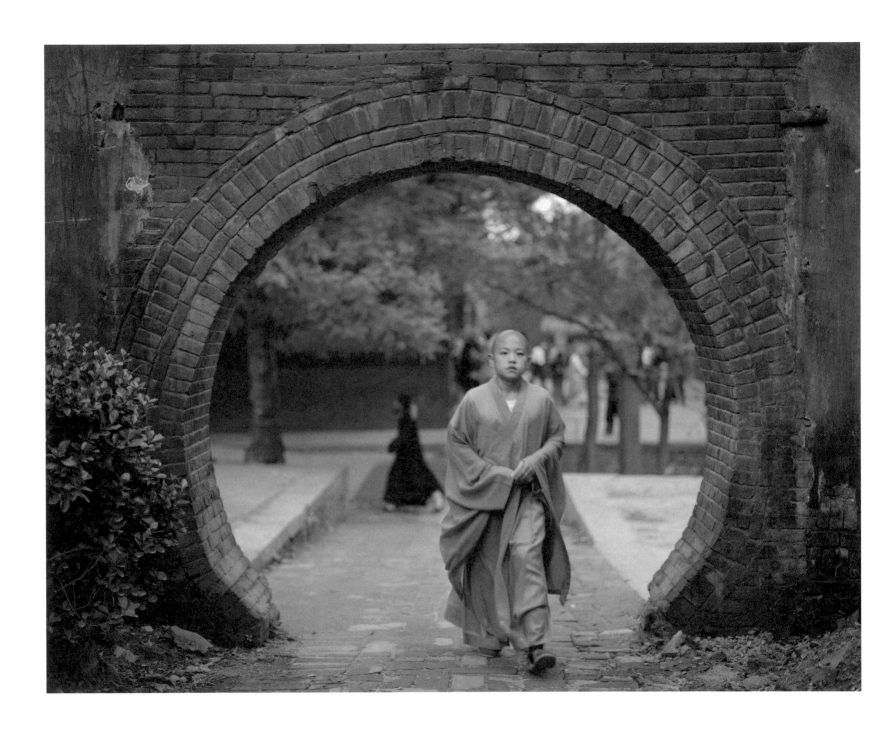

Buddha *is Sanskrit for what you call aware,*
miraculously aware. Responding, perceiving, arching your brows,
blinking your eyes, moving your hands and feet, it's all your miraculously aware nature.
And this nature is the mind. And the mind is the buddha.
And the buddha is the path. And the path is Zen.

—Bodhidharma,
from *The Zen Teachings of Bodhidharma*

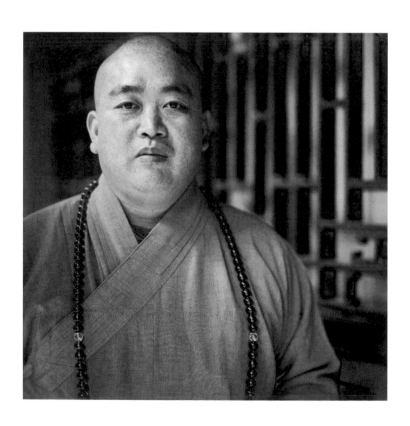

FOREWORD

SHI YONG XIN

THIRTIETH ABBOT OF THE SHAOLIN TEMPLE

Shaolin Temple is located at the base of Song Mountain in the heart of China. It was built in the fifth century by Emperor Xiao Wen at a time when the borders between China and the outside world were first opened for cultural exchange. The temple honored the Indian priest Batuo. From his new base in Shaolin, Batuo taught both traditional Indian Zen doctrine and Taoism. In time Shaolin Temple became an important outpost for Zen masters, wielding significant influence on the later growth of Buddhism as a whole.

In the sixth century Bodhidharma, a revered Zen priest from southern India, established a teaching center on the mountain behind Shaolin Temple. Here he sat in ascetic meditation, imparting wisdom to those who sought it. It was through his teachings that Zen became an important part of Chinese Buddhism; Zen philosophies contain many of the treasures of Chinese thought, and have impacted Chinese culture as a whole. Over the centuries, the Shaolin monks perfected a unique form of Zen study combined with military training and skill. This led to the creation of a new martial arts form, Shaolin kung fu. This knowledge has been passed from generation to generation of monks.

In the ninth century the Zen sect founded by Bodhidharma became the largest in Chinese Buddhism, and during the Song Dynasty in the tenth century, Shaolin Temple became an important pilgrimage destination. In order to memorialize Bodhidharma, an ancestral shrine was built on the site where he once sat in meditation. "Zen and martial arts first" became the motto of Shaolin kung fu.

Shaolin Temple and its kung fu practices have continued to grow and evolve throughout the centuries. Unlike other forms of Buddhism at the time, for which missionary work was one of the basic principles, the Zen teachings of Shaolin stressed singularity and steadfastness—monks were expected to dedicate themselves to training, and travel only under special circumstances. Today, the Zen style of the Shaolin Temple emphasizes a duality of openness and constancy.

From the end of the seventeenth century into the twentieth, the Shaolin came under rigorous scrutiny and numerous attempts to curtail its power. Despite this, the temple's monks conducted their lessons and meditated during the day. At night, they persisted in their martial arts, practicing in the most secluded areas, including Thousand Buddha Hall. (As a result of constant, repetitive practice sessions, the floor was worn down by their pounding feet, and remains a sunken pit to this day.)

Today, with governmental and societal support, Shaolin Temple has come into its own, and continues to nurture its singular traditions. It is not only a world-famous kung fu shrine, but also one of the world's spiritual healing centers. At the same time, we are committed to developing cultural exchange outside of China; Shaolin's disciples can be found all over the globe and its culture is revered by increasing numbers of people. Shaolin culture has not only become representative of Chinese martial arts and Chinese Buddhism, it has also become a symbol of the traditional culture of China.

Justin Guariglia is deeply familiar with the history of Song Mountain's Shaolin Temple. He loves the culture of Shaolin as well as traditional Chinese culture. Over the last few years, no matter how far he travels, he always returns to Shaolin to photograph. Every time Mr. Guariglia comes to Shaolin Temple, he shows me his images. Not only do I admire the beautiful artwork, but I also feel his photographs inspire a feeling of devotion toward the temple. I hope that when I speak of Shaolin Temple's history and culture, it helps the reader to gain a deeper understanding of the temple, just as one might through Mr. Guariglia's photographs.

March 2007, Shaolin Temple Monastery
Song Mountain, China

SHI XING DU b. 1969

32nd Generation

Hu Yue Shuang Gou | Tiger Leaping Double Hooks

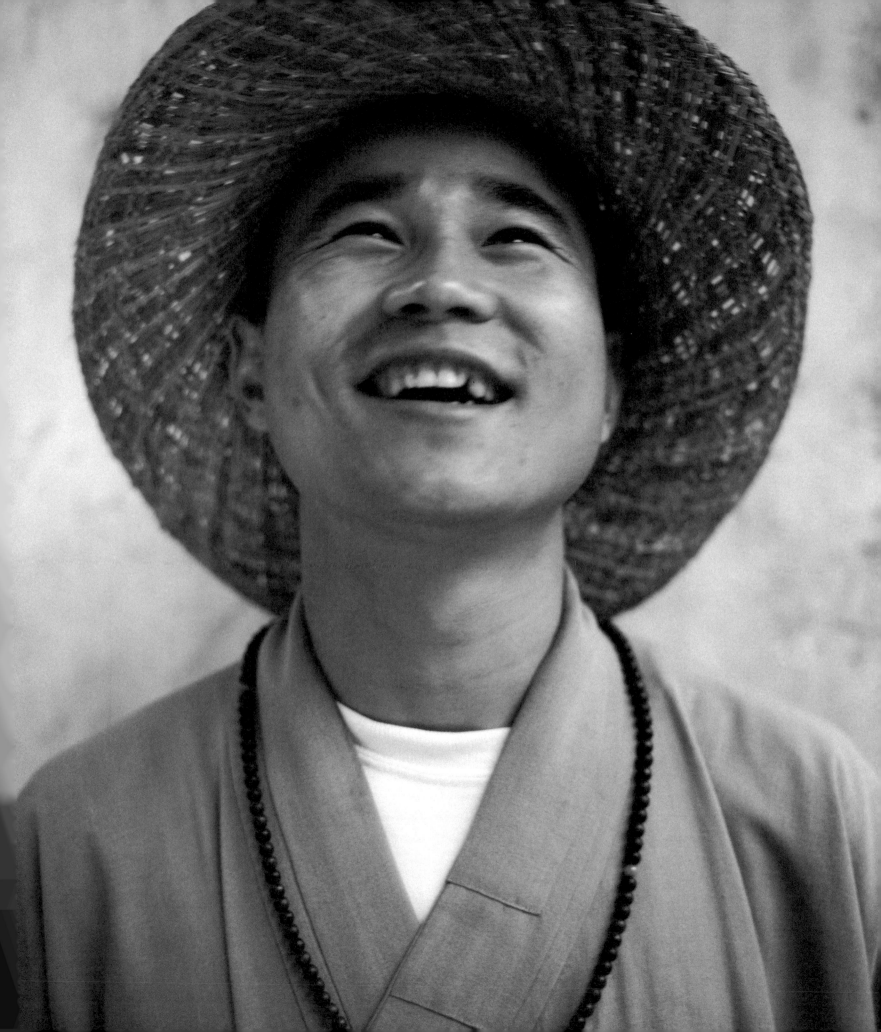

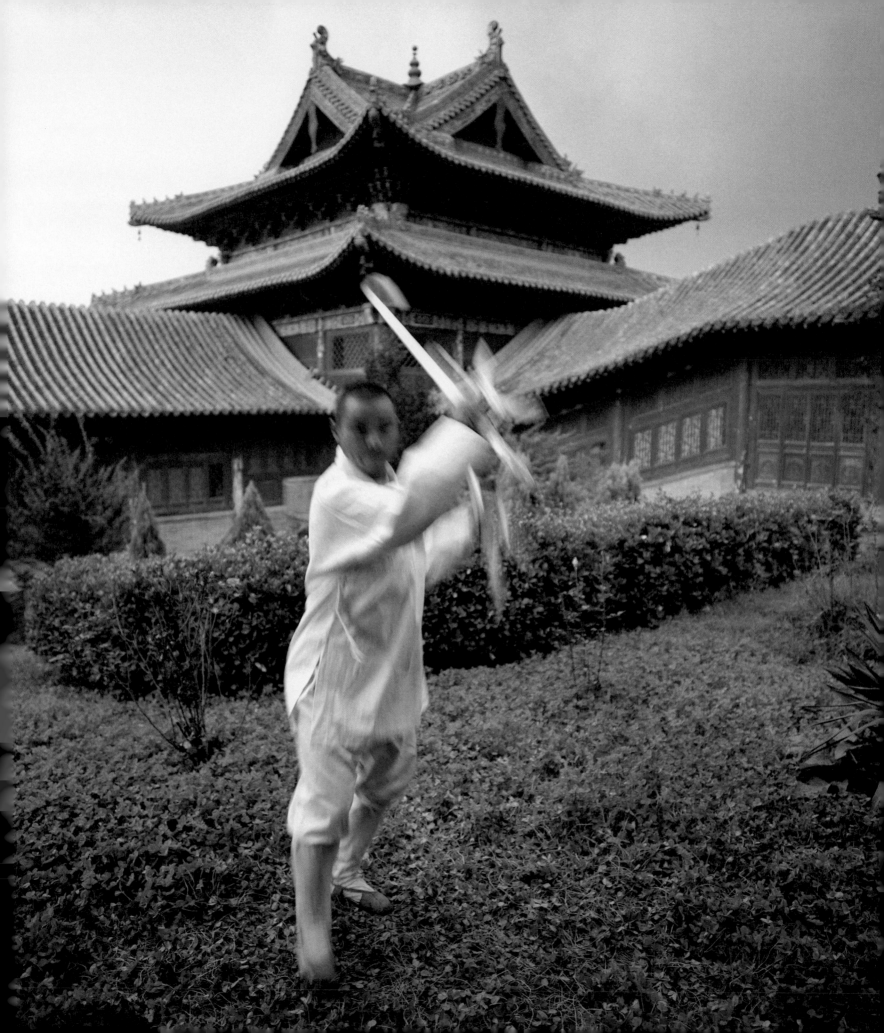

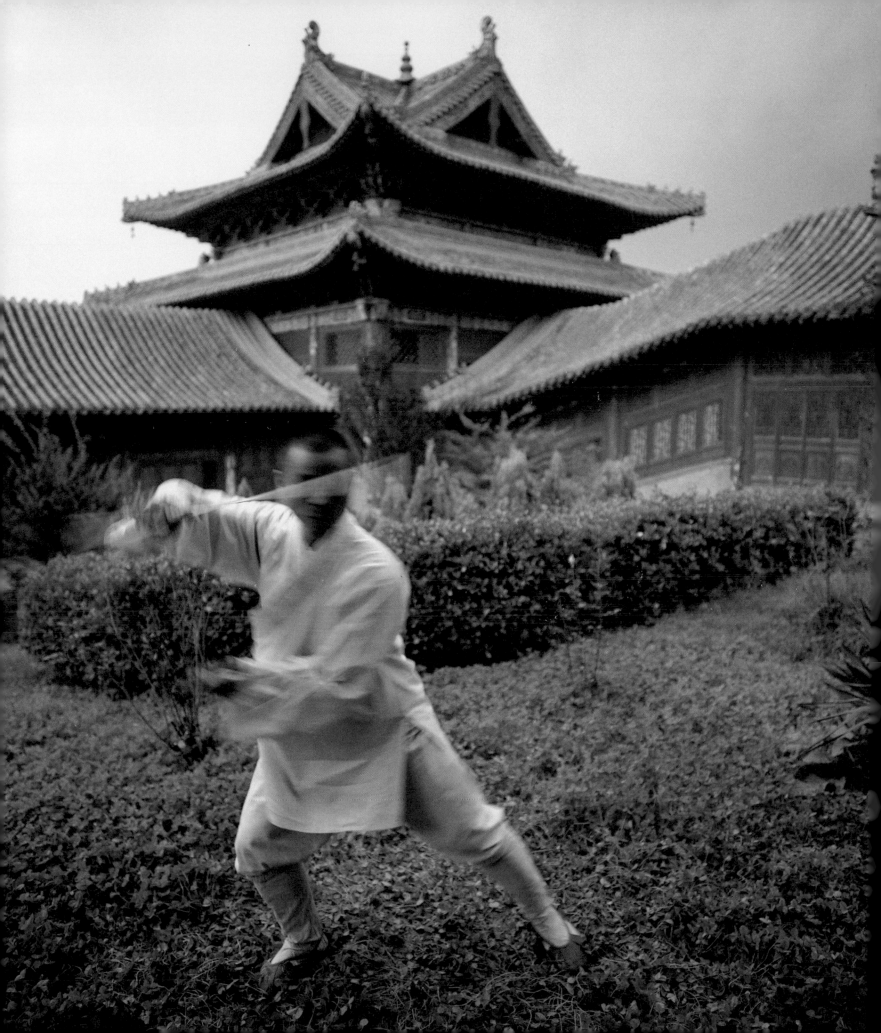

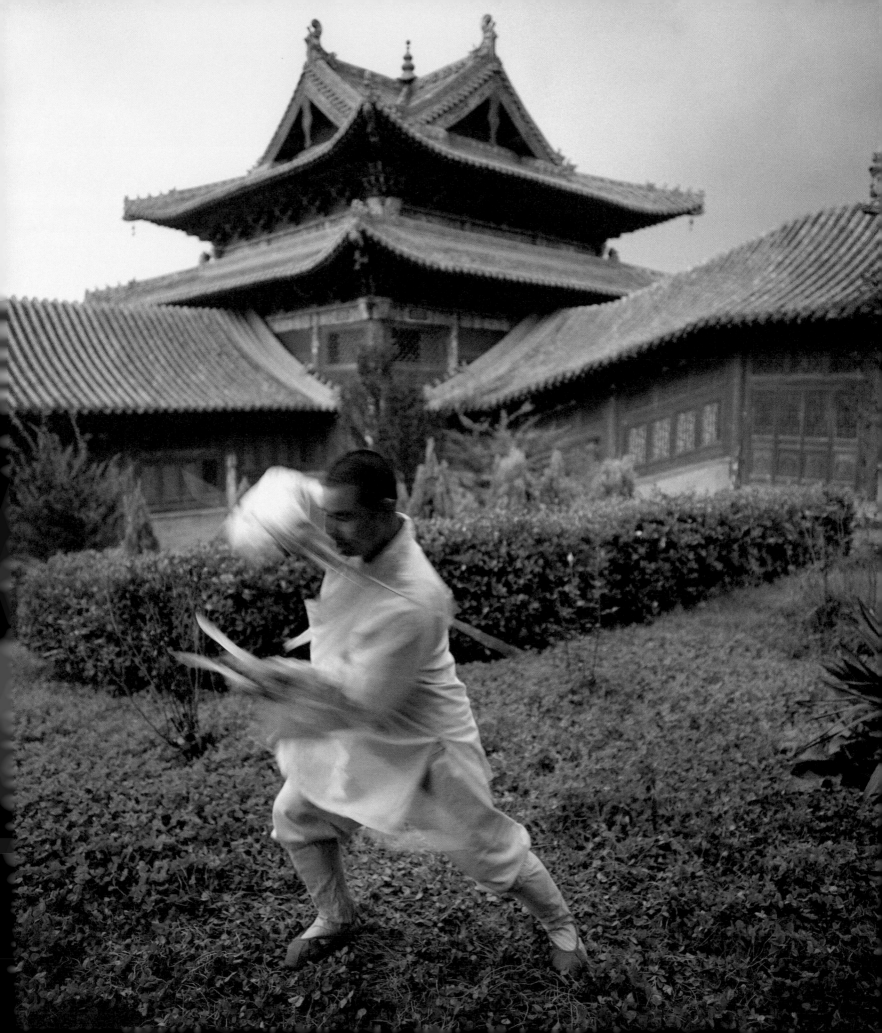

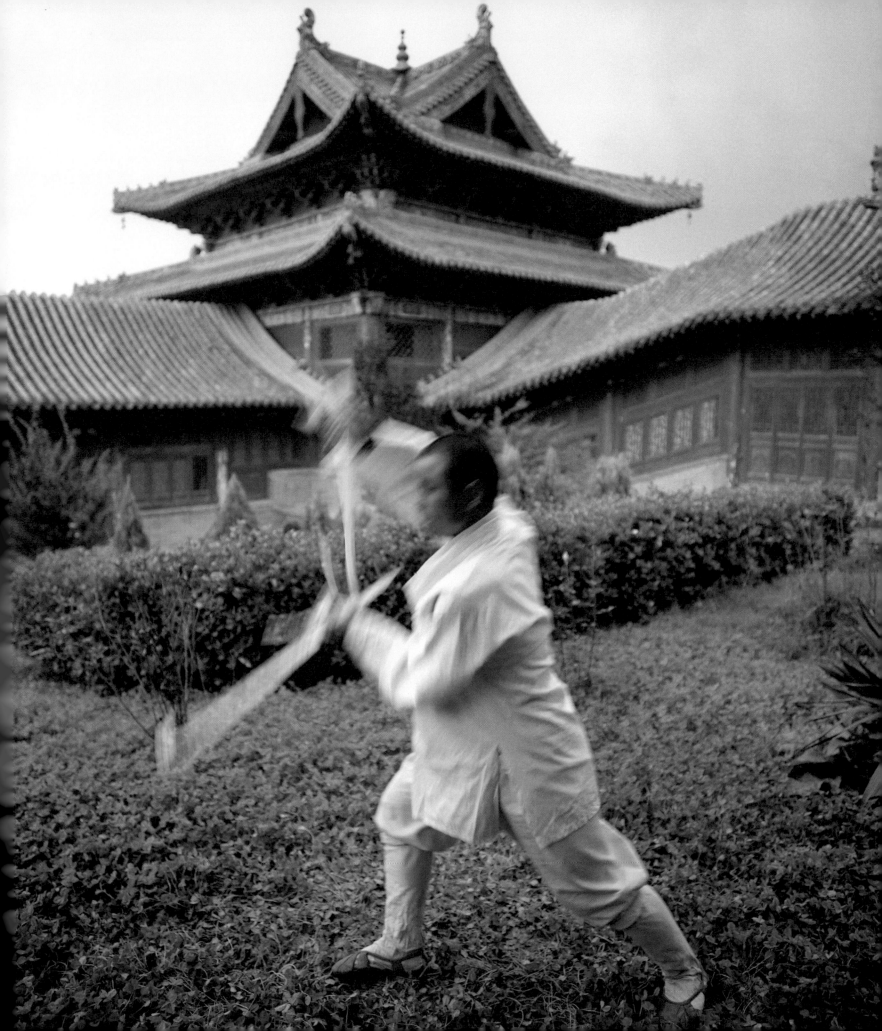

SHI GUO SONG b. 1972

34th Generation

Tang Lang Quan | Praying Mantis Fist

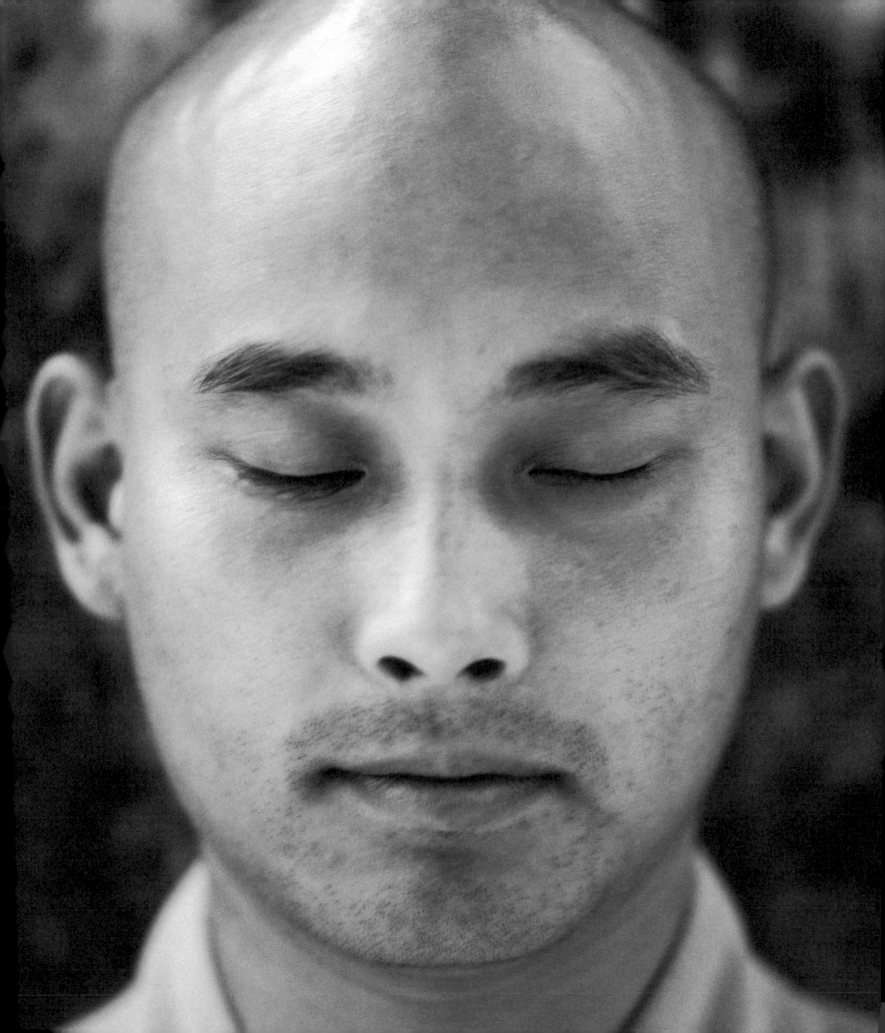

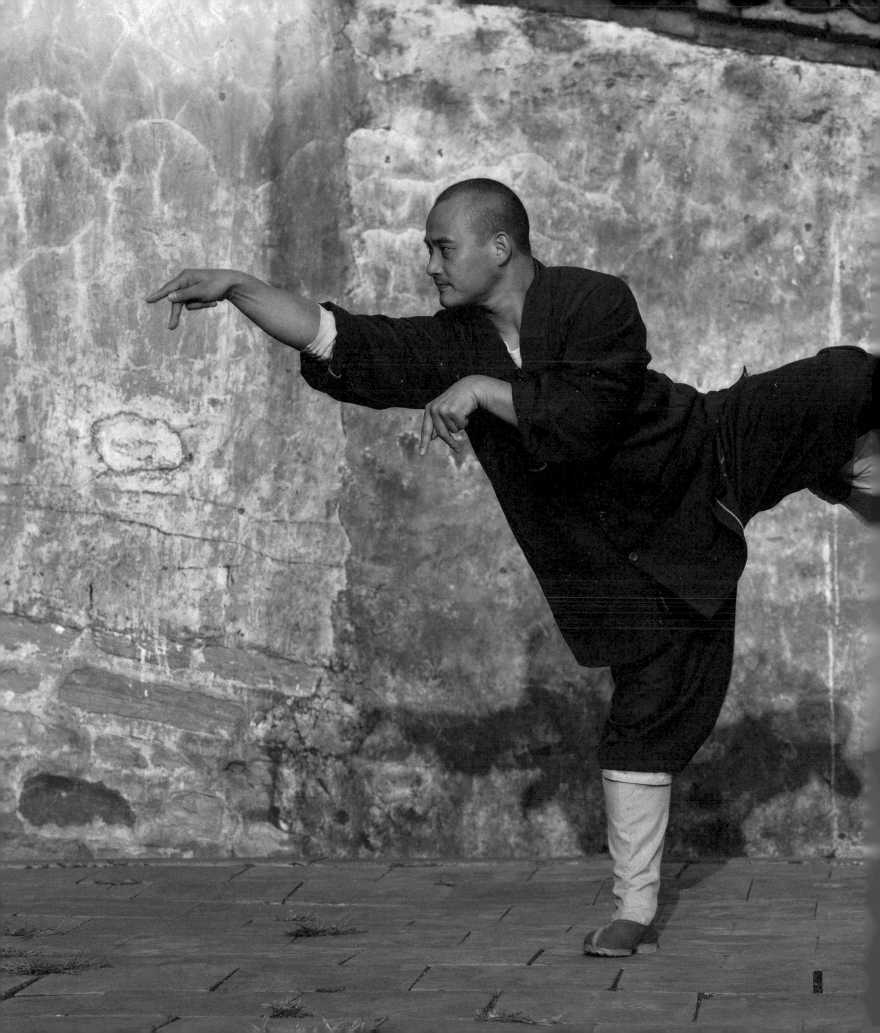

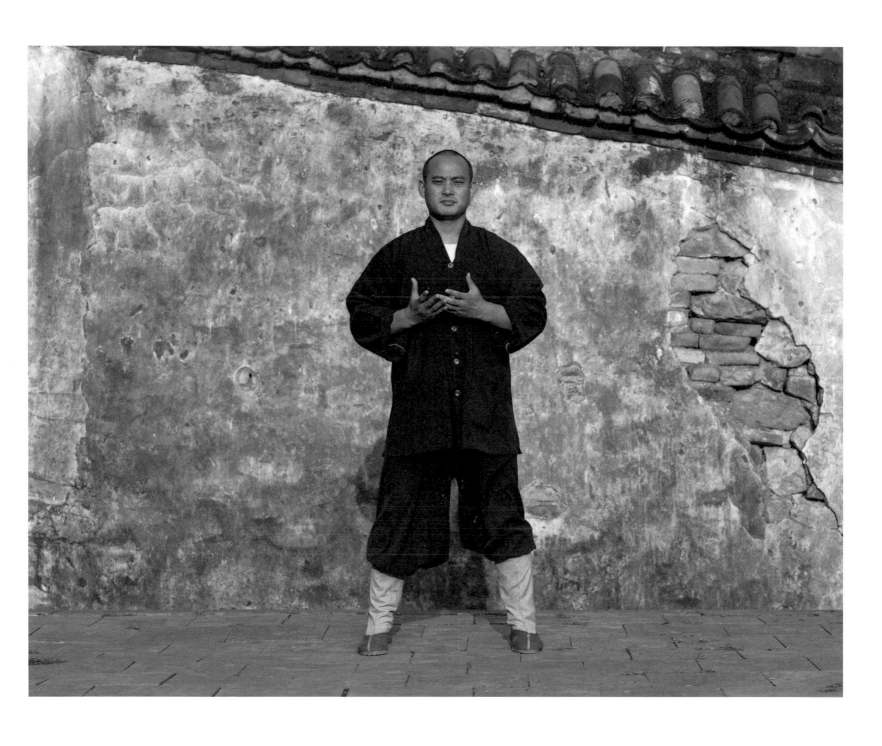

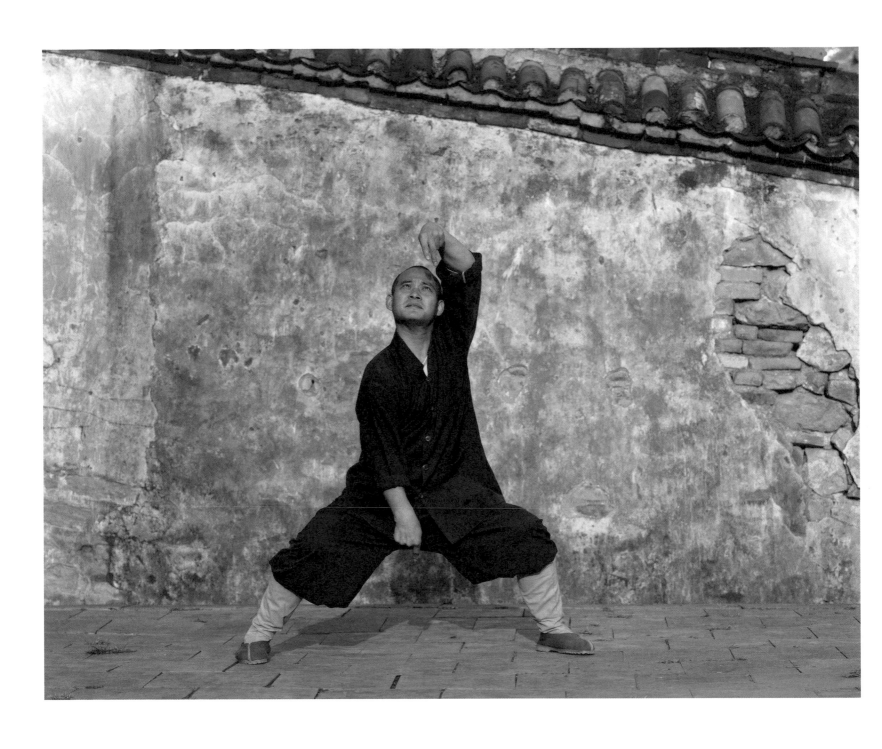

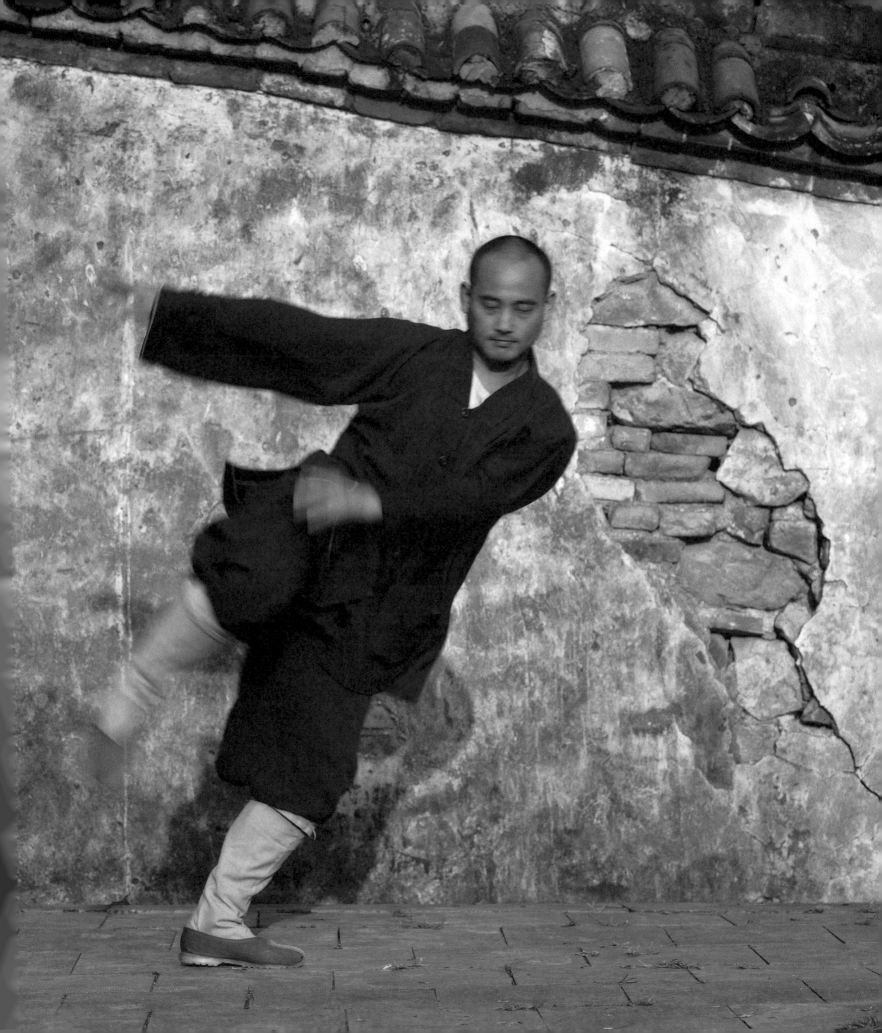

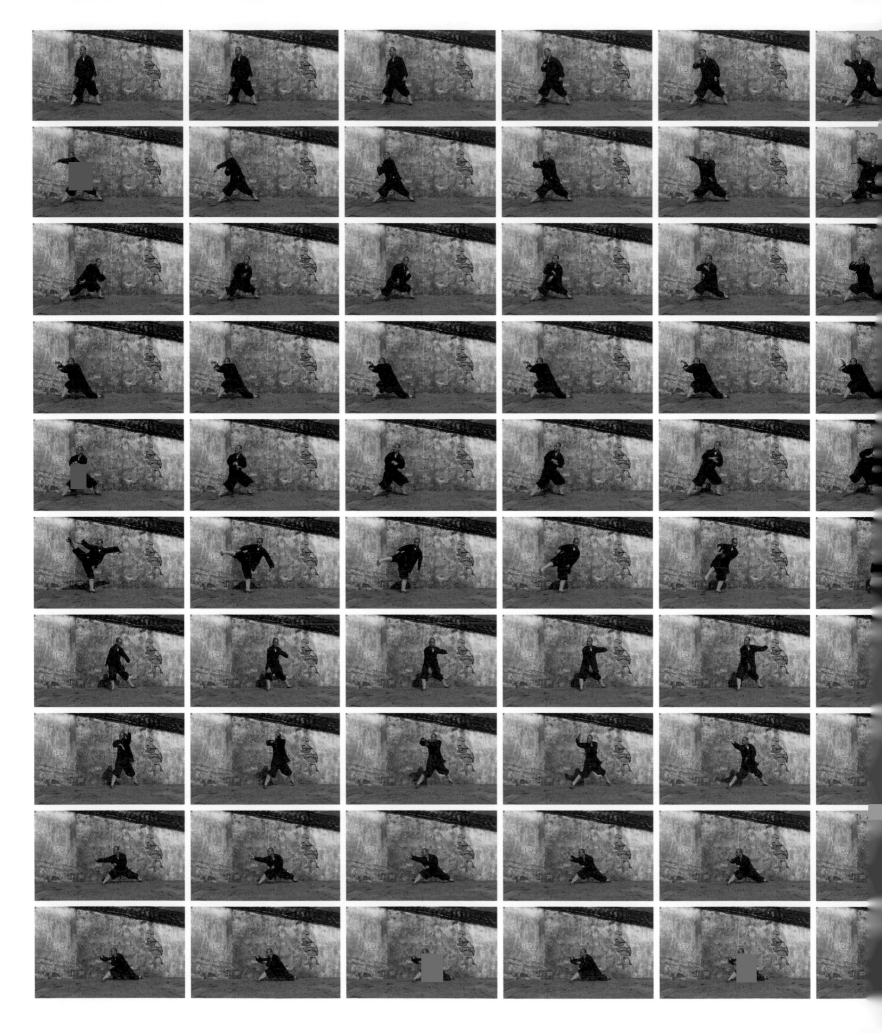

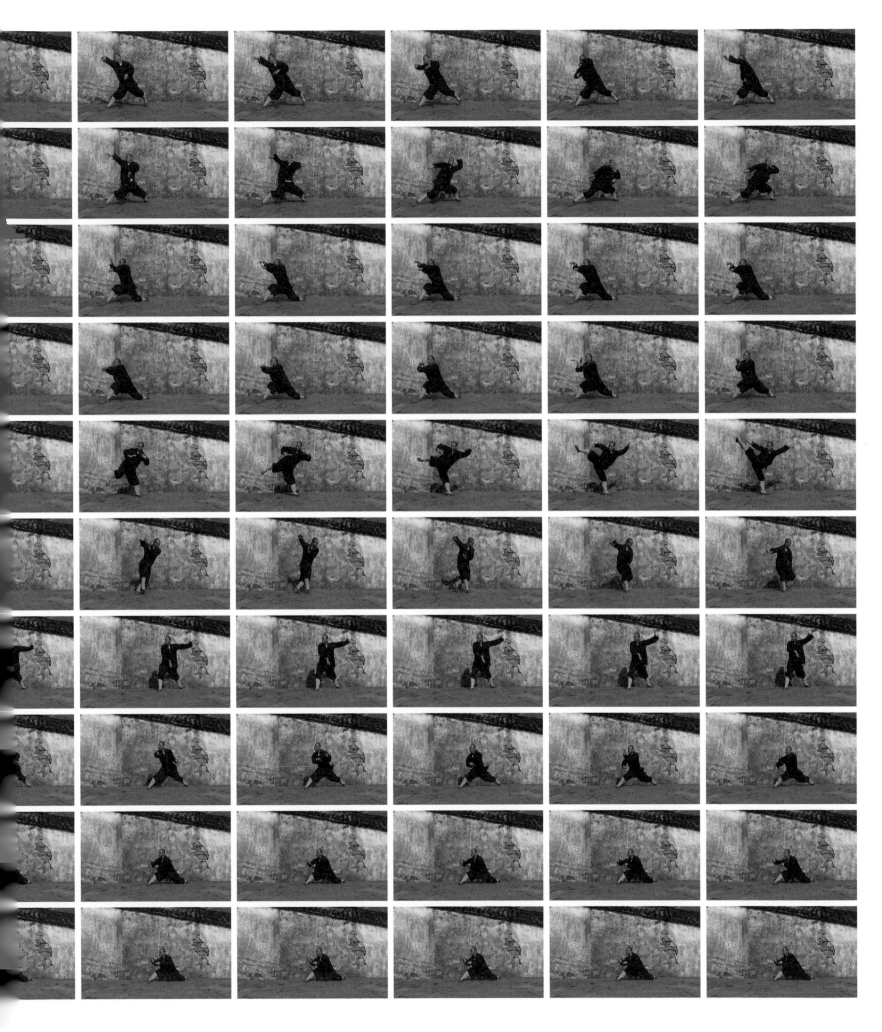

SHI YAN ZHUANG b. 1963

34th Generation

Shi Shan Qiang | Thirteen Spears

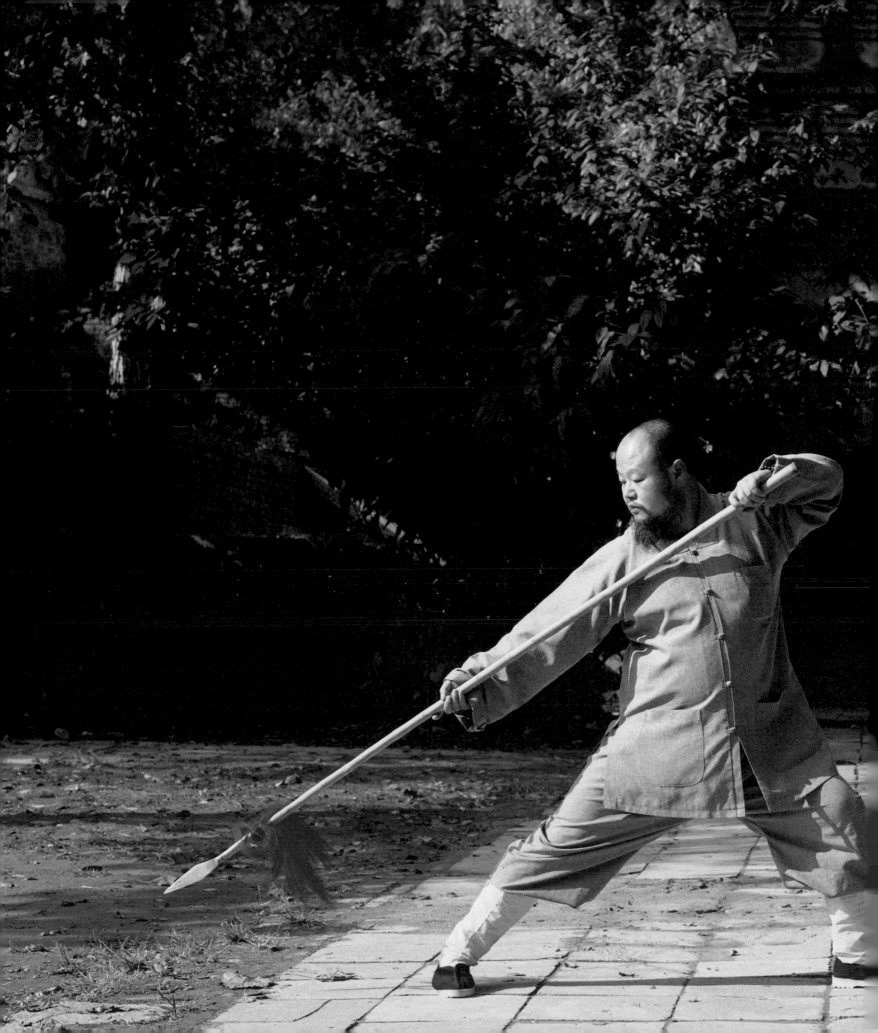

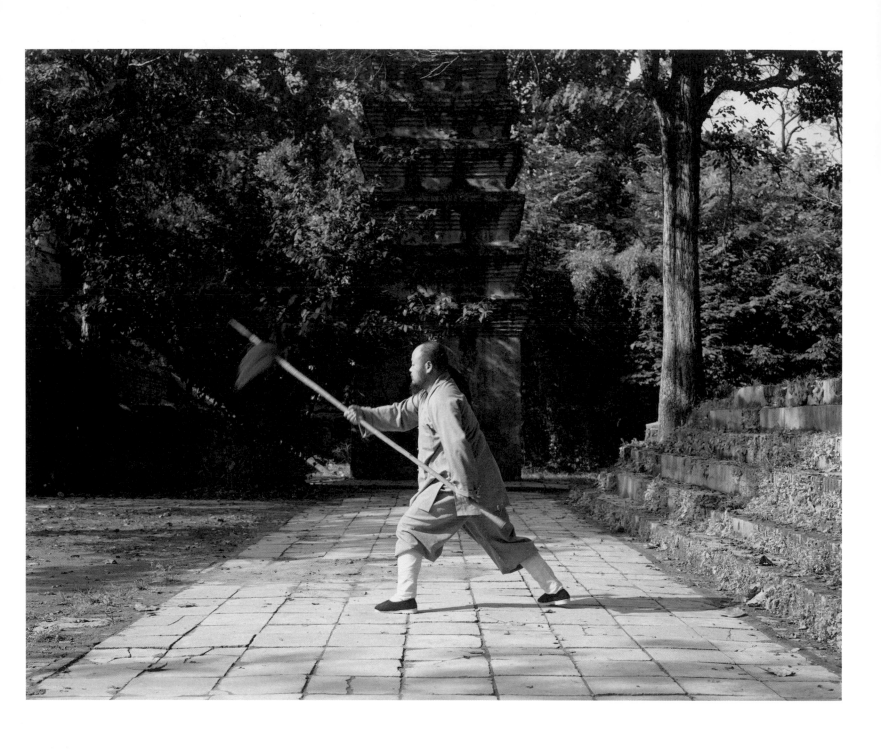

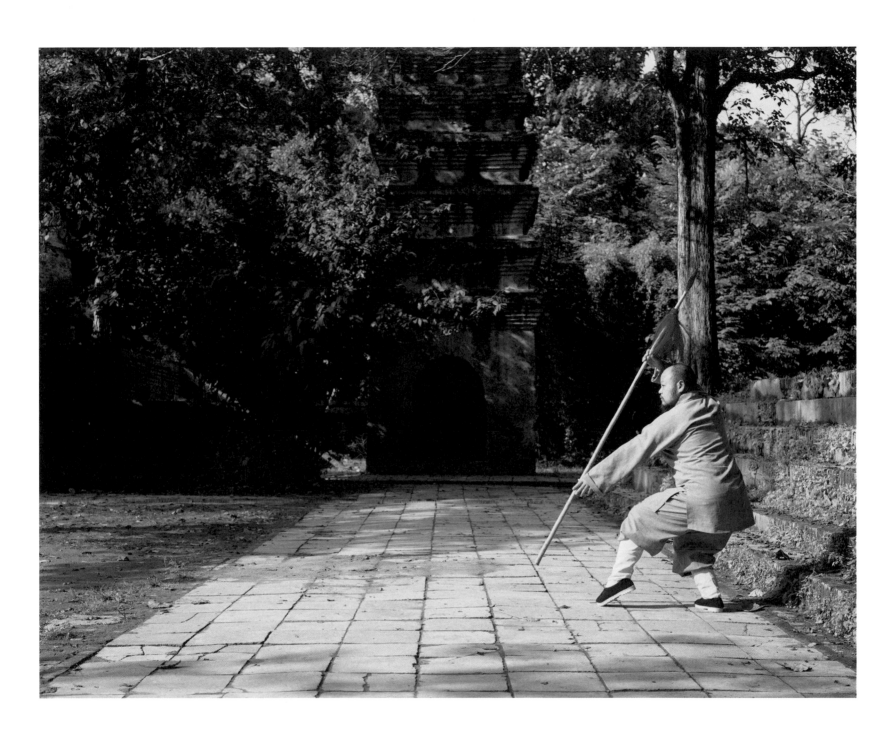

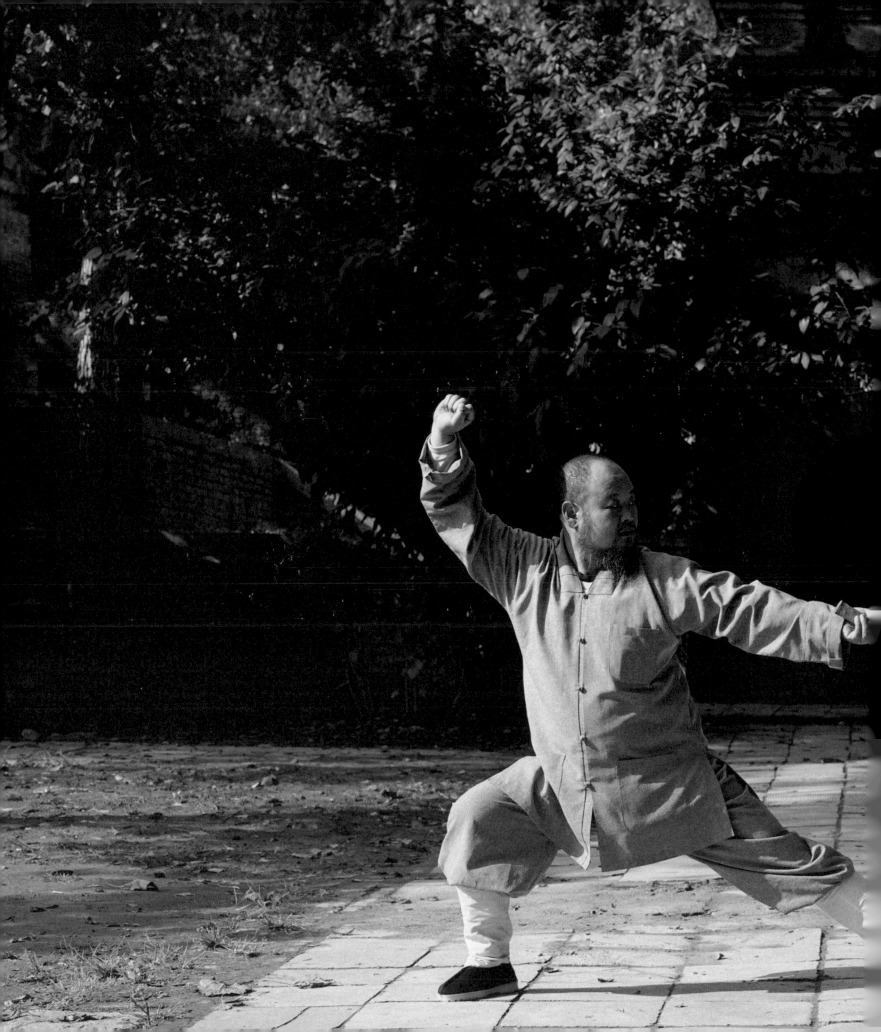

SHI YAN AO b. 1963

34th Generation

Qi Mei Gun | Equal Eyebrow Staff

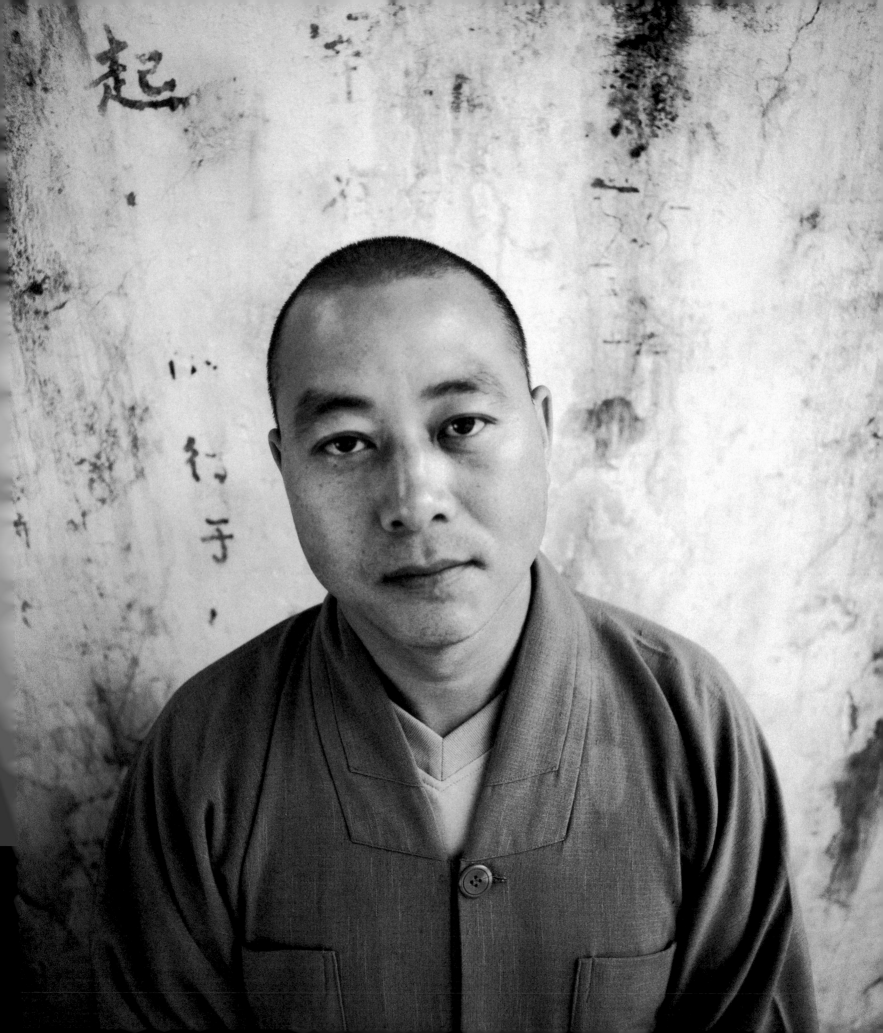

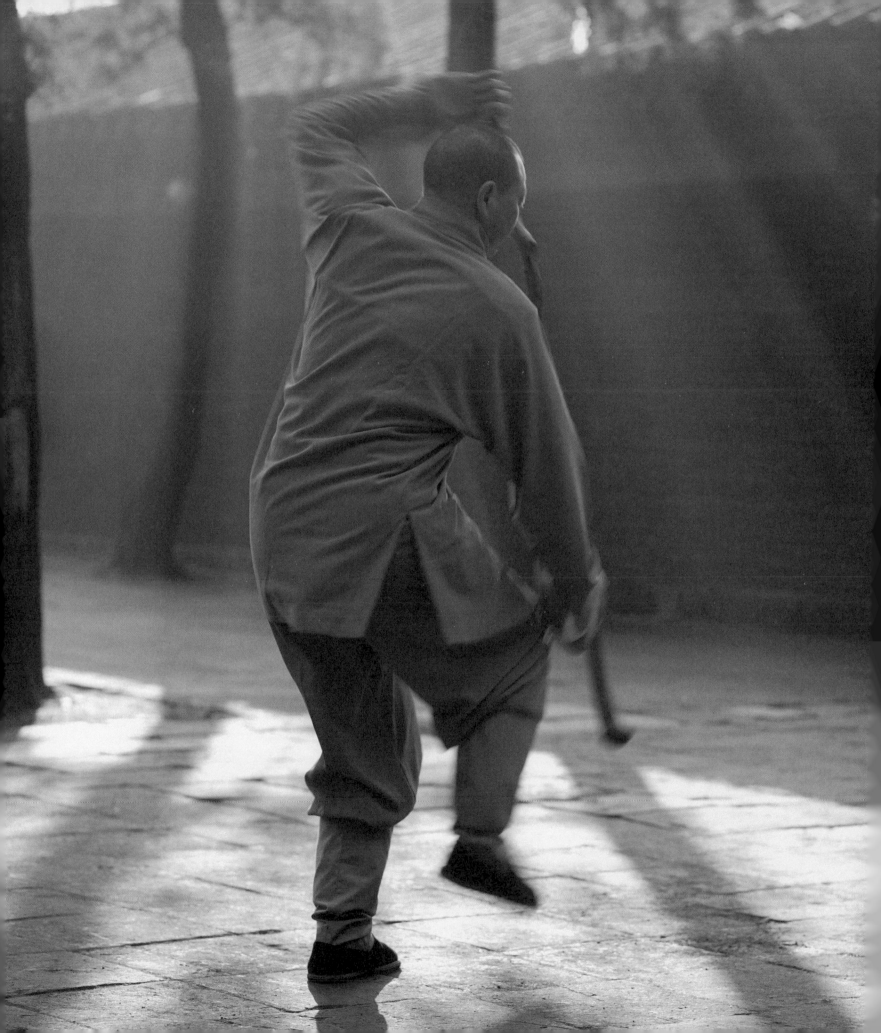

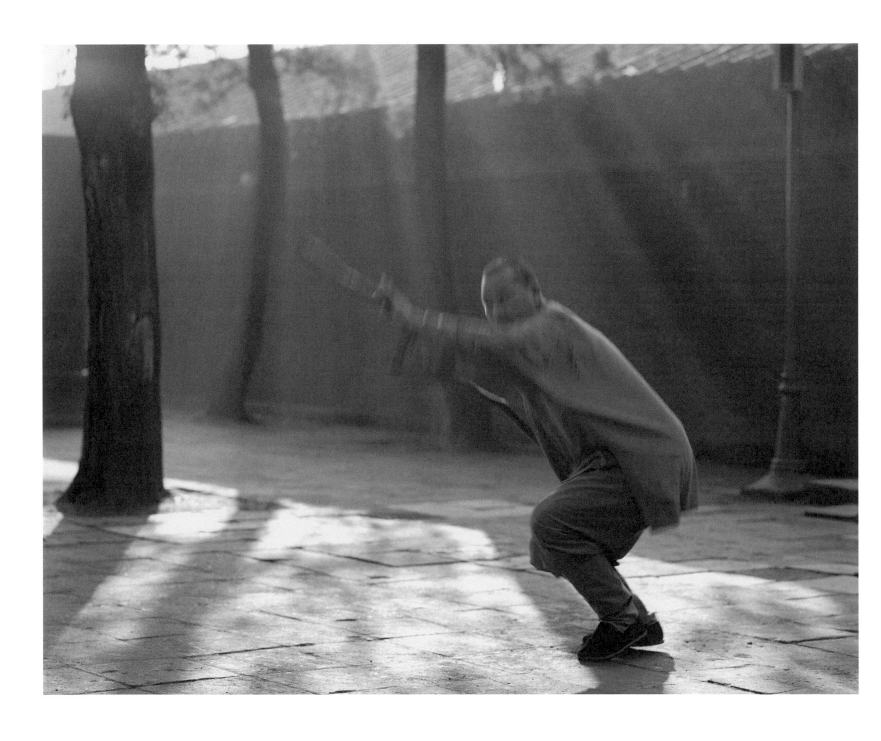

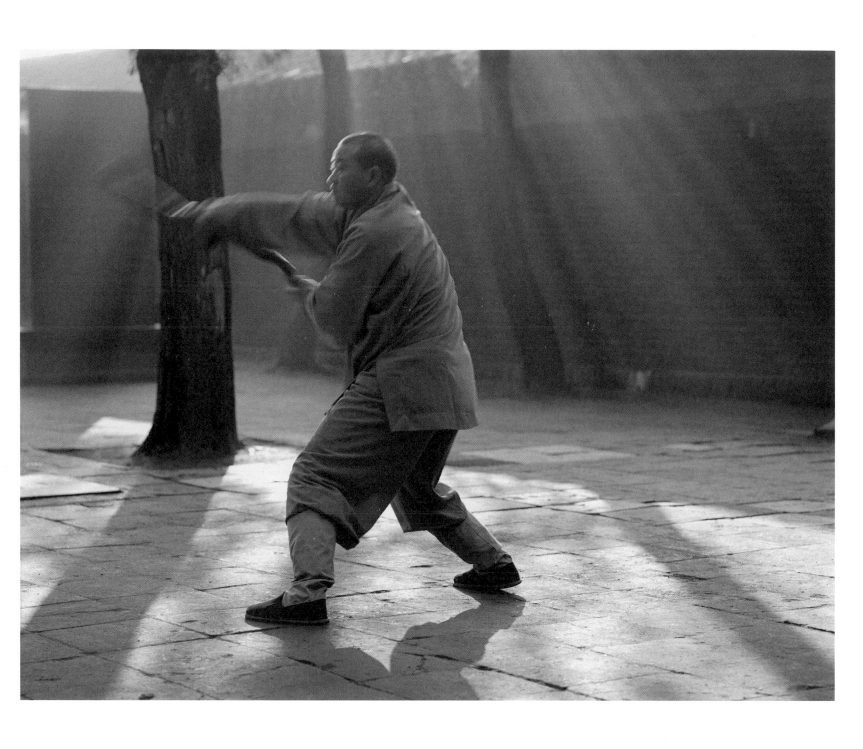

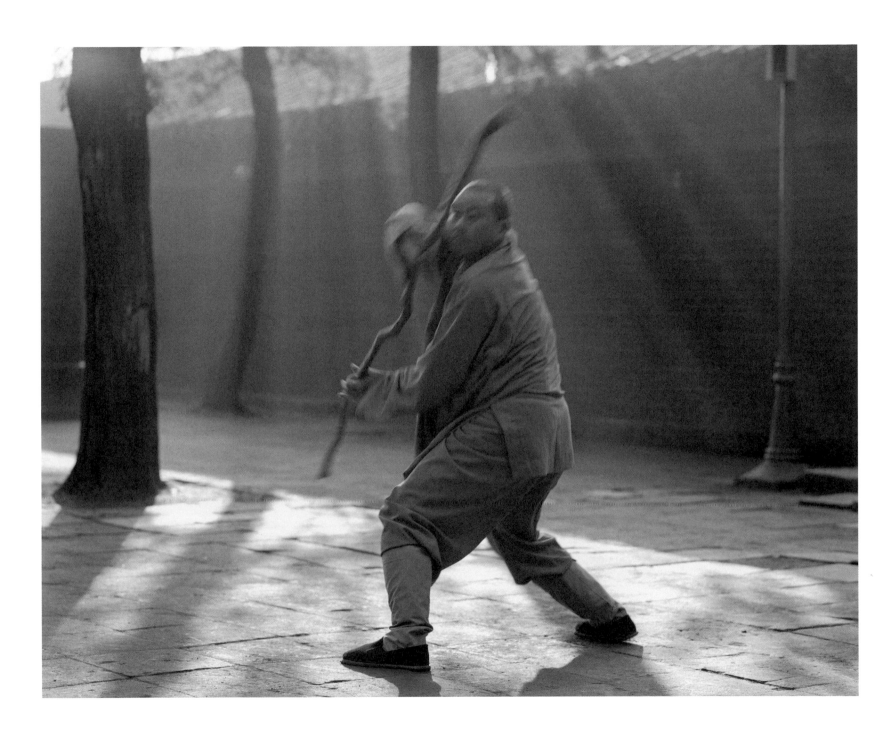

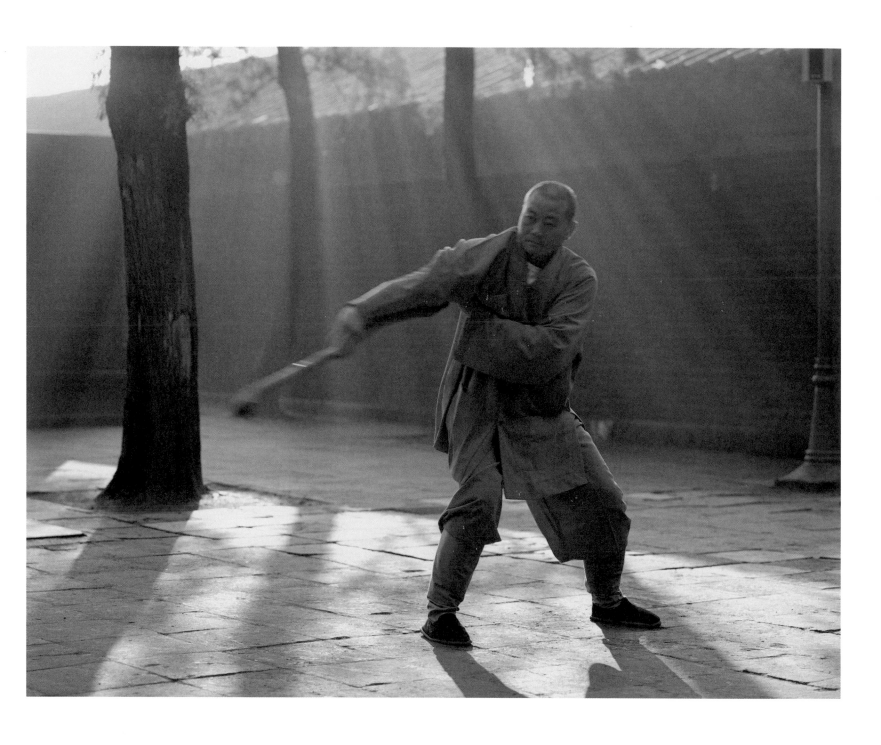

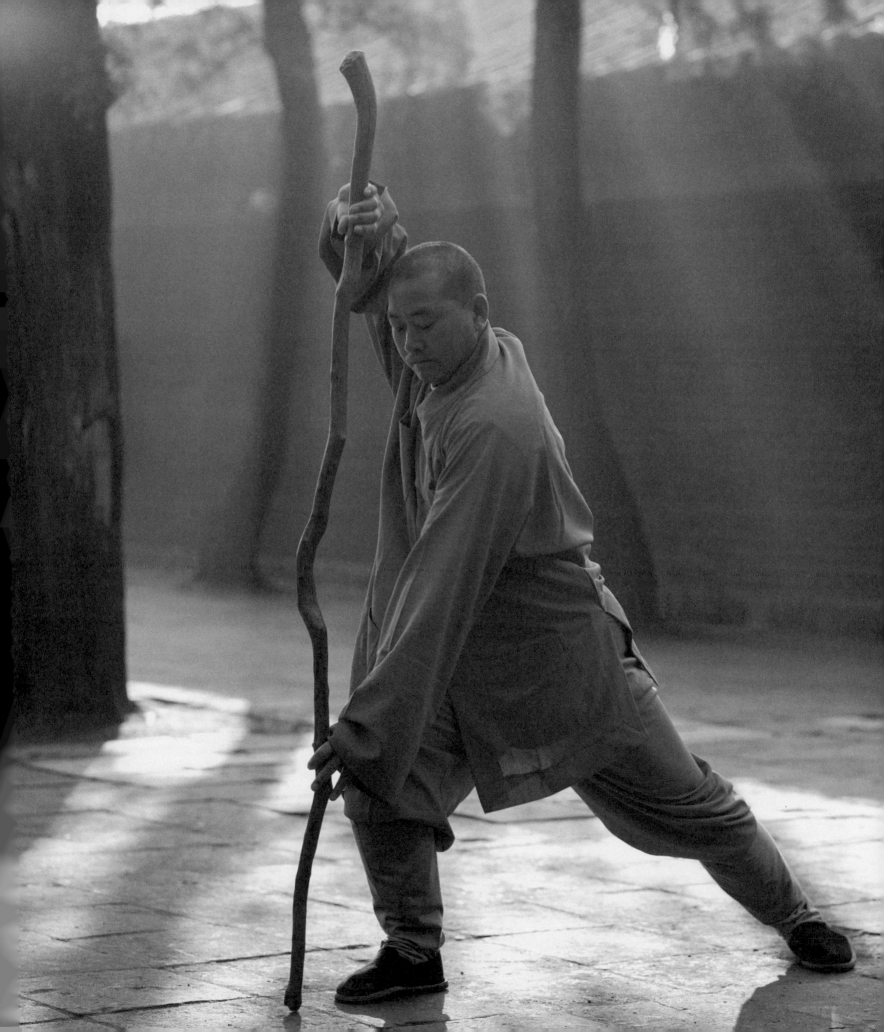

SHI HENG FU b. 1963

35th Generation

Chao Yang Quan | Facing the Sun Fist

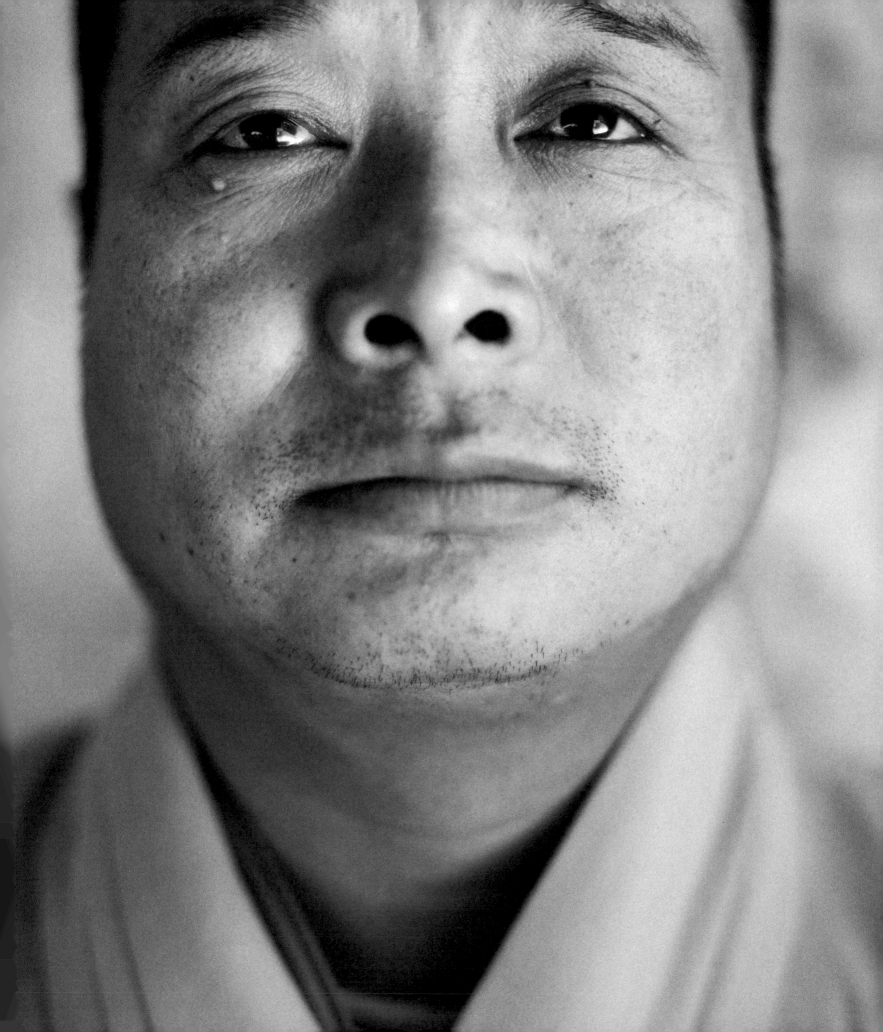

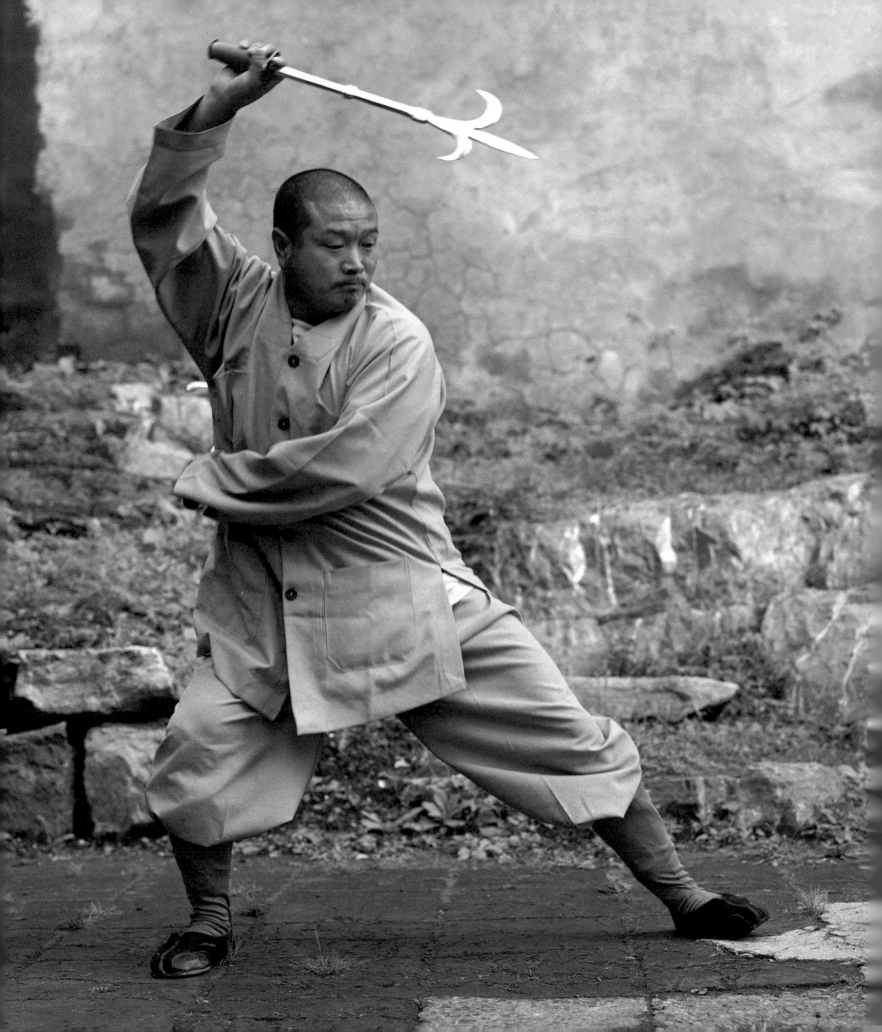

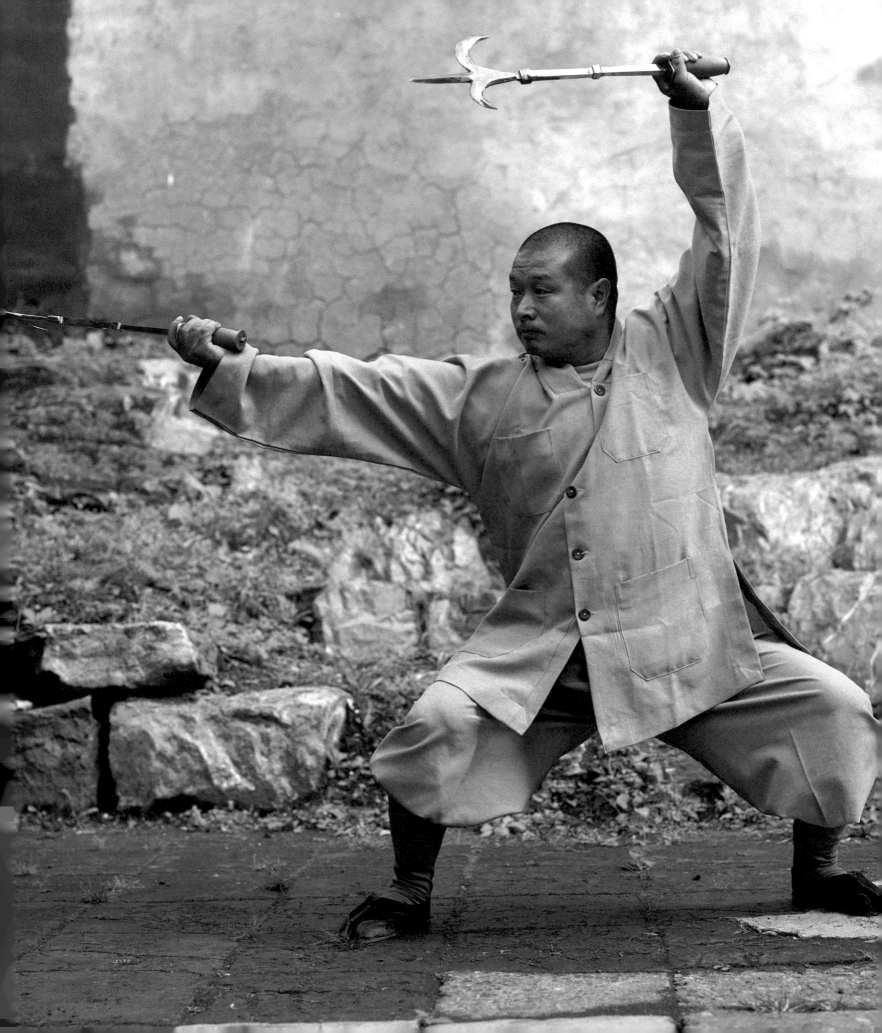

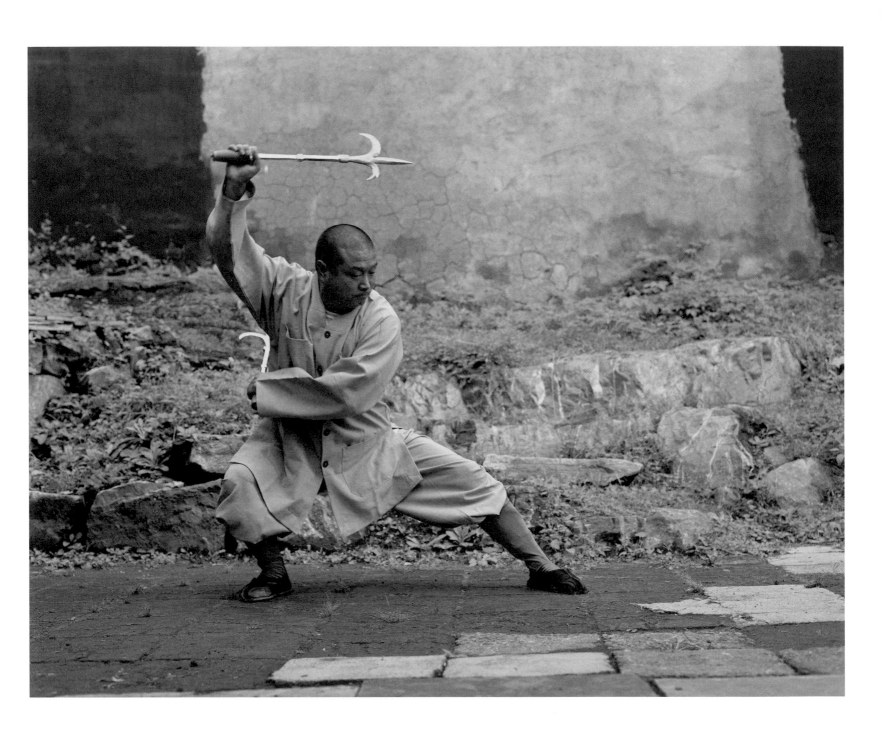

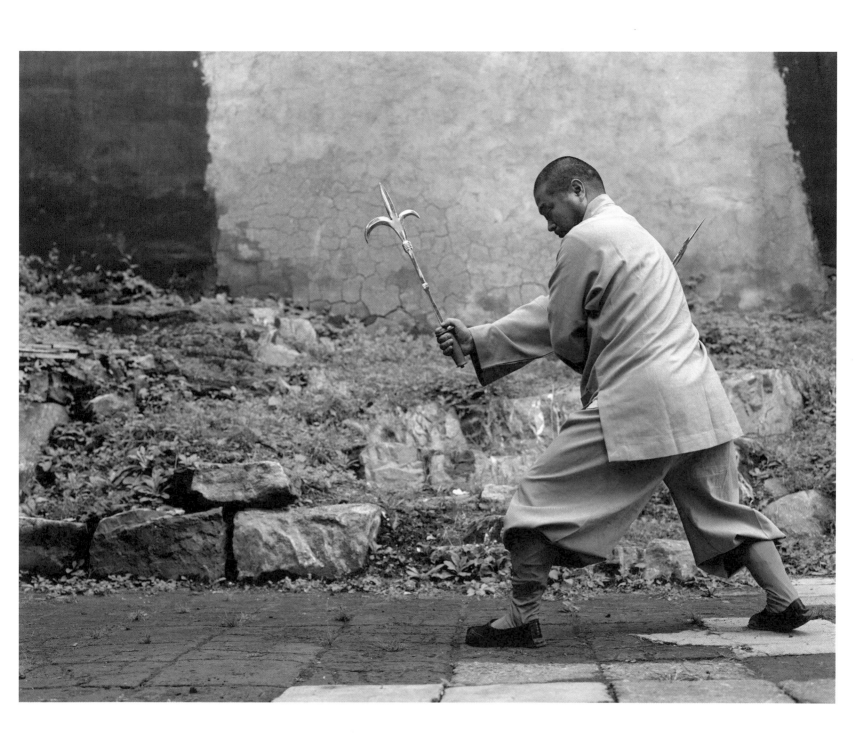

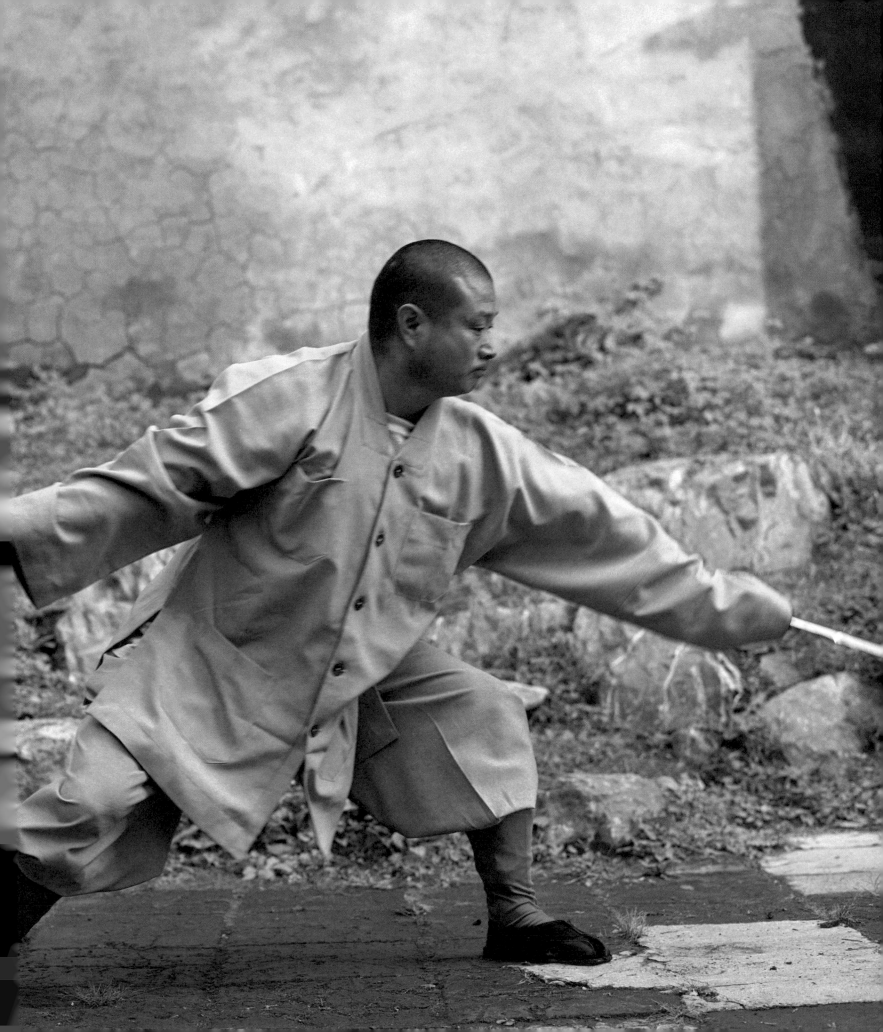

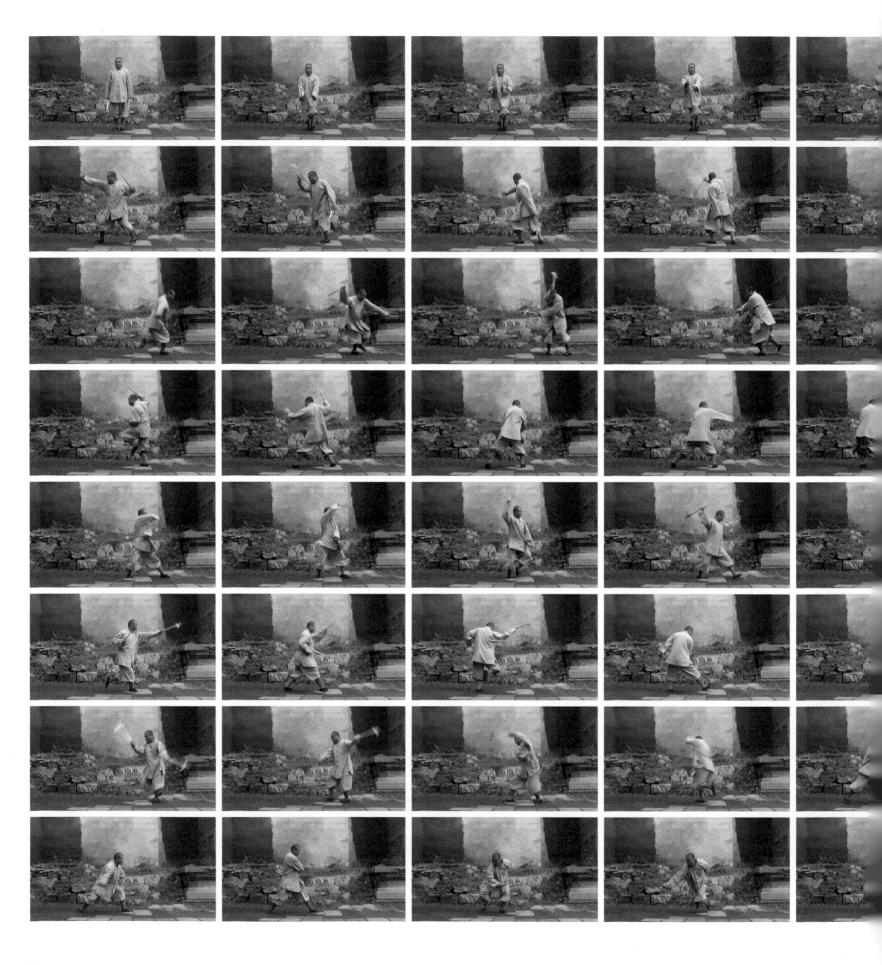

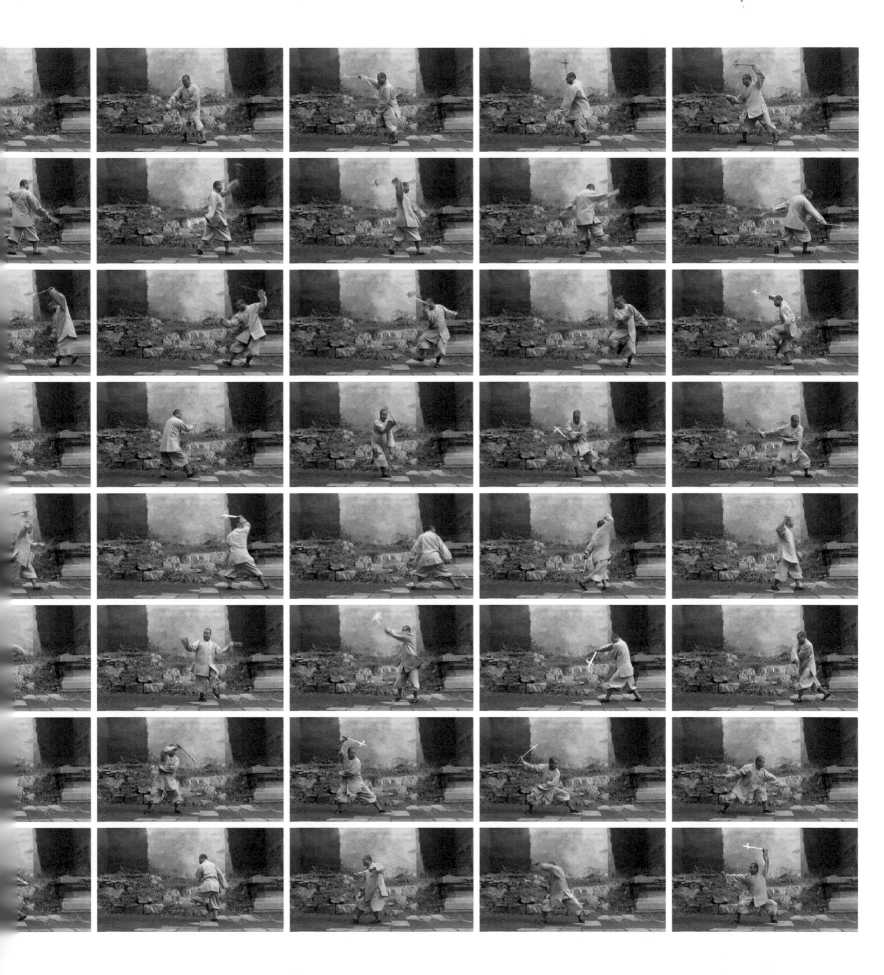

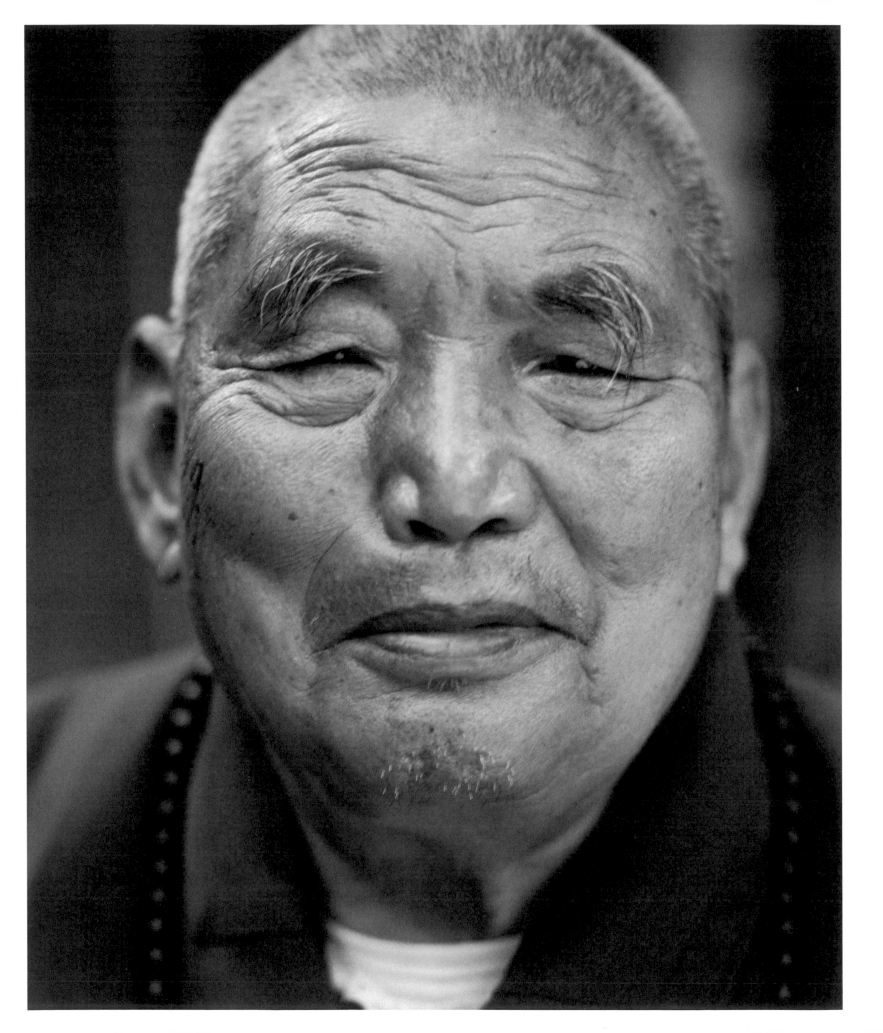

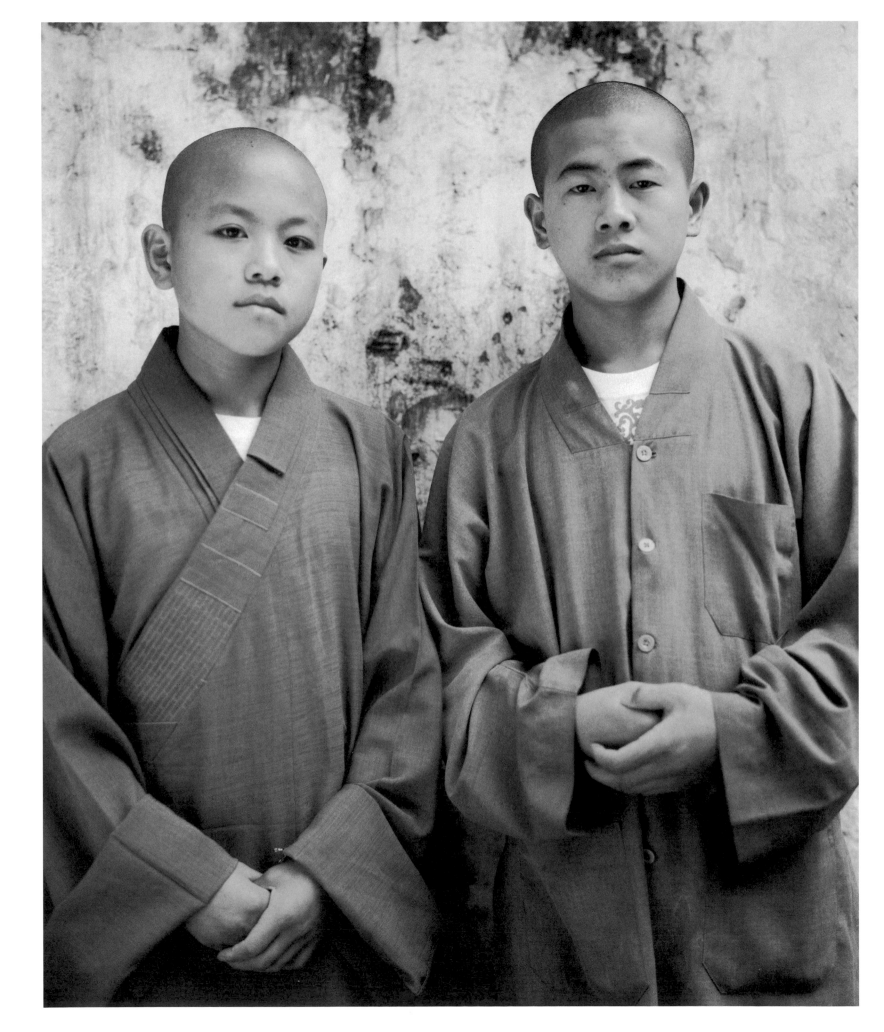

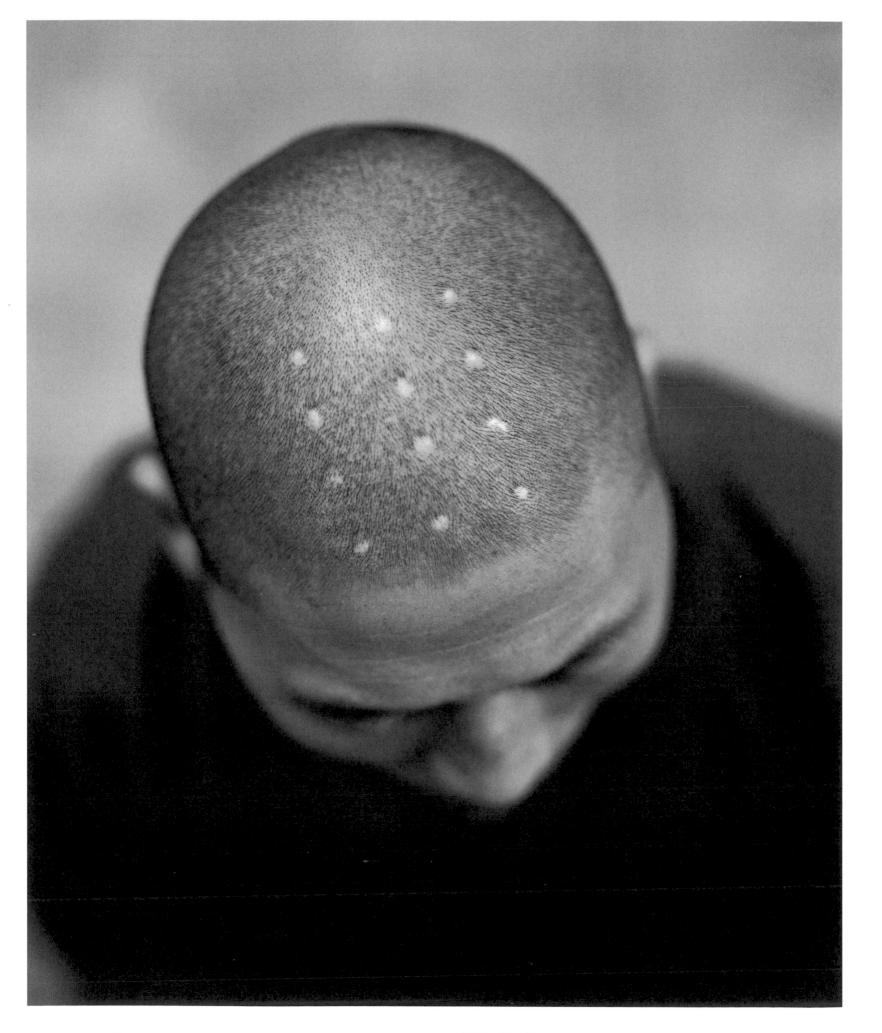

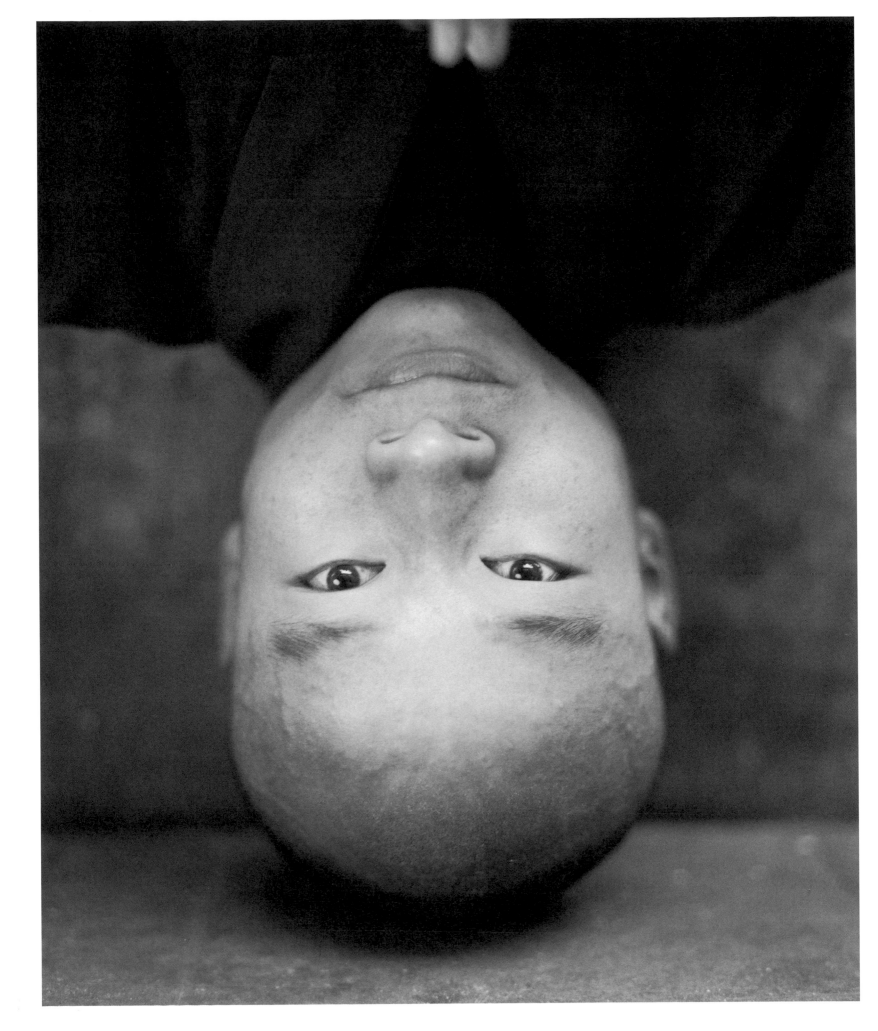

Page 70:
Grandmaster Shi Su Xi, 30th generation, b. 1923
Page 71:
(left) Shi Yan Yang, 33rd generation, b. 1989
(right) Shi Yan Qian, 34th generation, b. 1988

Page 72:
Shi Yong Chuan, generation and date of birth
unknown
Page 73:
Shi Yong Ze, 33rd generation, b. 1986

Pages 75–77; 92–94:
Shaolin incorporates the practice of ritual sym-
bolic gestures or *mudras*. There are hundreds of
variations, twelve of which are portrayed here.
These movements are used in combination with
specific breathing patterns, and chanting, to
express a variety of meditation themes. Many of
these gestures can be seen in Buddhist statuary
throughout Asia.

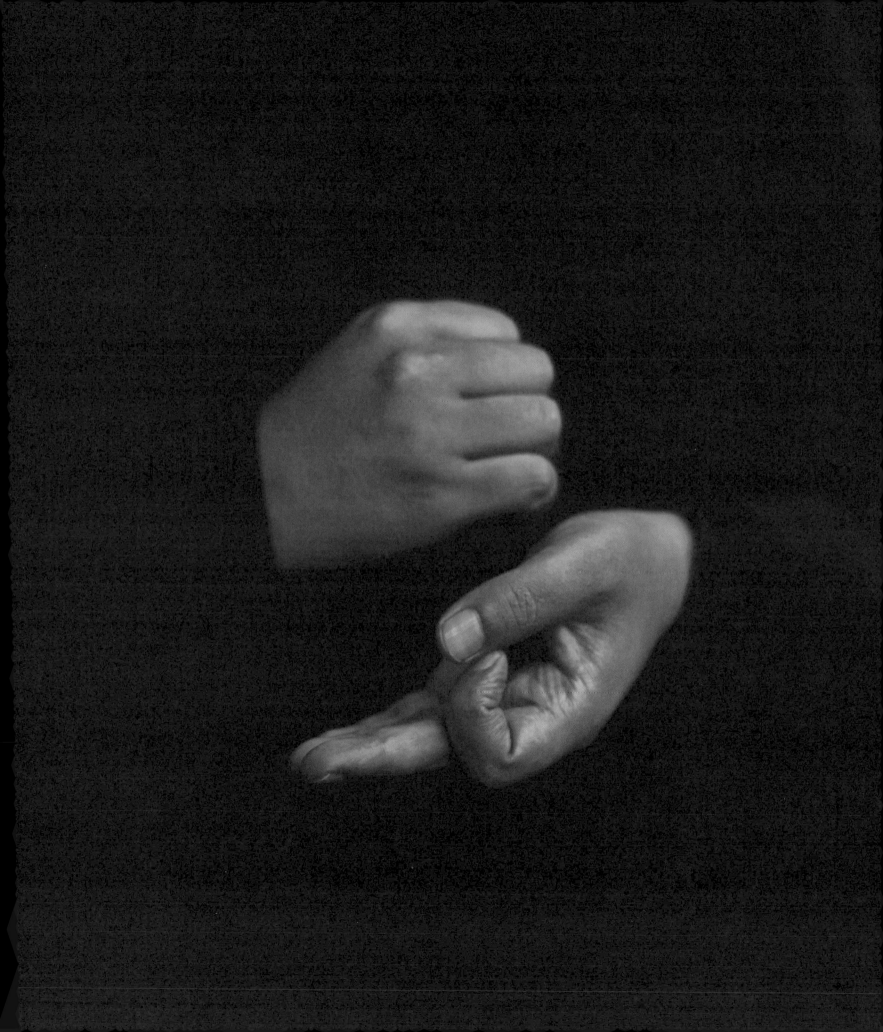

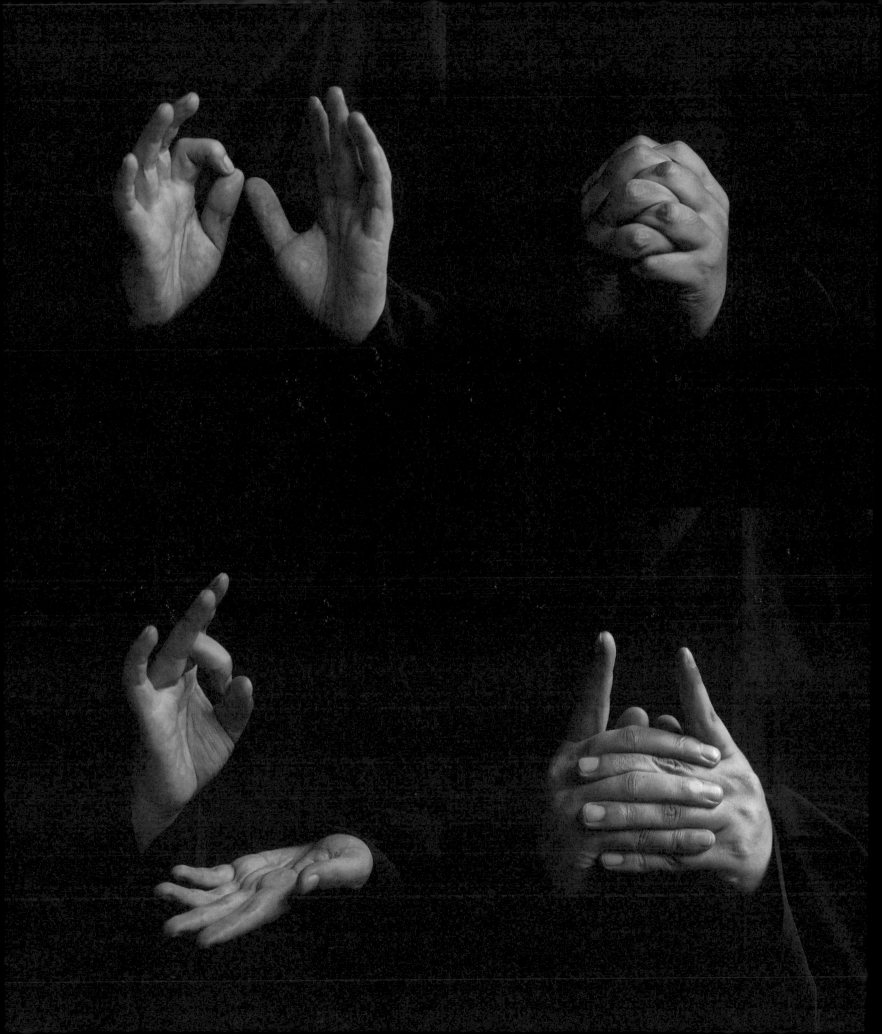

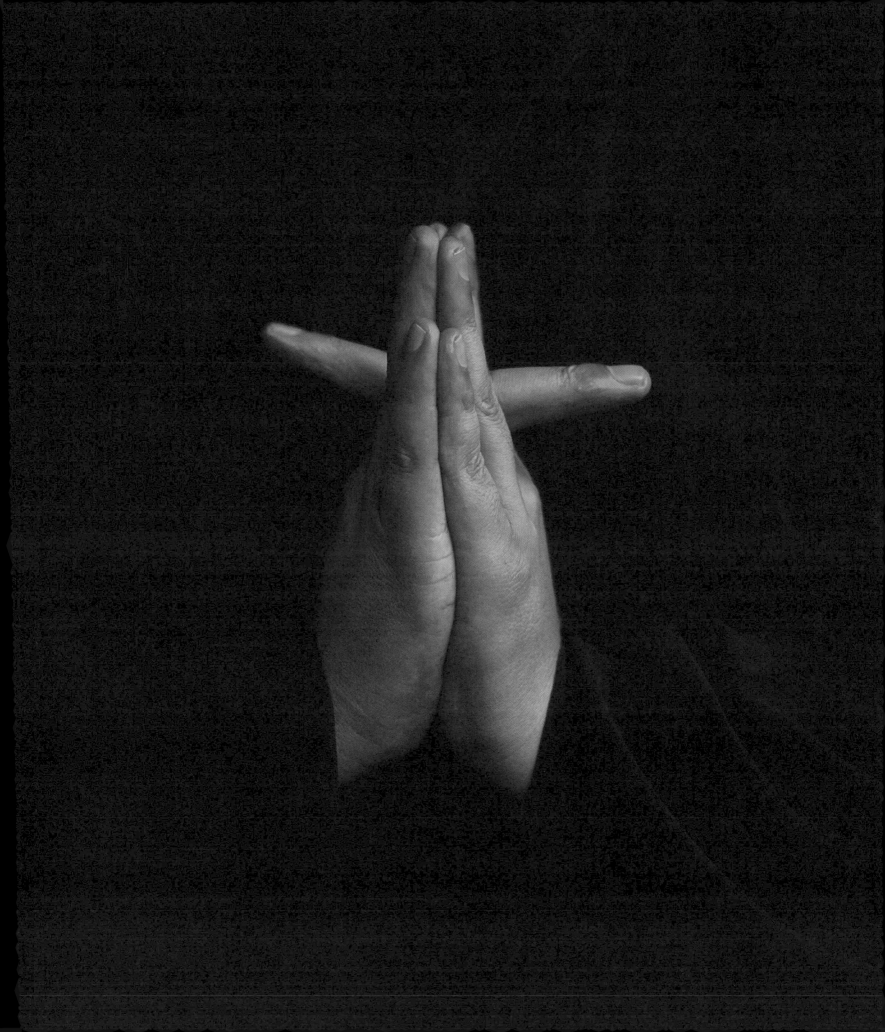

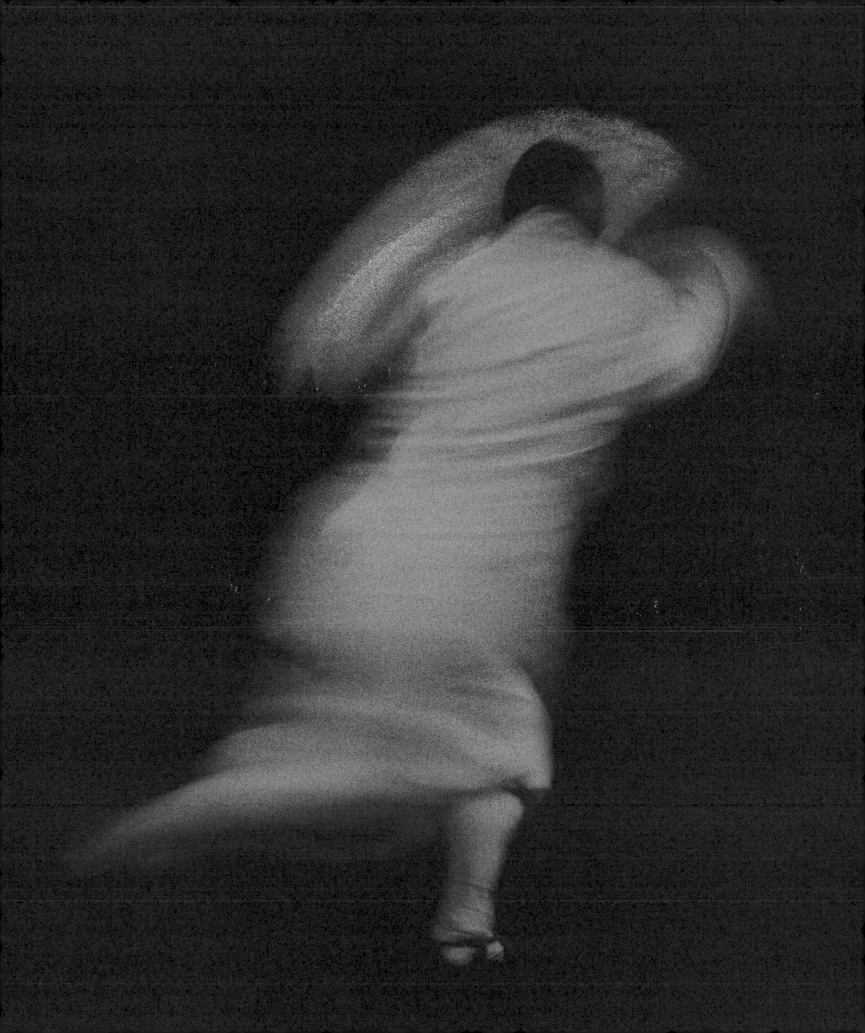

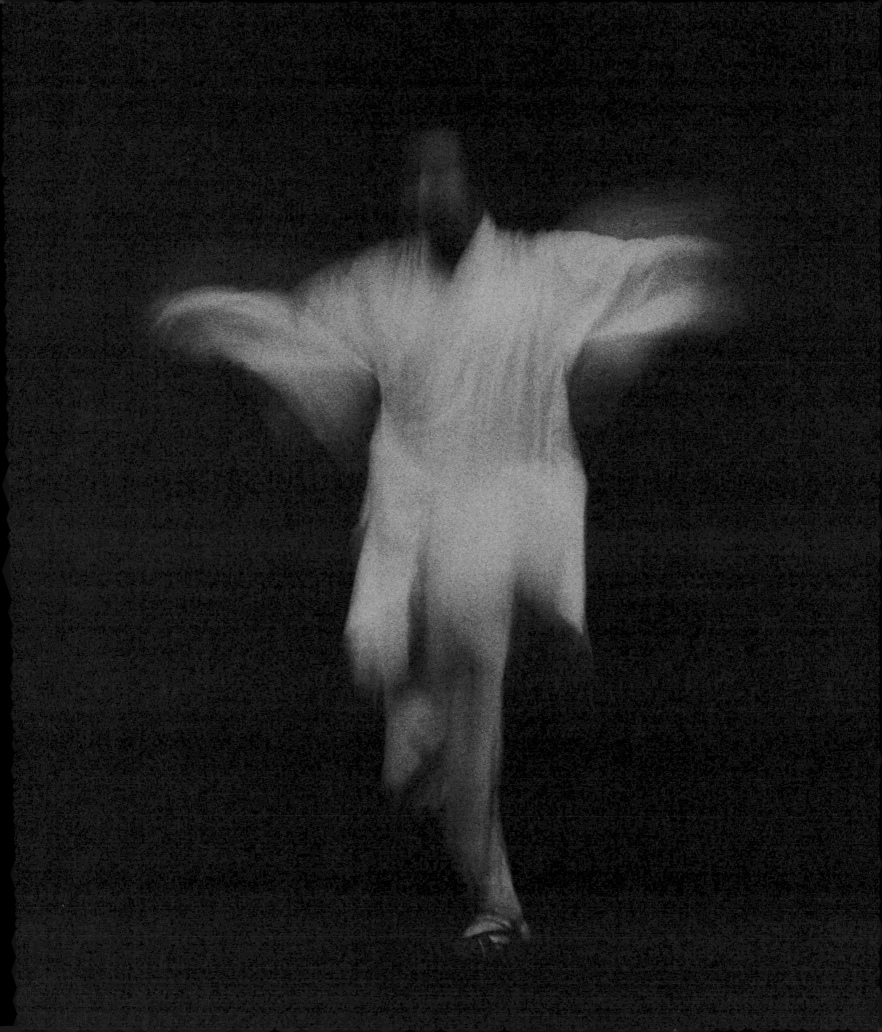

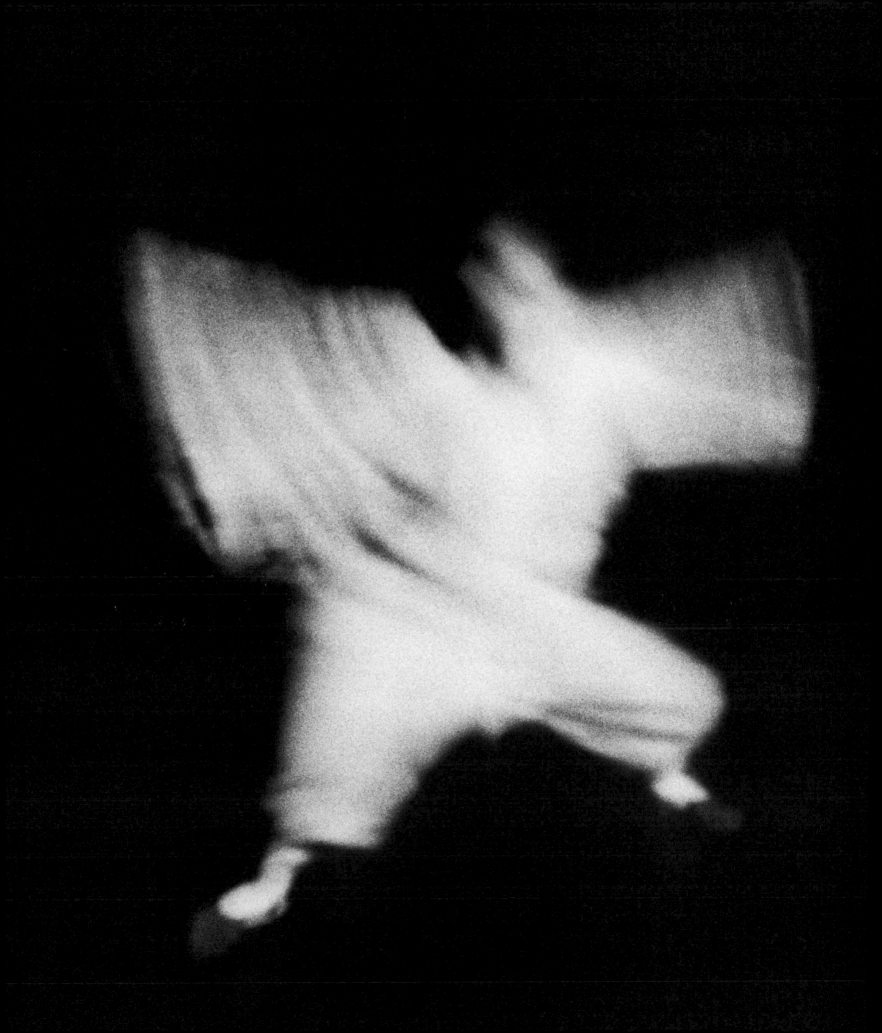

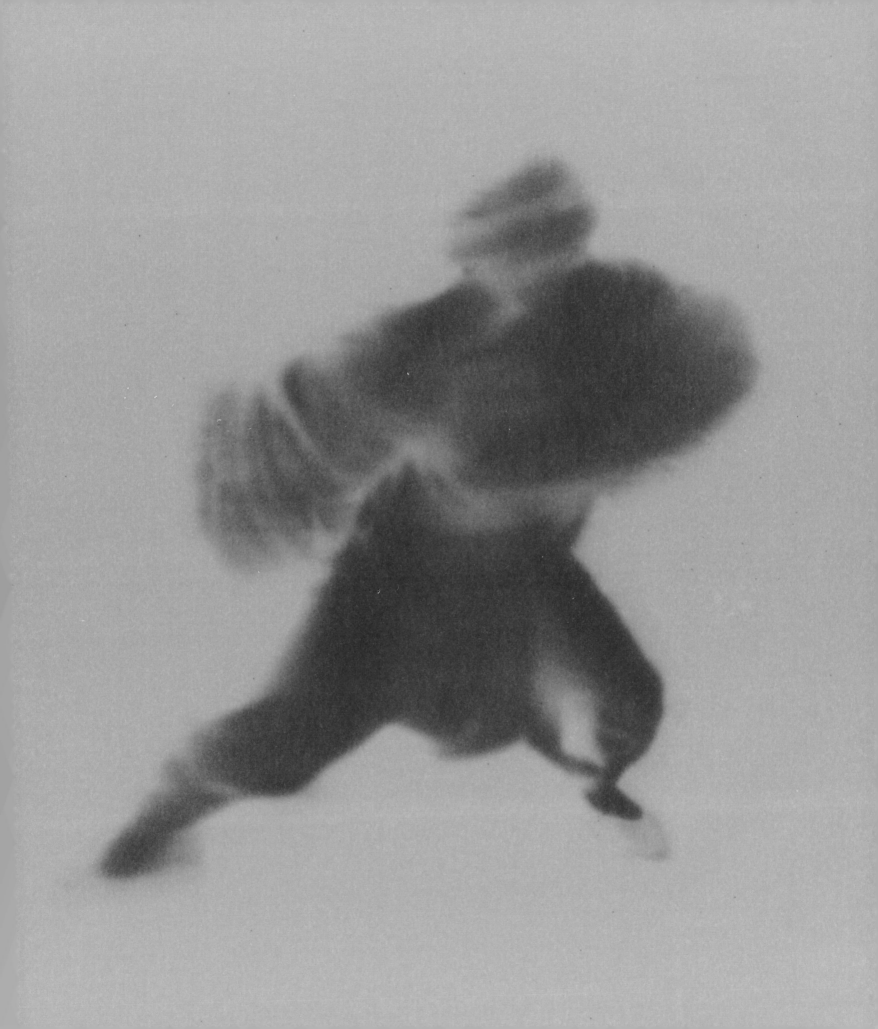

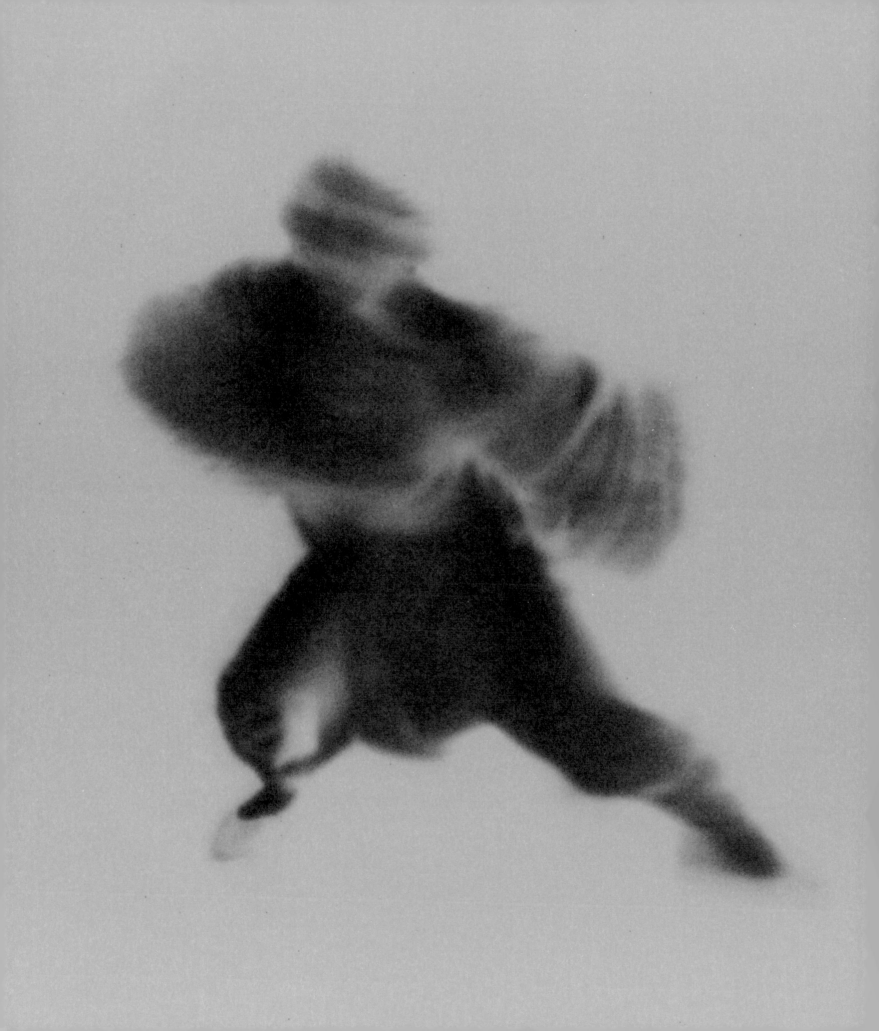

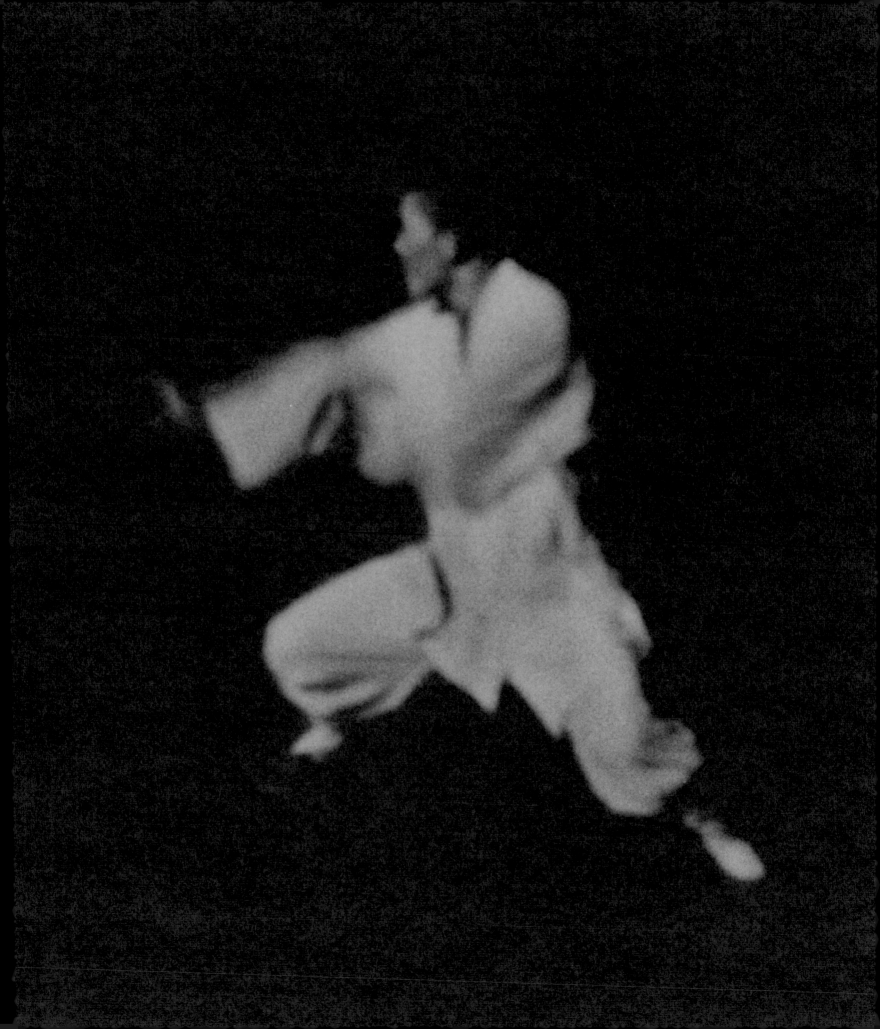

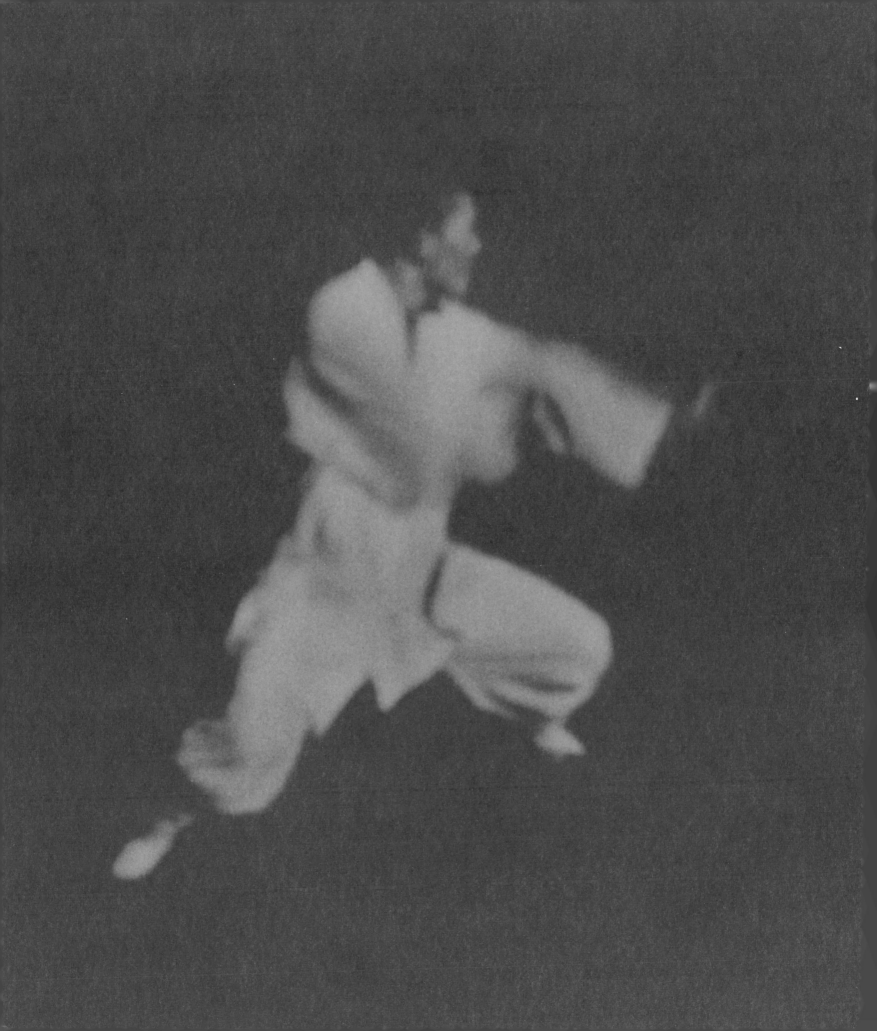

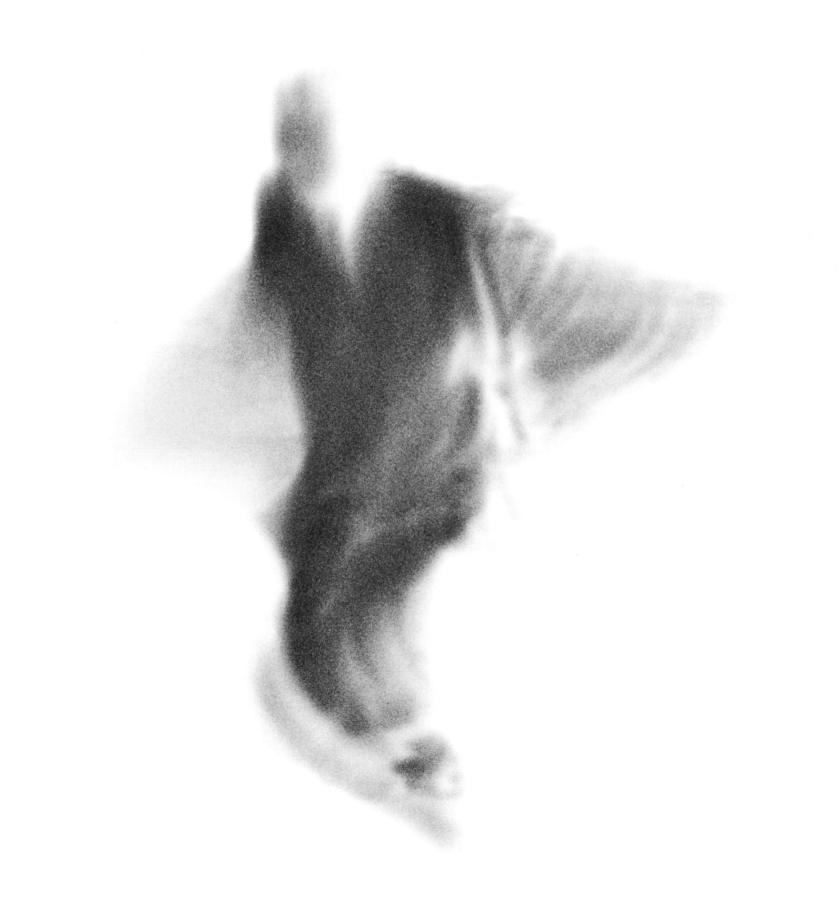

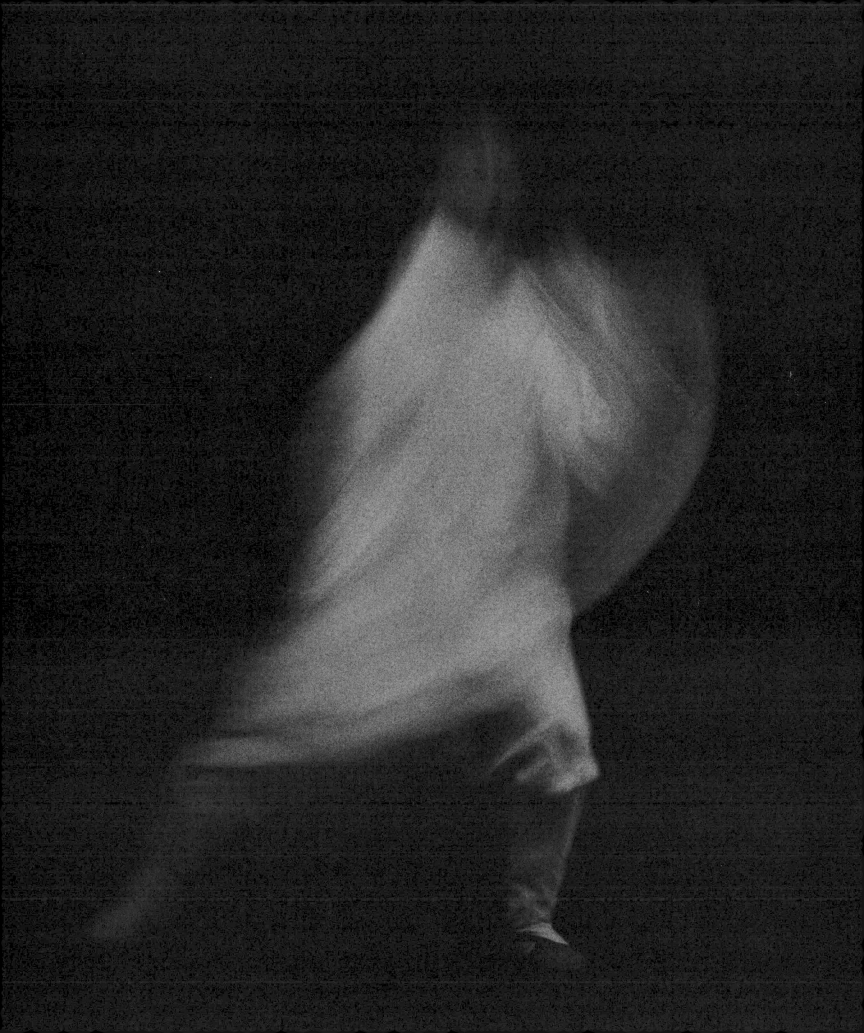

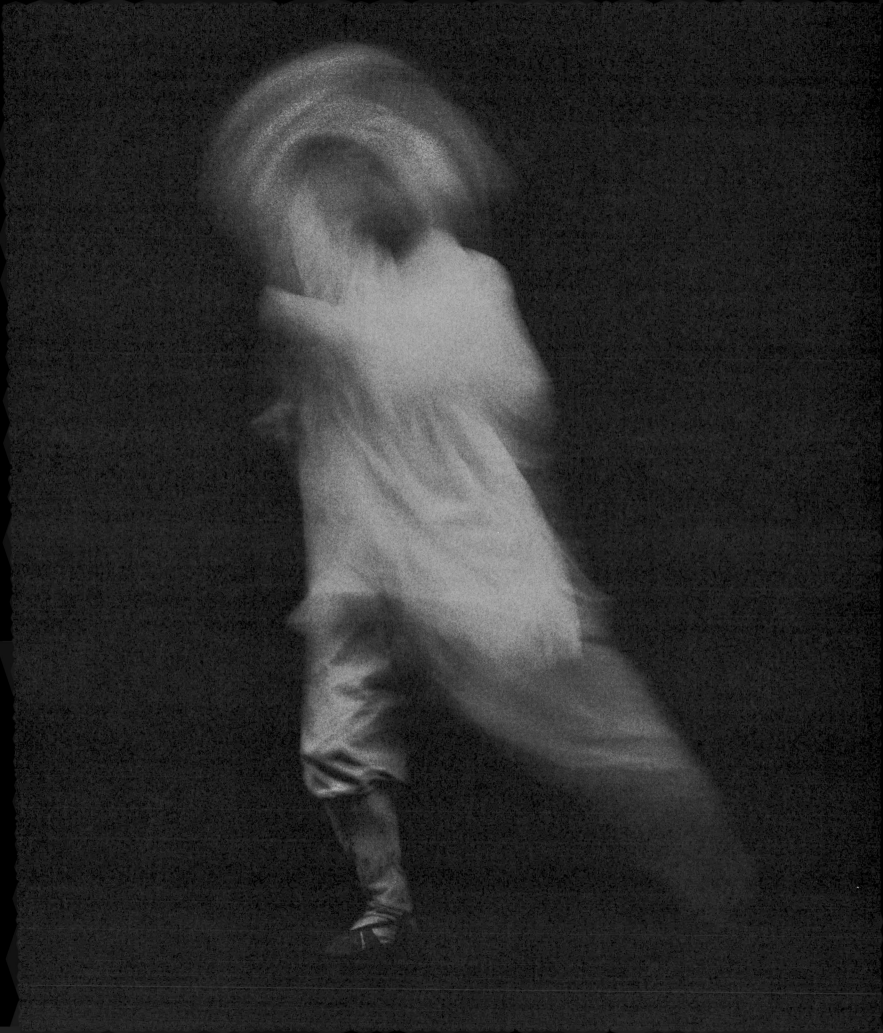

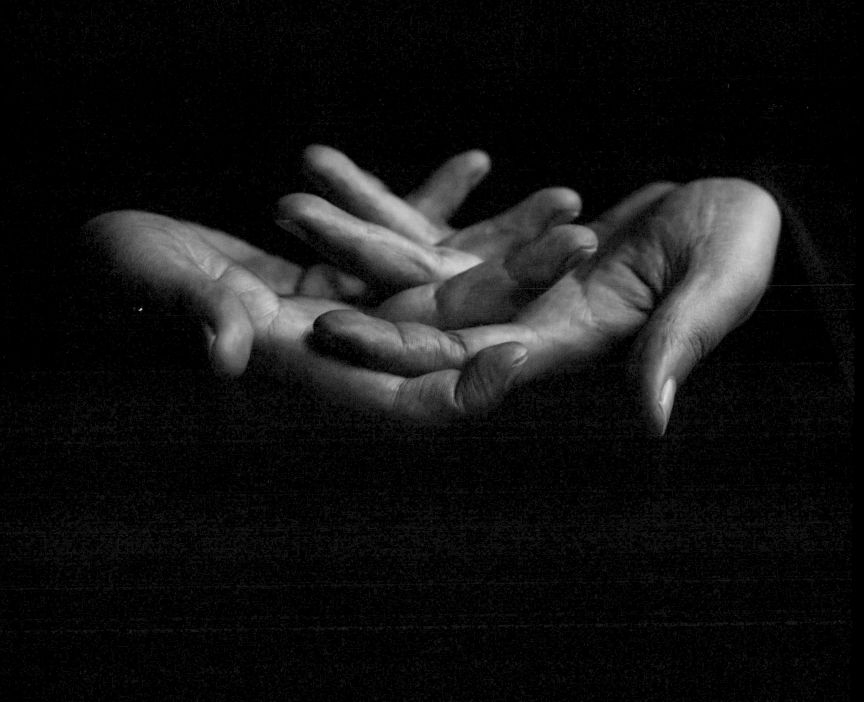

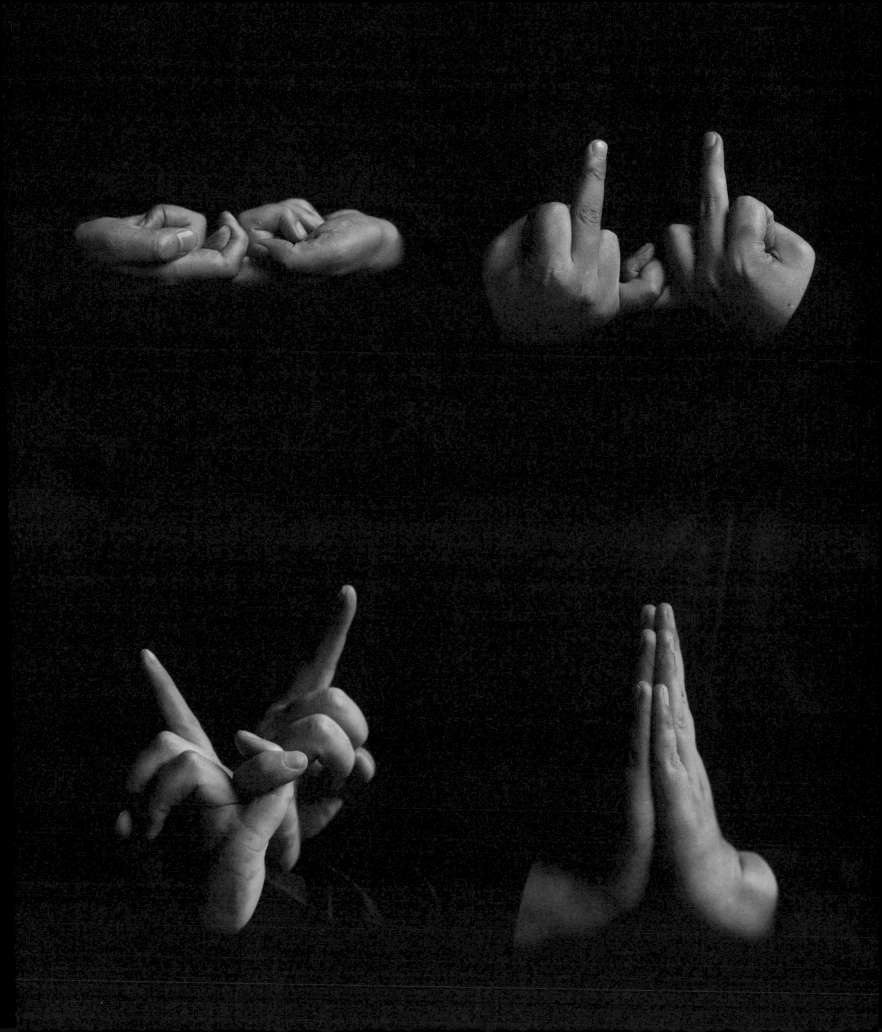

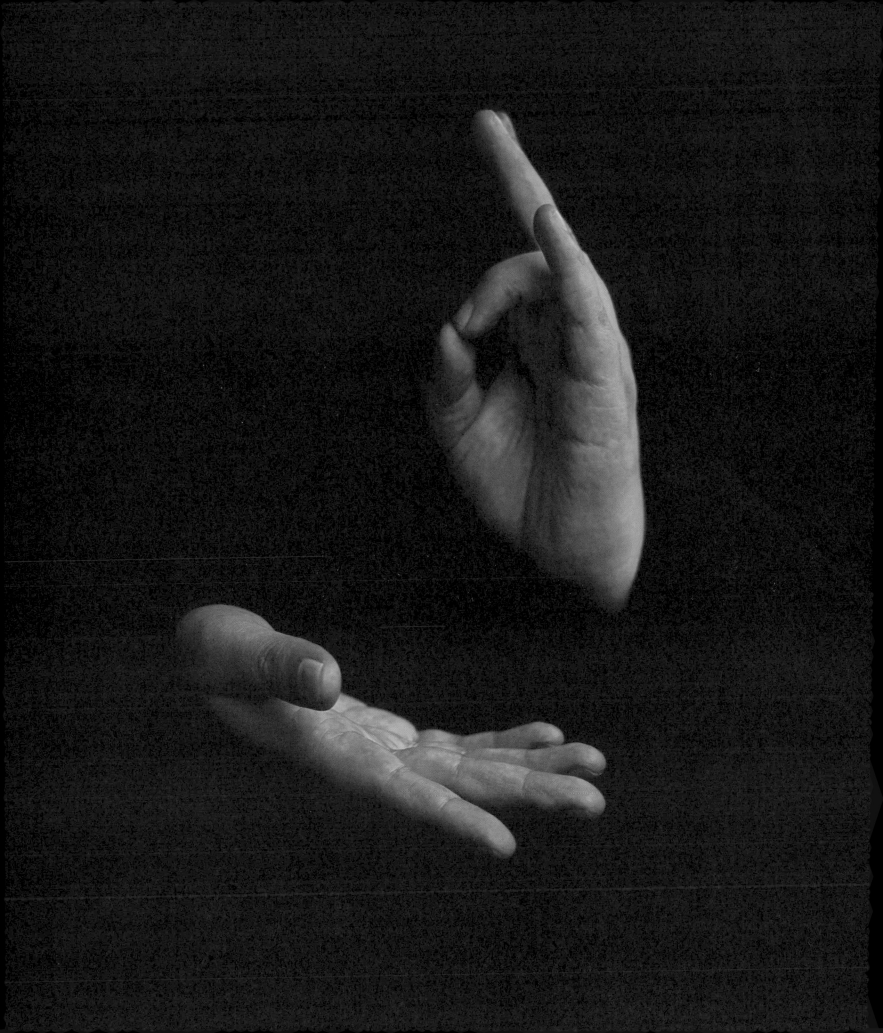

Page 96:
Shi Yan Chen, 34th generation, b. 1967
Page 97:
Shi Xing Zhou, 32nd generation, b. 1934

Page 98:
Shi Yan He, 34th generation, b. 1936
Page 99:
Shi Yan Ci, 34th generation, b. 1968

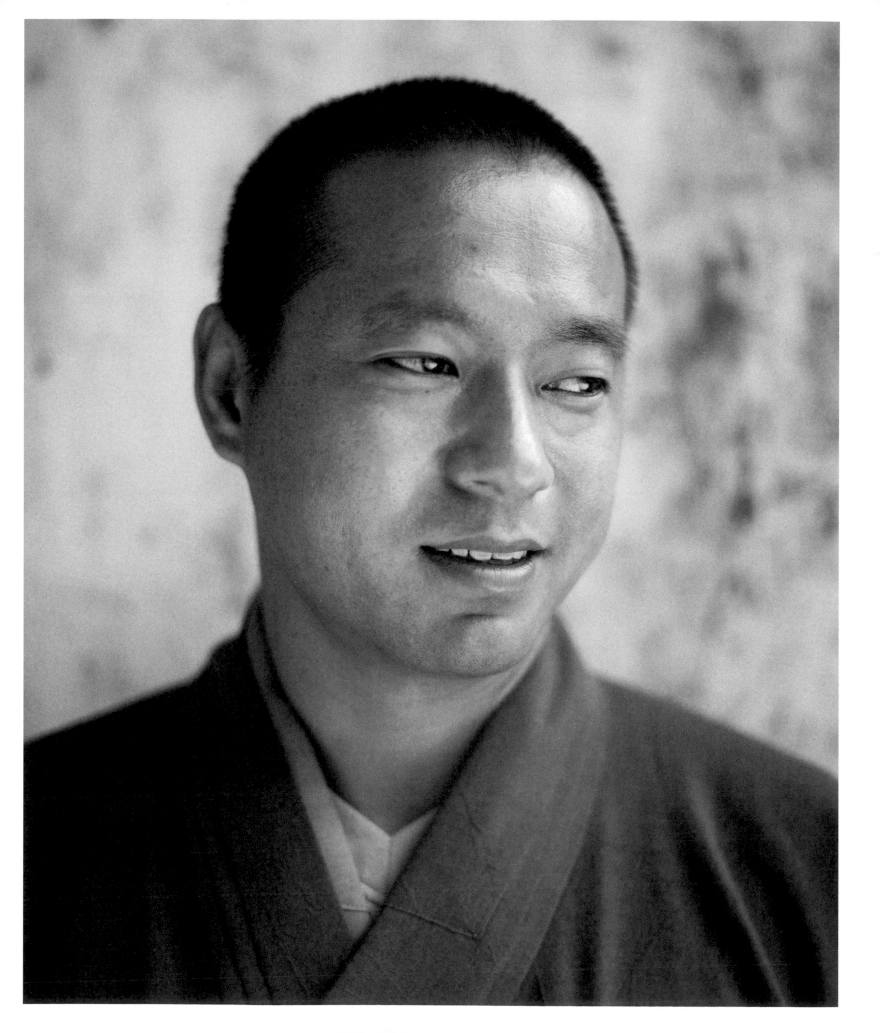

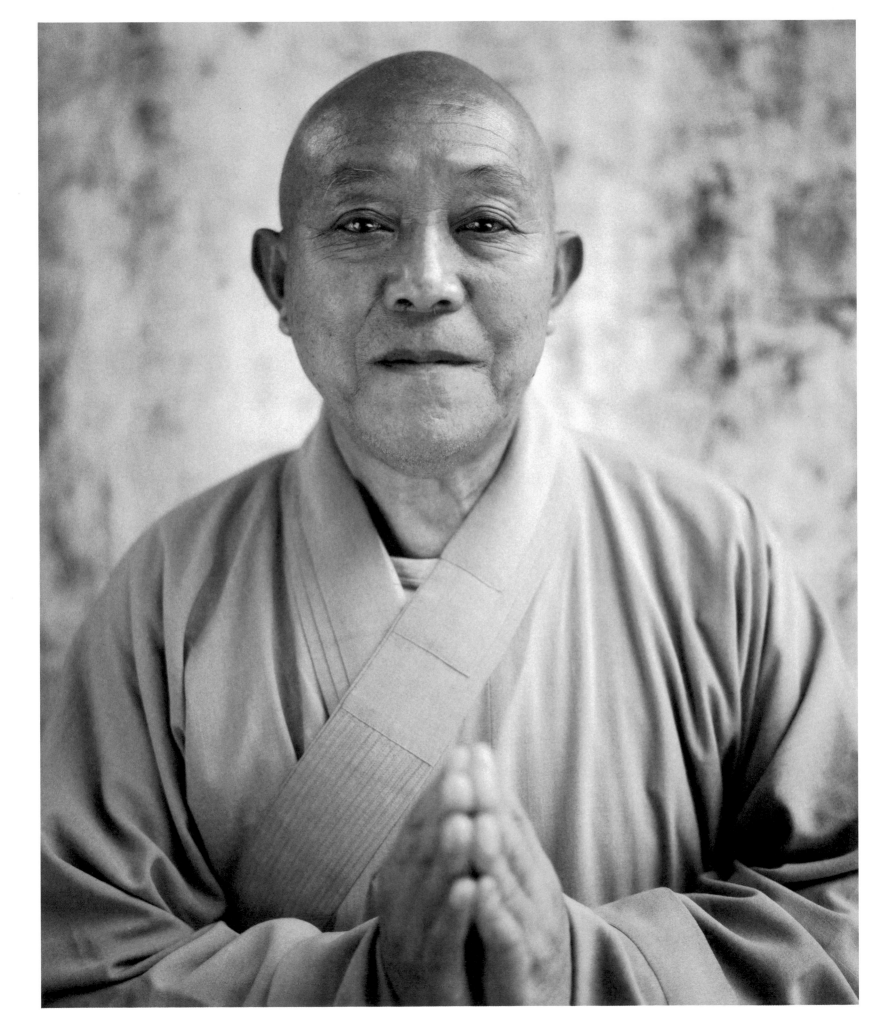

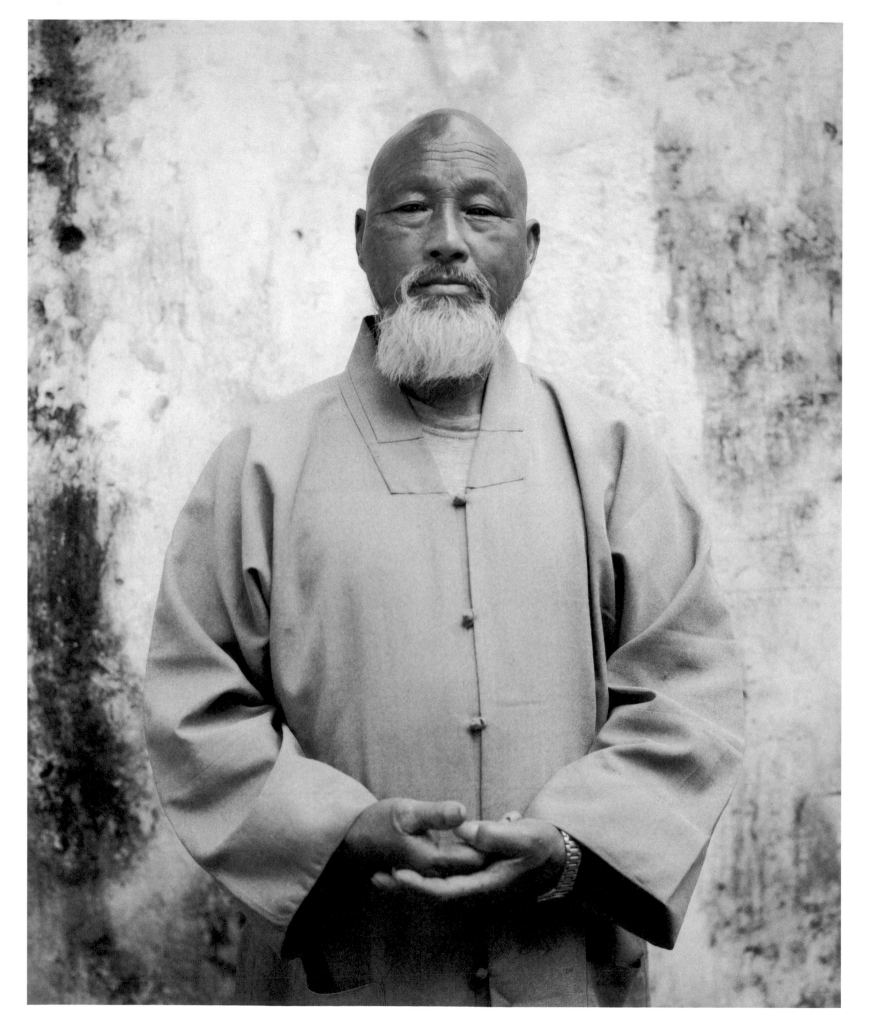

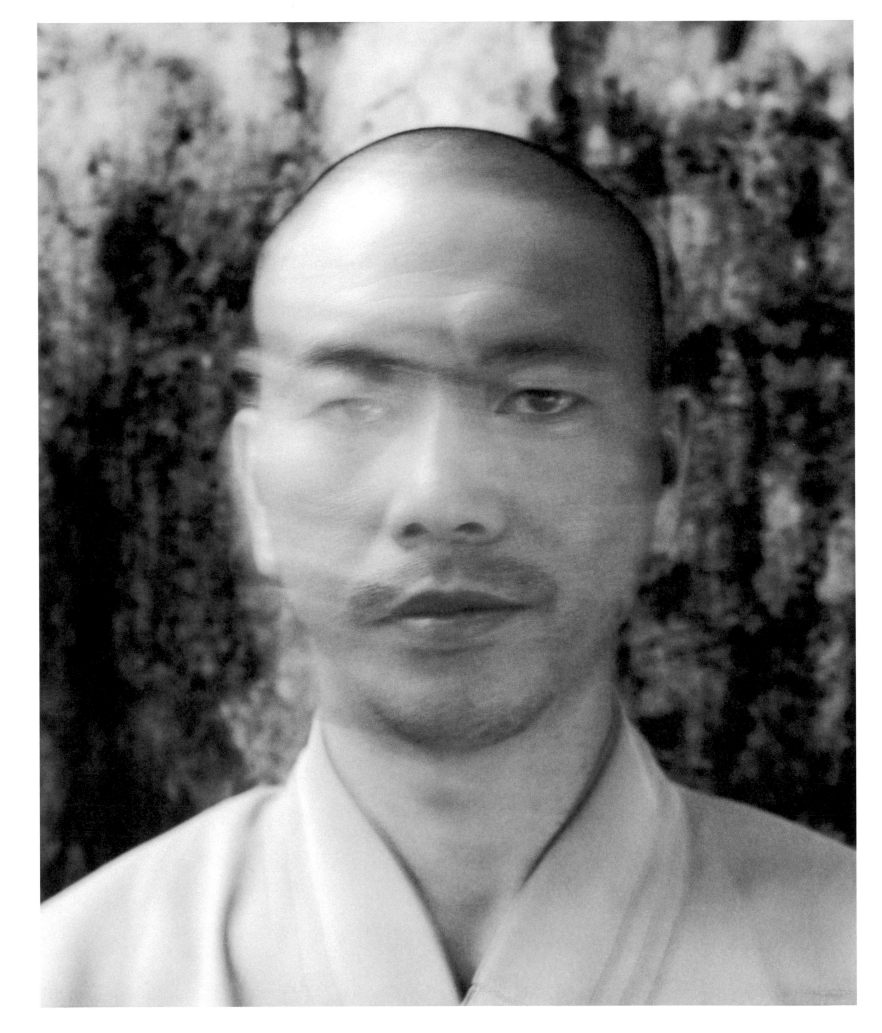

SHI YONG ZHI b. 1968

33rd Generation

Qi Xin Quan | Seven Star Boxing

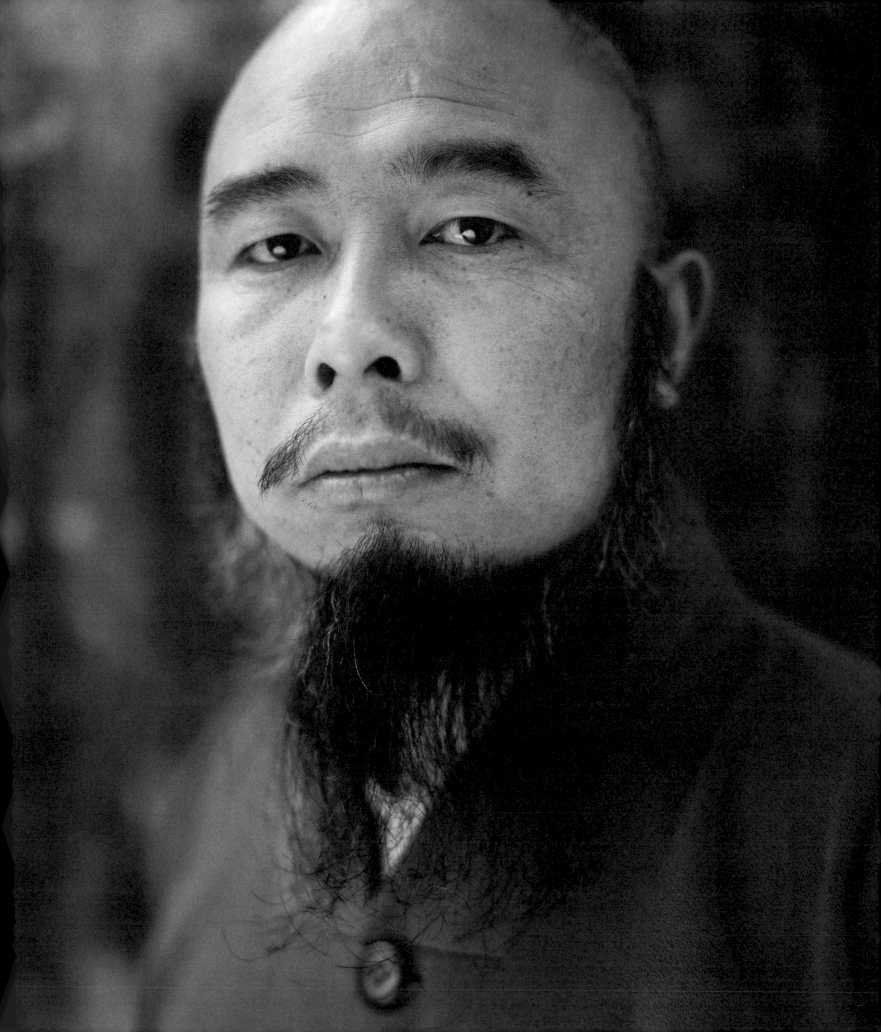

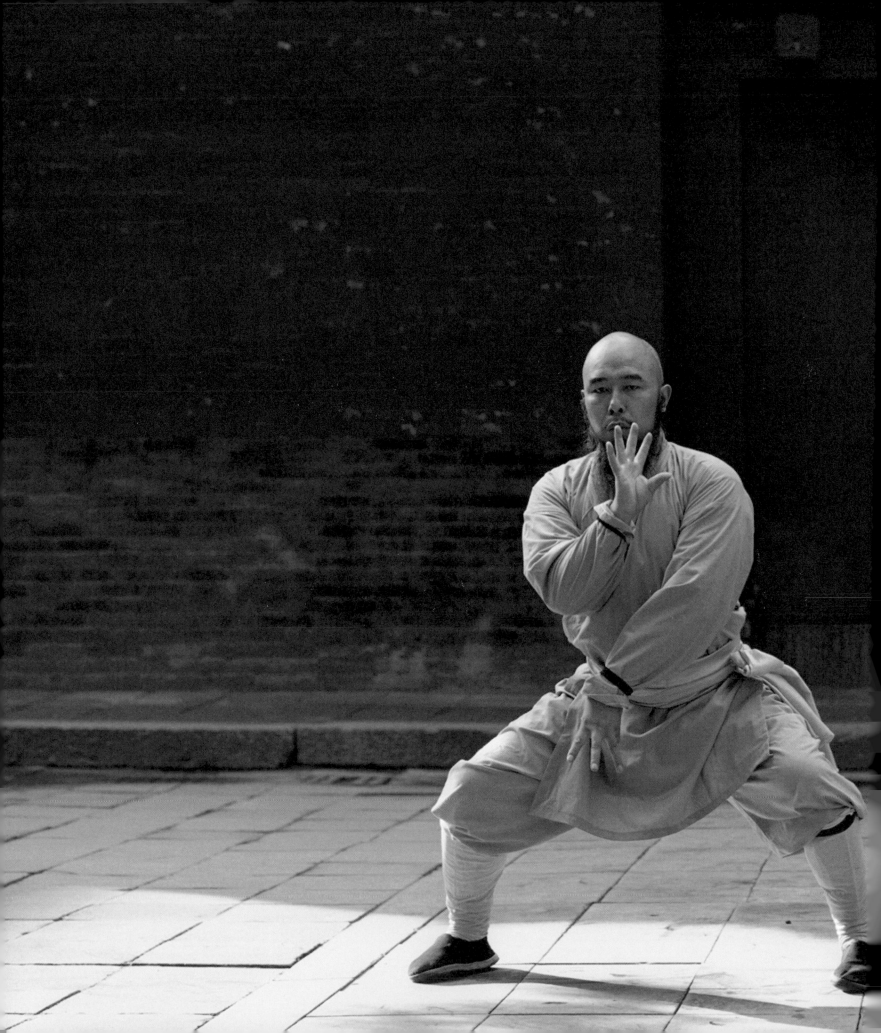

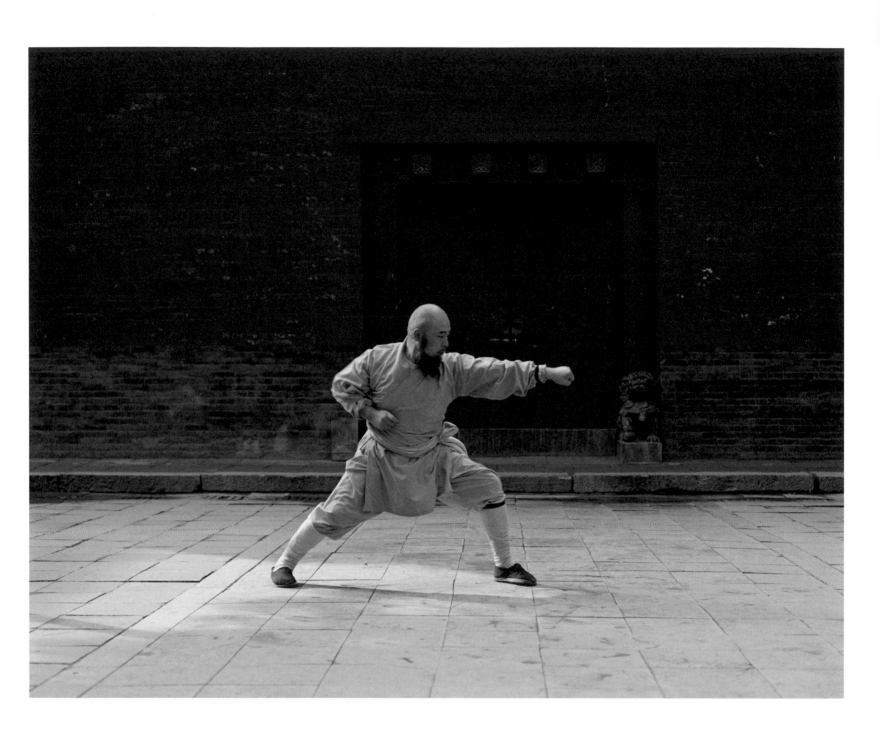

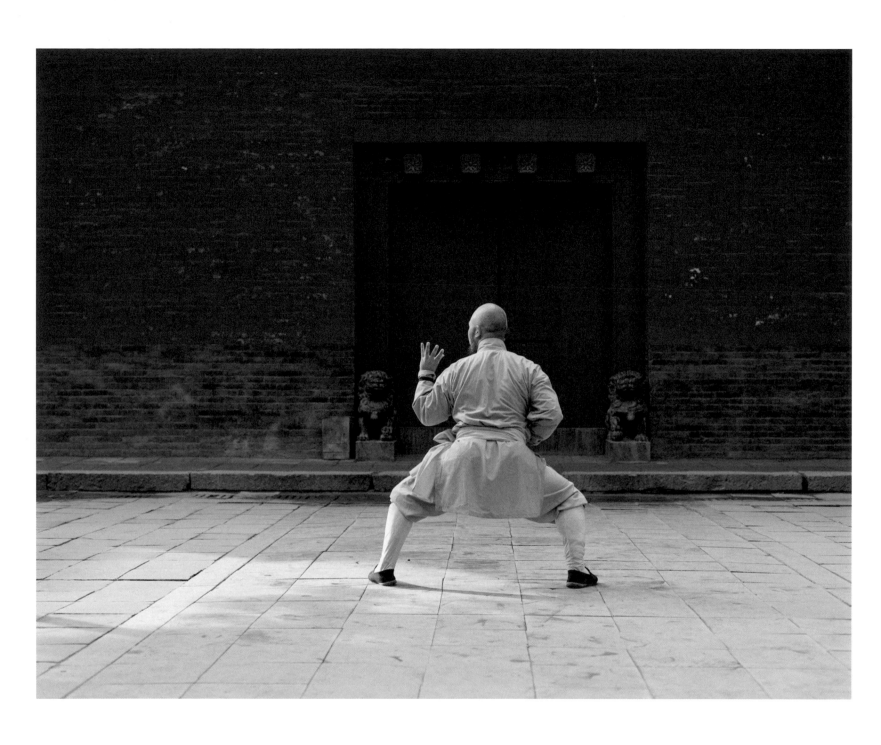

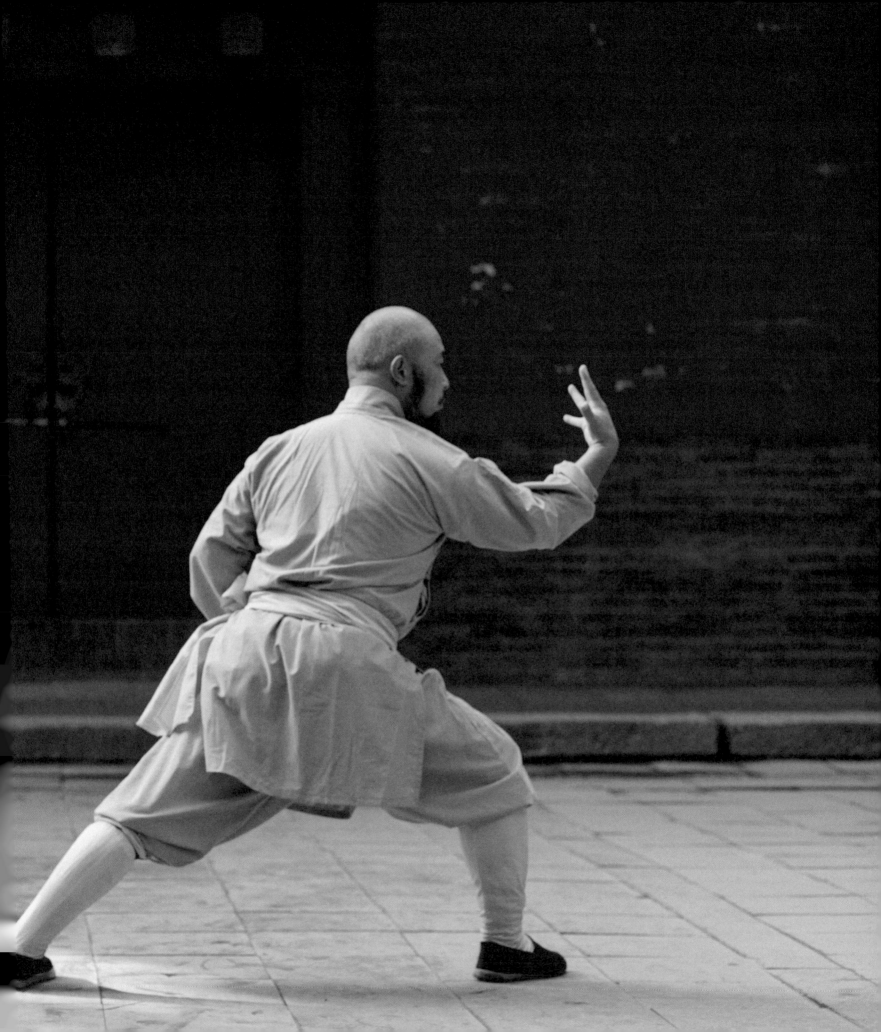

SHI DE YANG b. 1967

3lst Generation

Yi Jin Jing | Bone Marrow Cleansing

Nan Yuan Da Hong Quan | Big Hong Fist

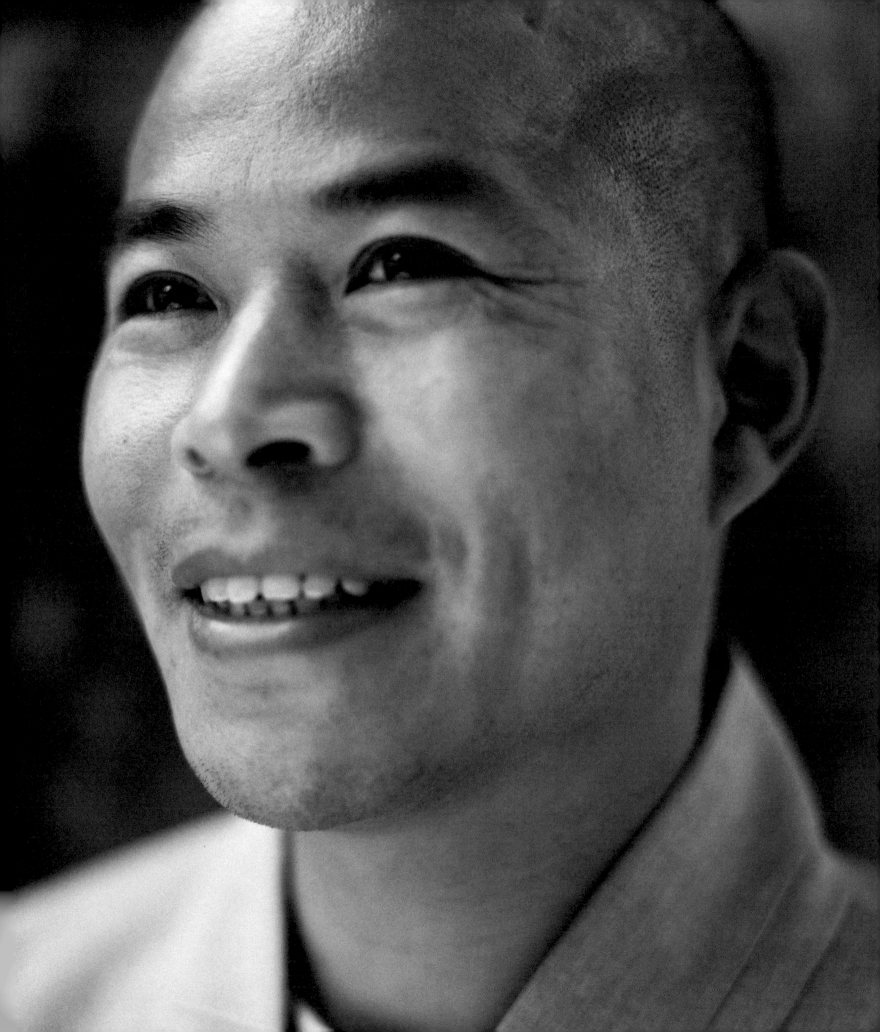

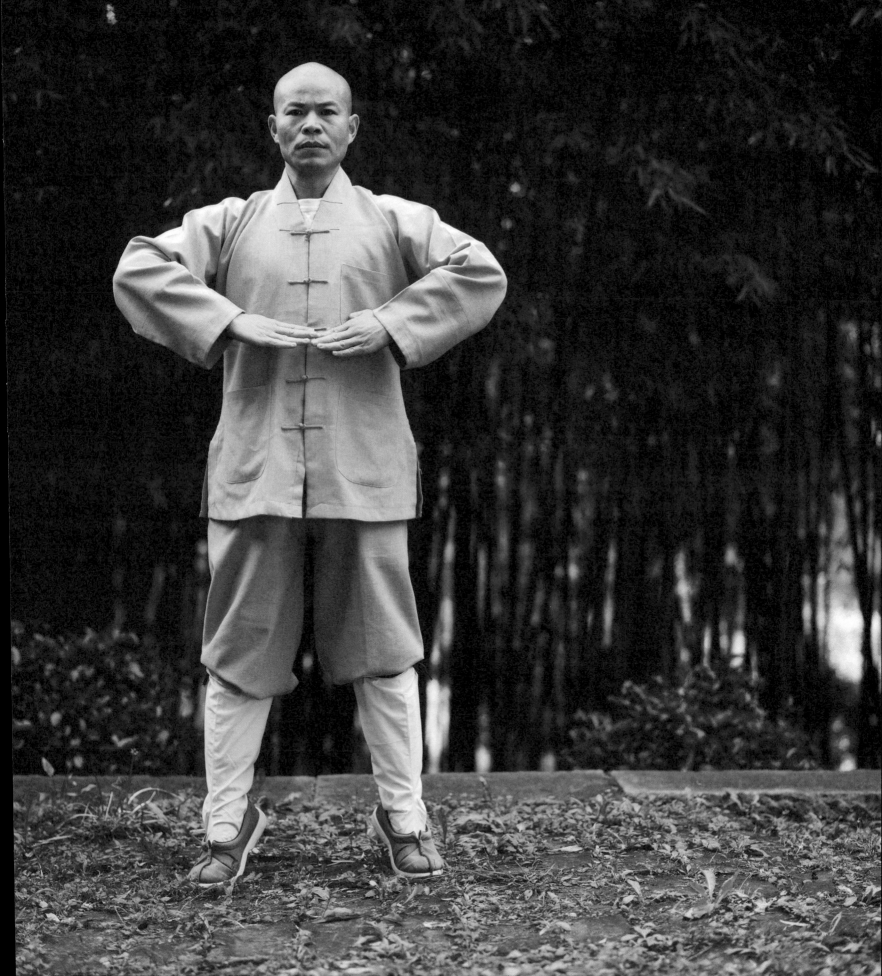

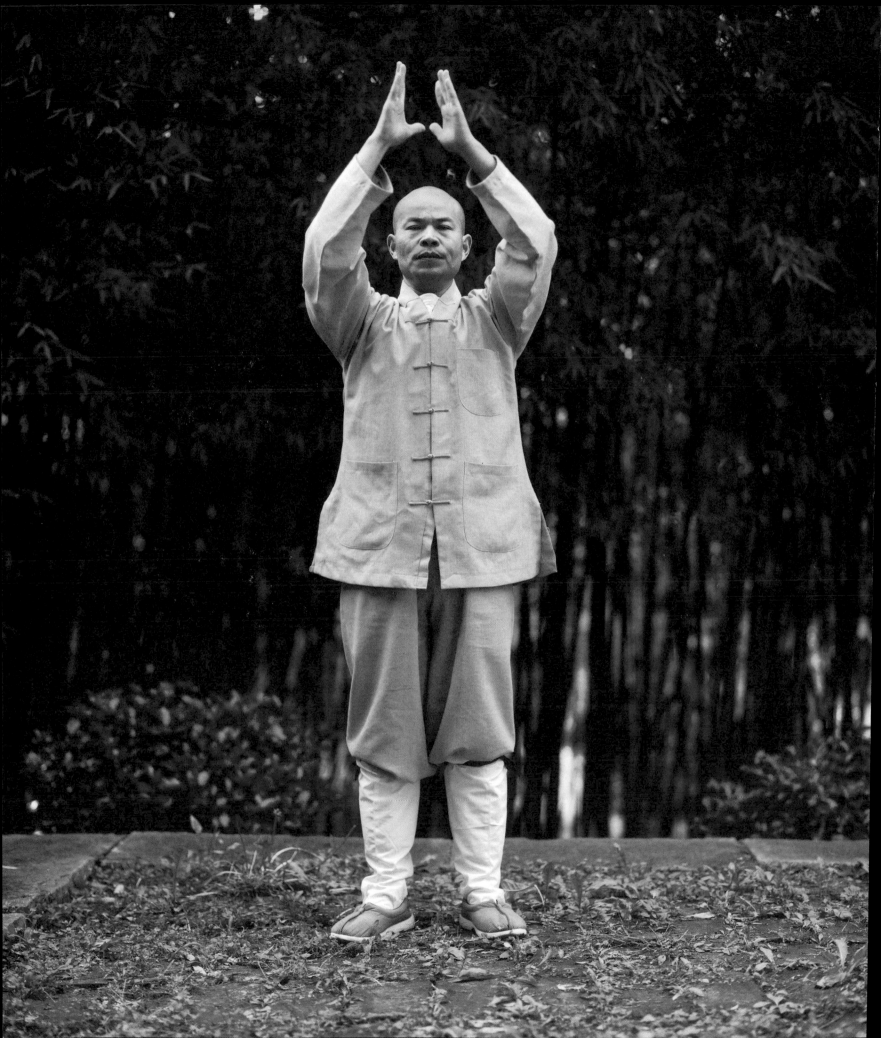

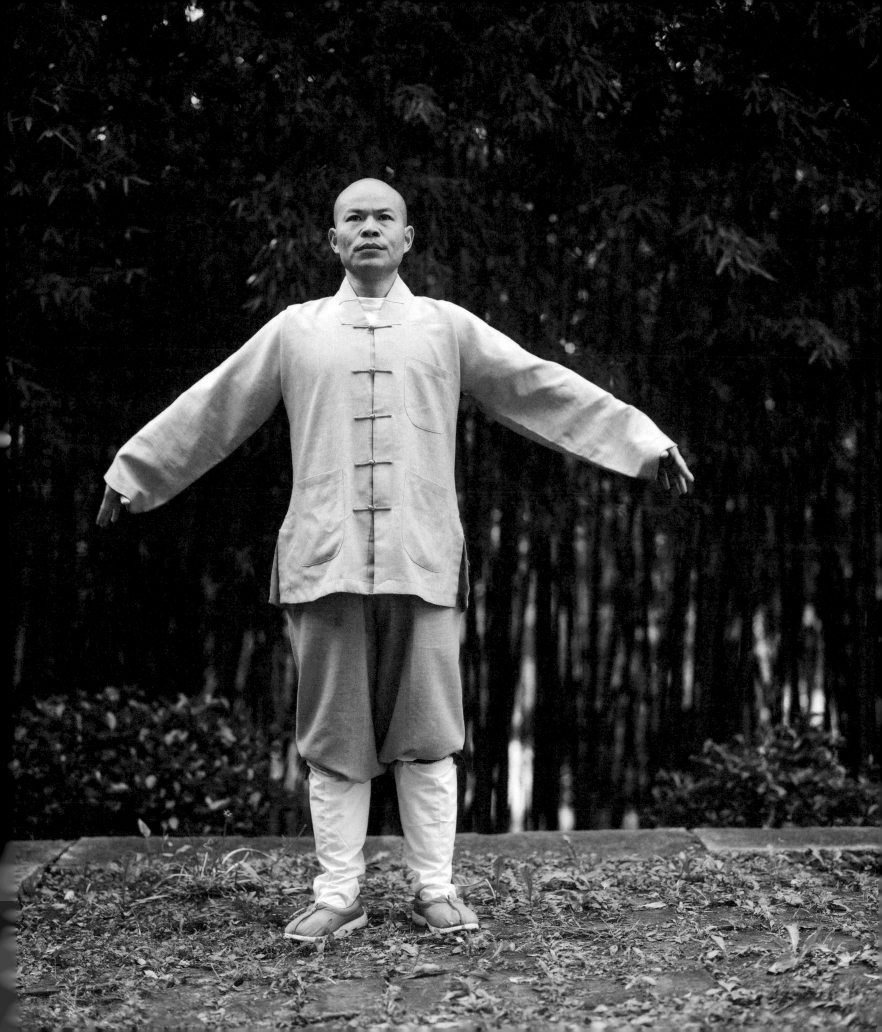

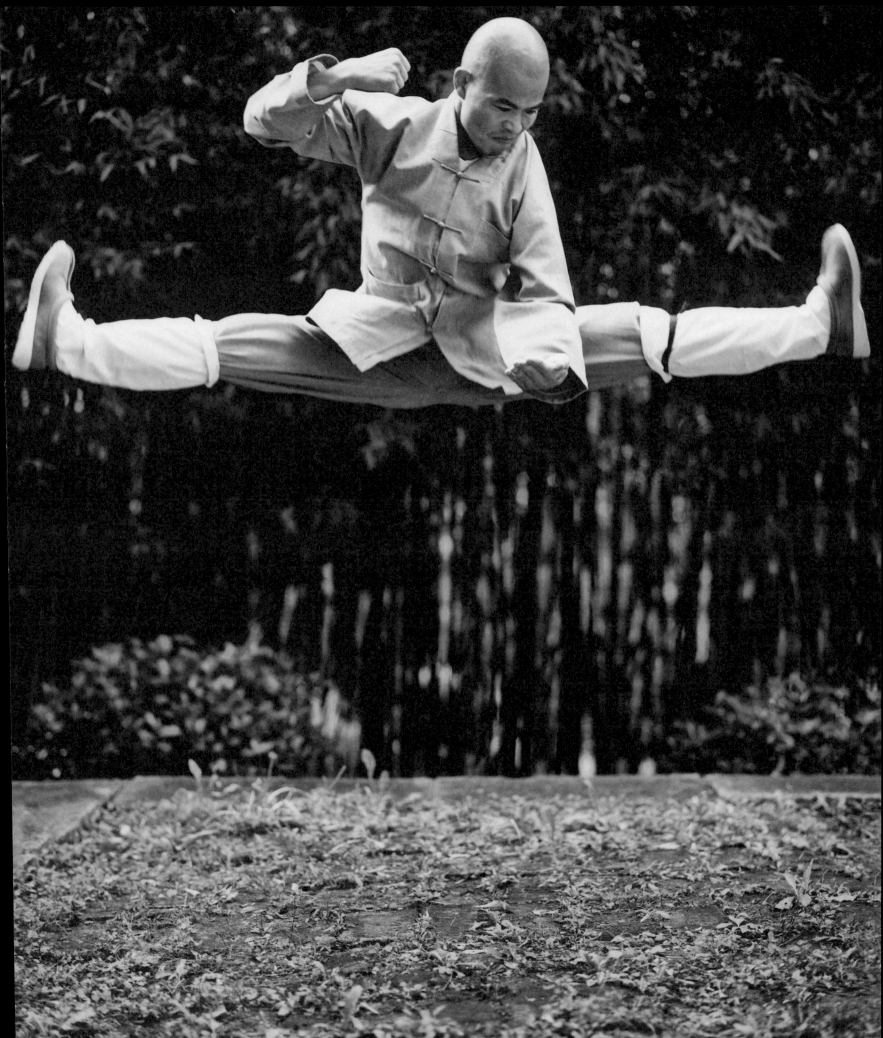

SHI YAN XIAN b. 1963

34th Generation

Xiao Hong Quan | Small Hong Fist

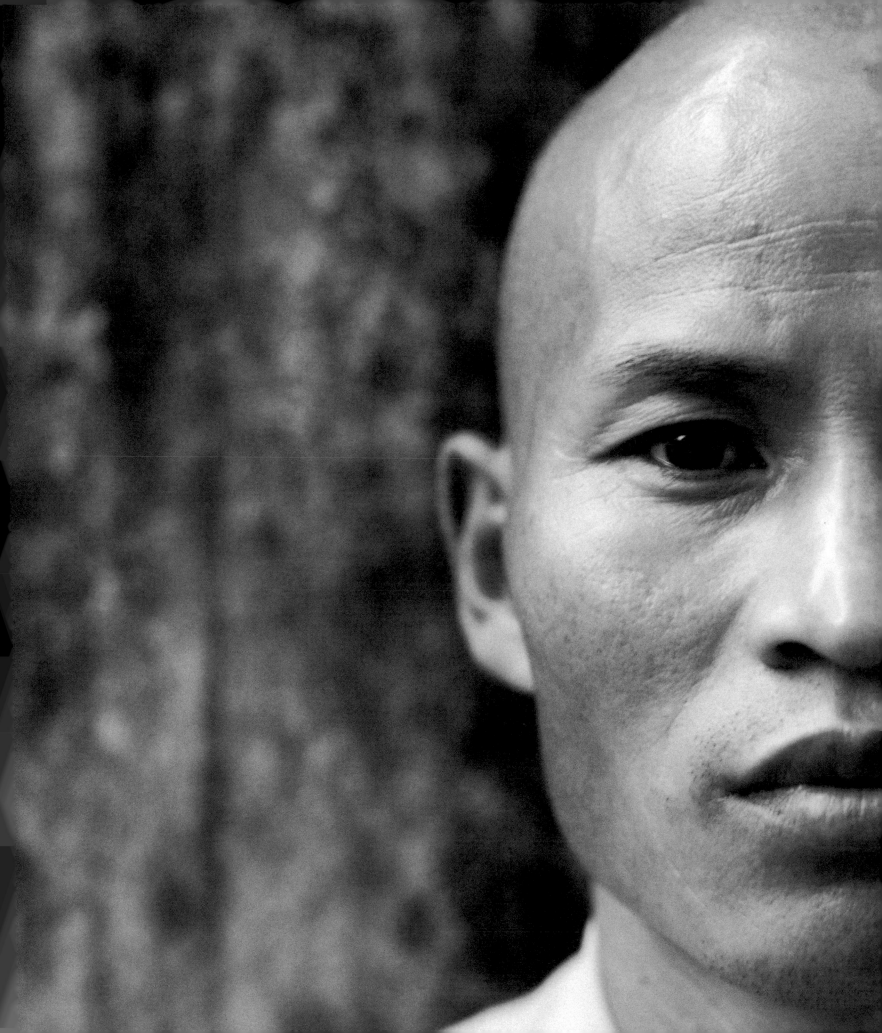

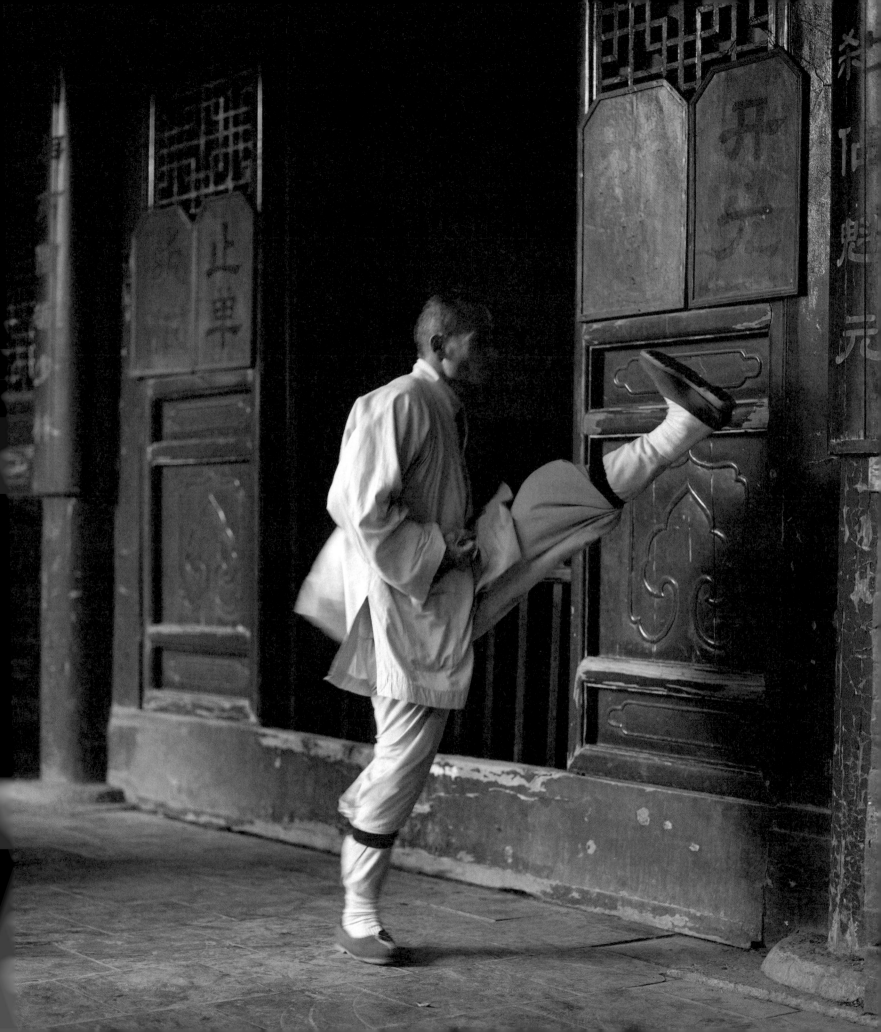

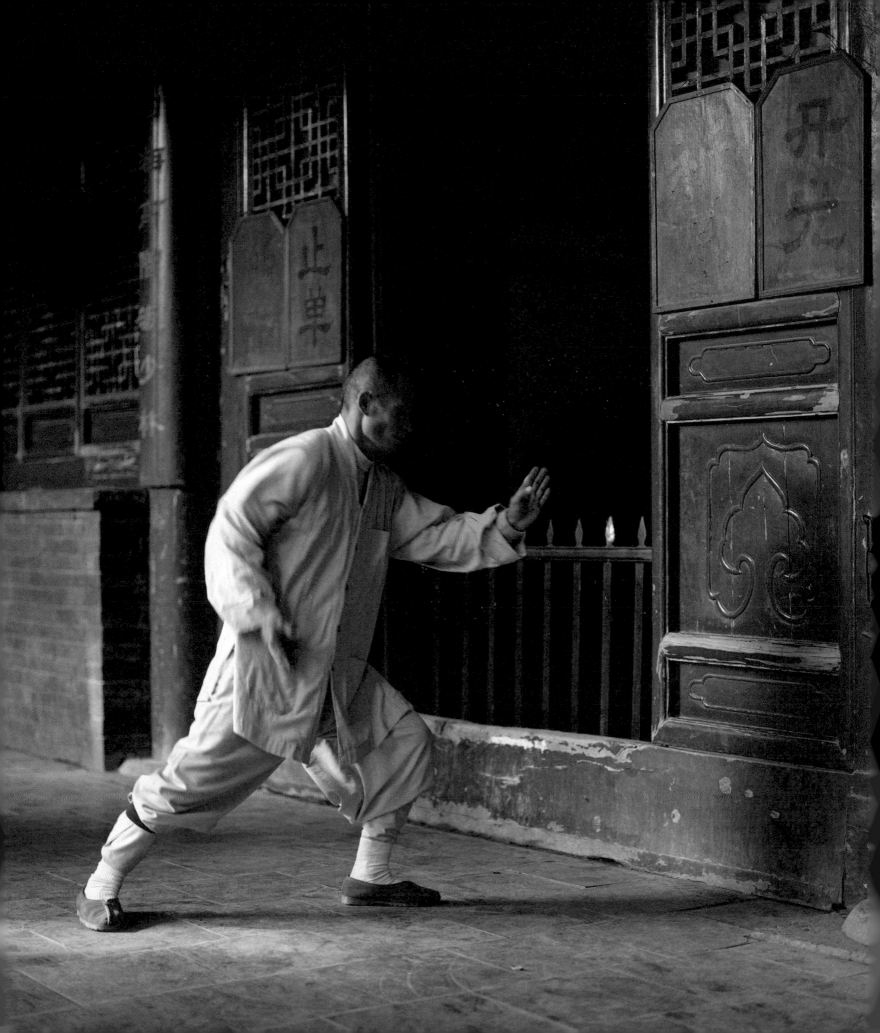

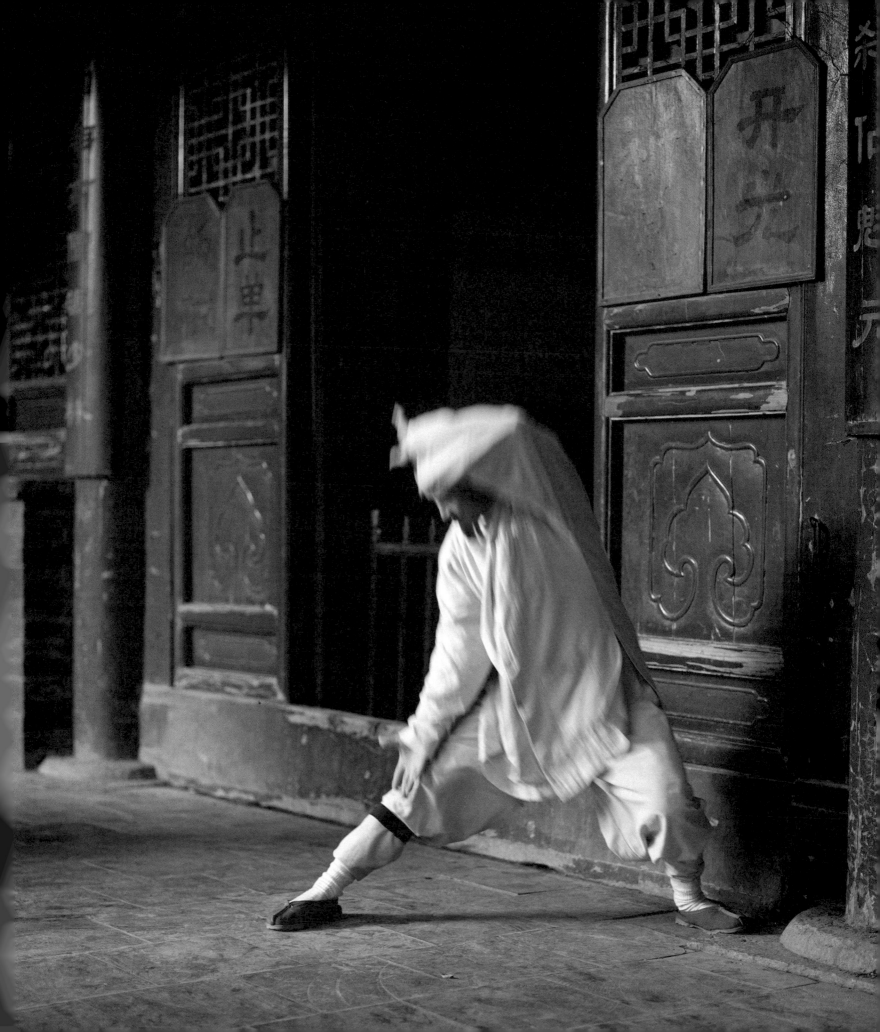

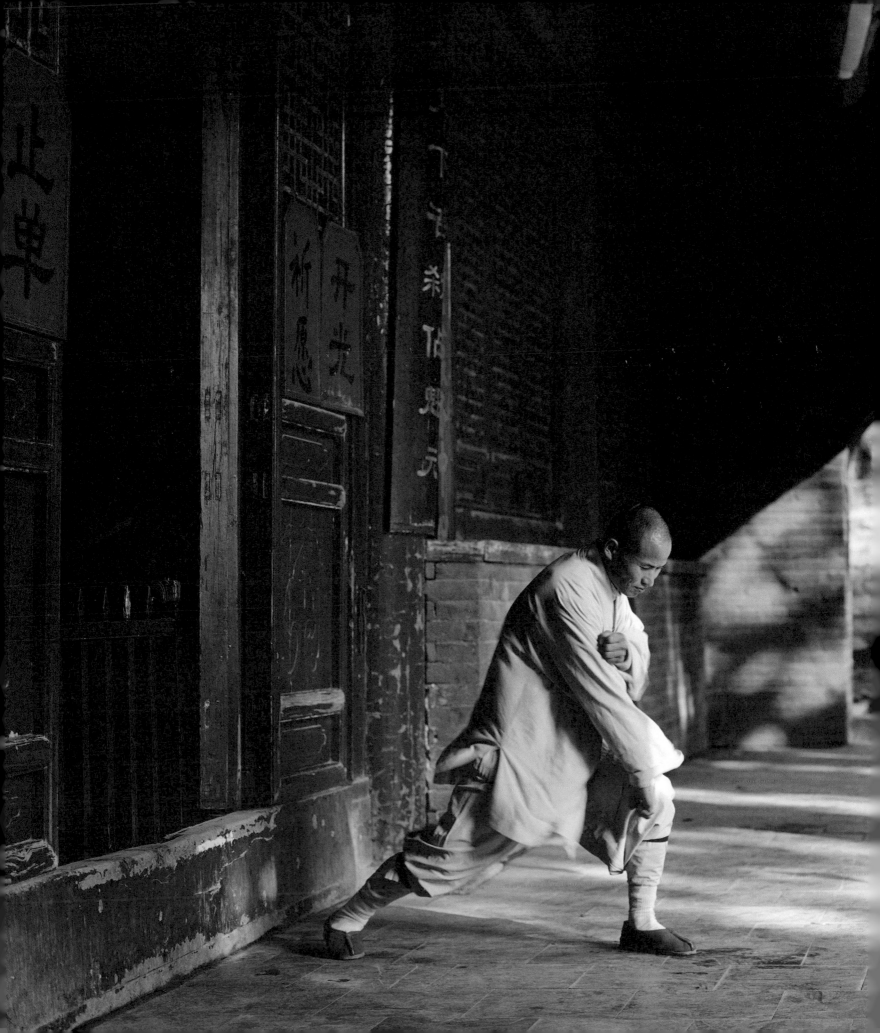

SHI DE CHAO b. 1967

31st Generation
Yue Ya Cha | Monk's Spade

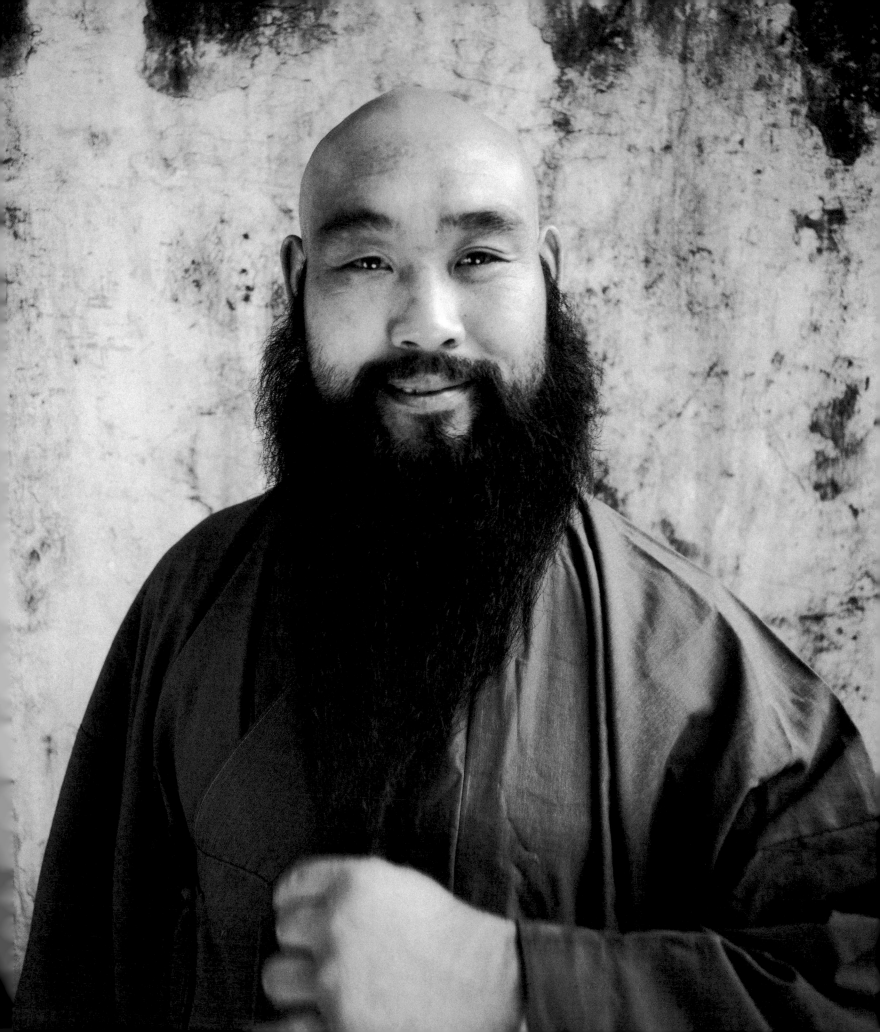

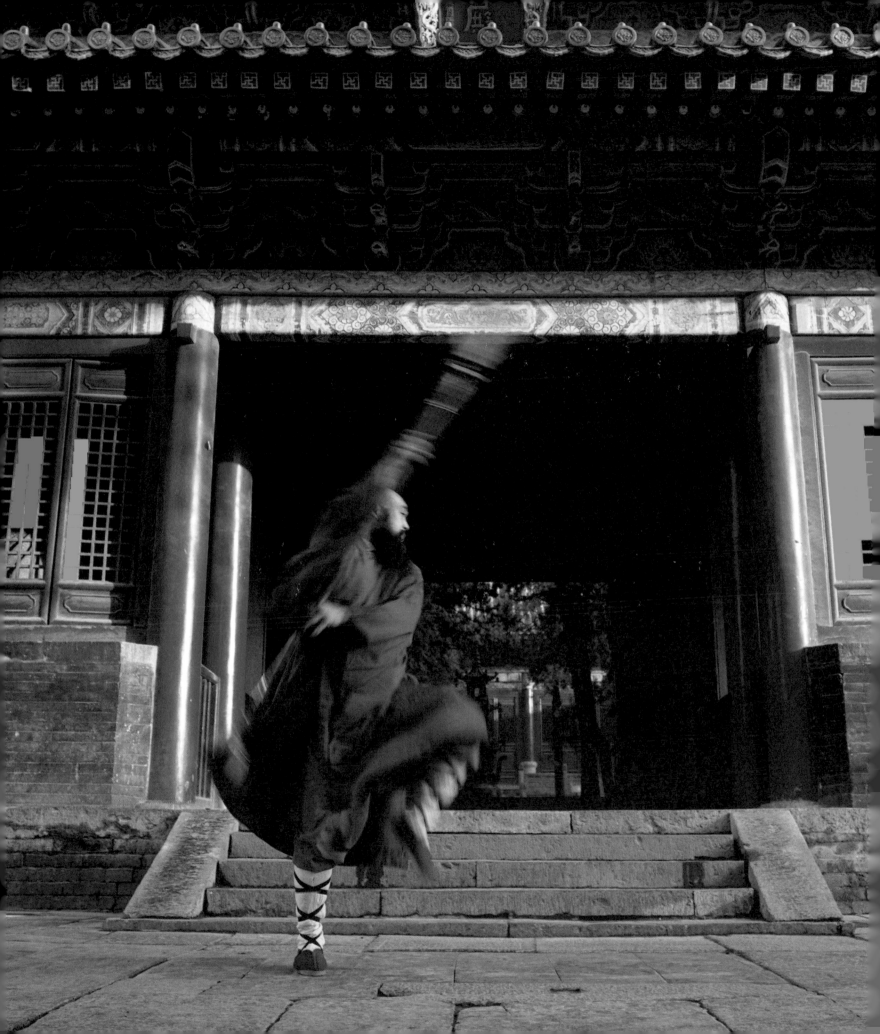

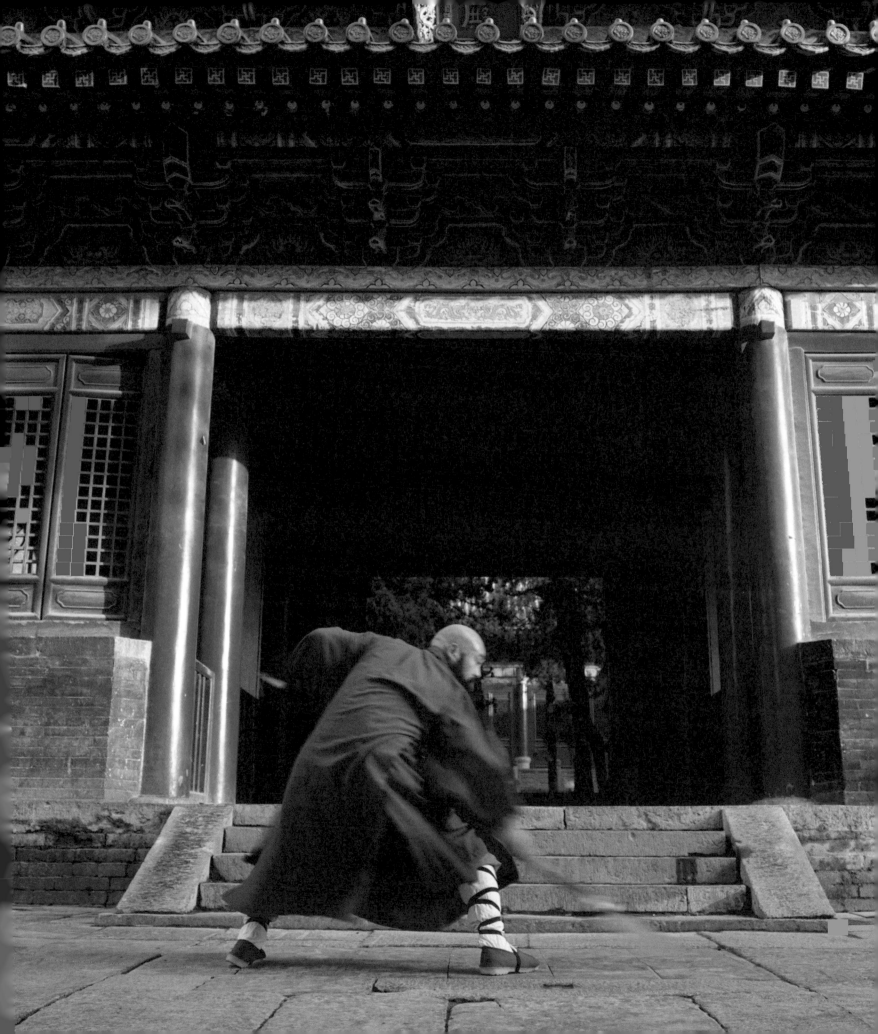

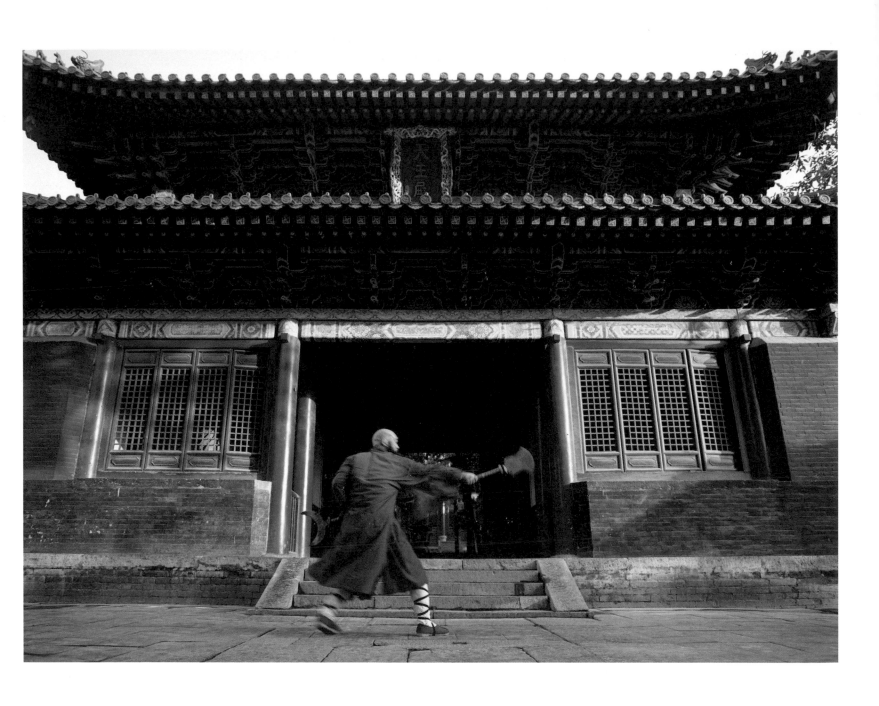

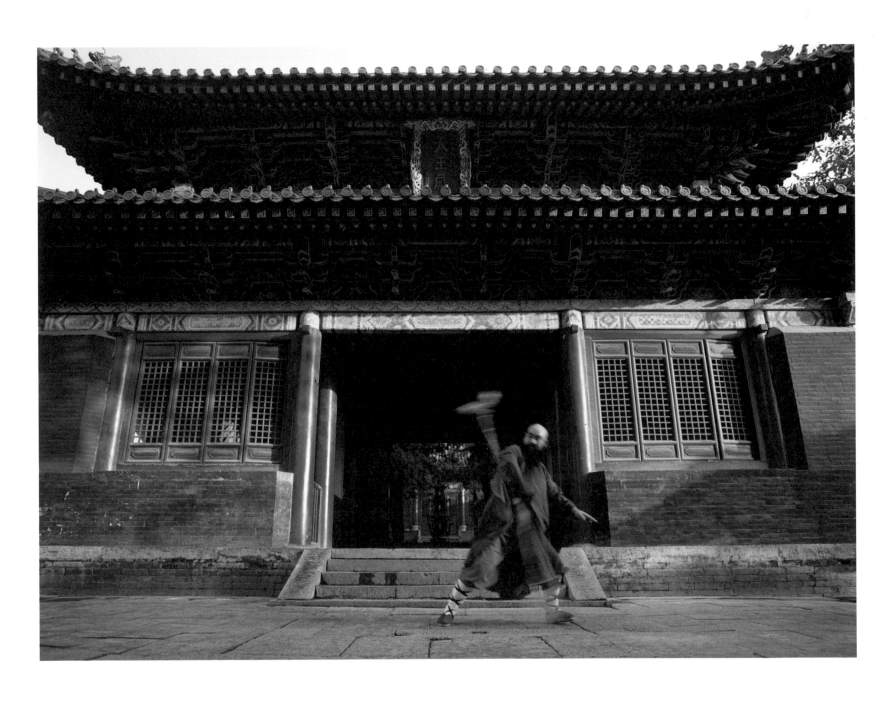

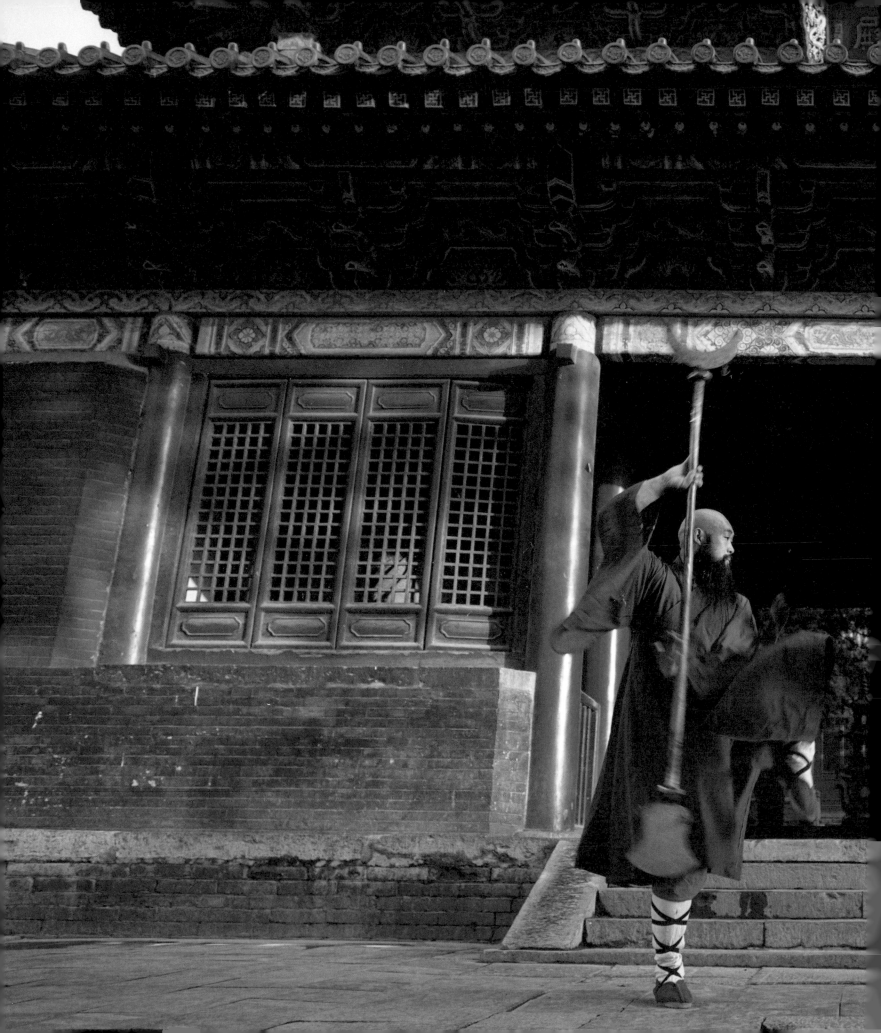

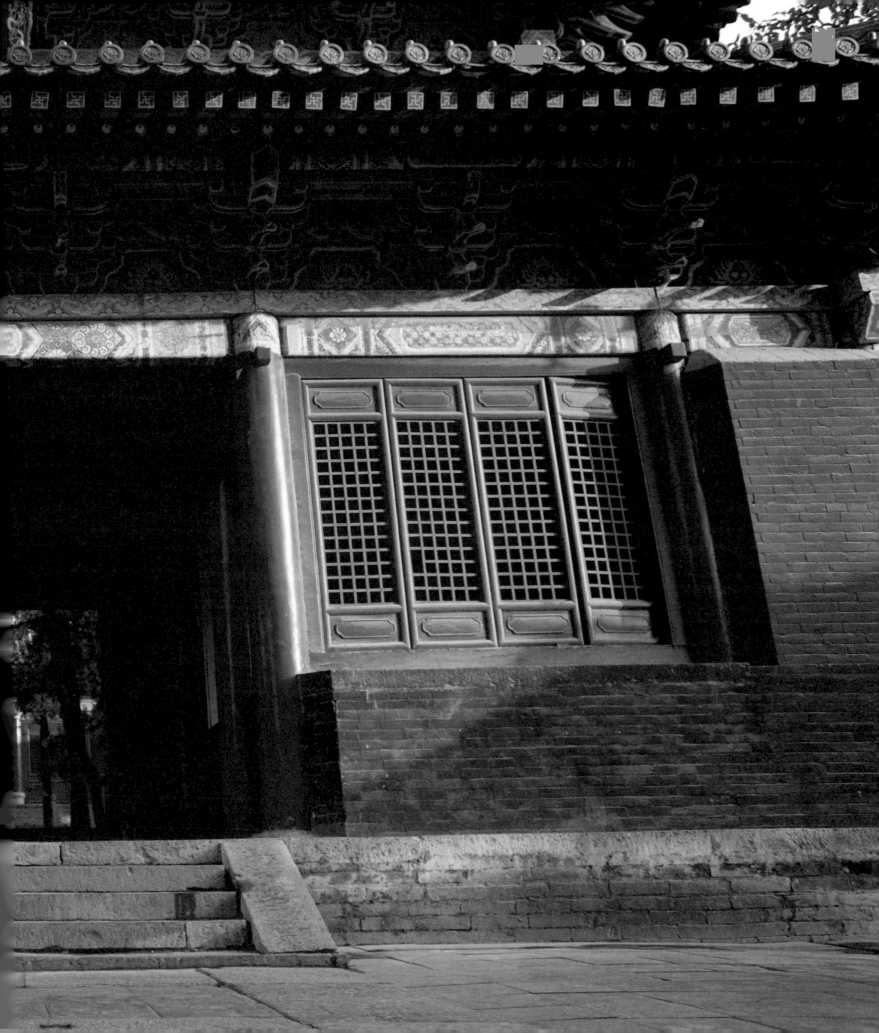

SHI YAN LANG b. 1981

34th Generation

Tong Jian Quan | Through the Shoulder Fist

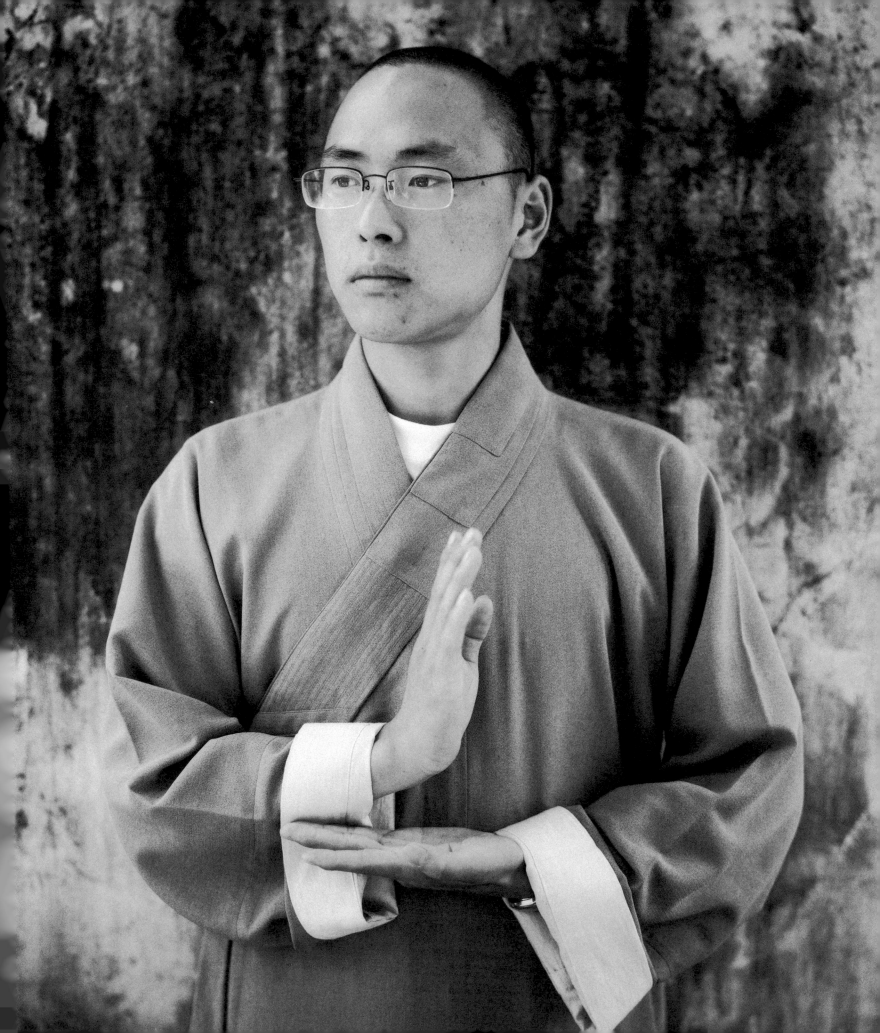

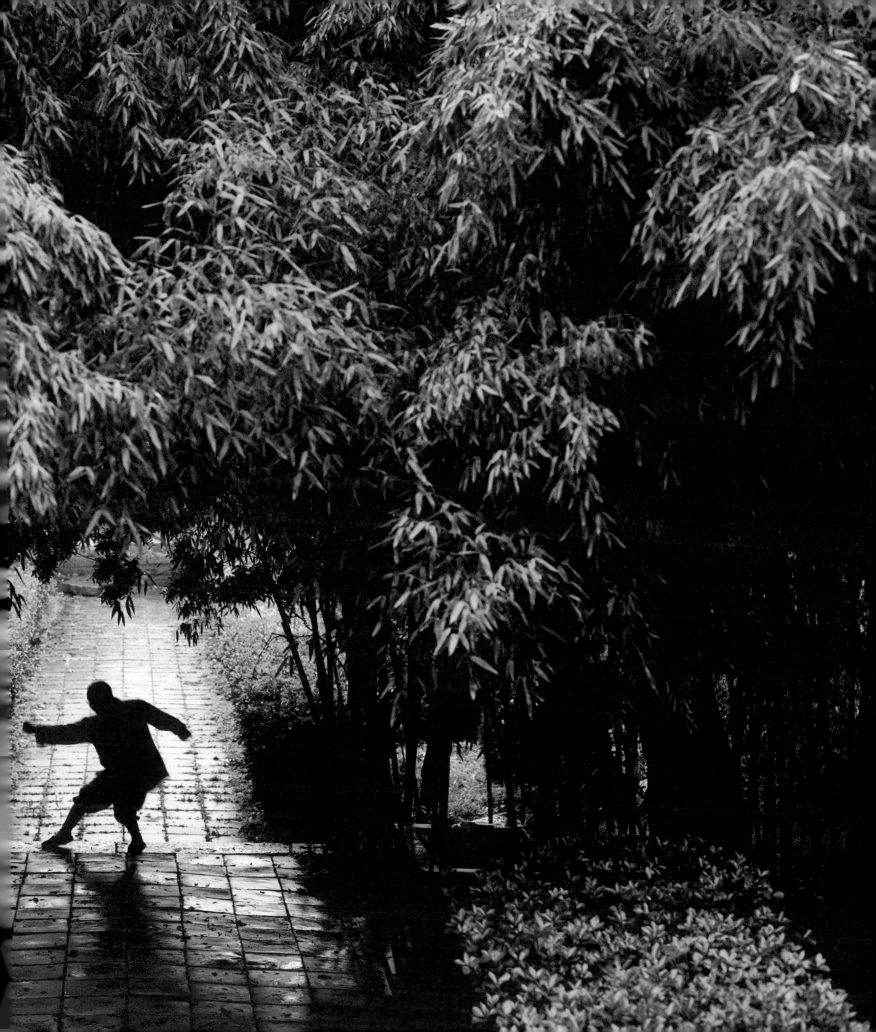

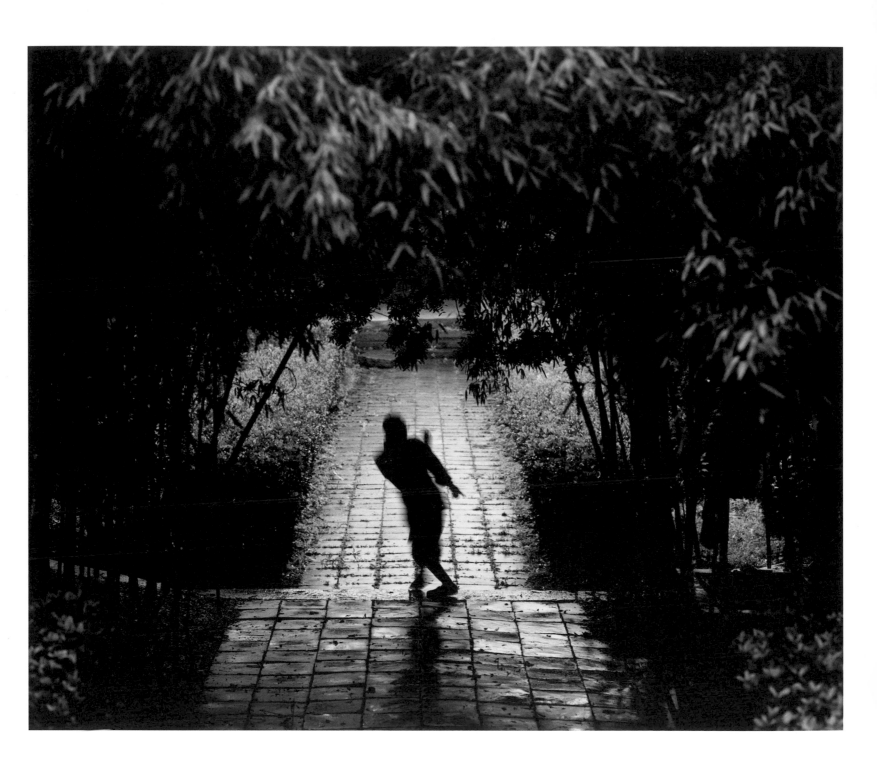

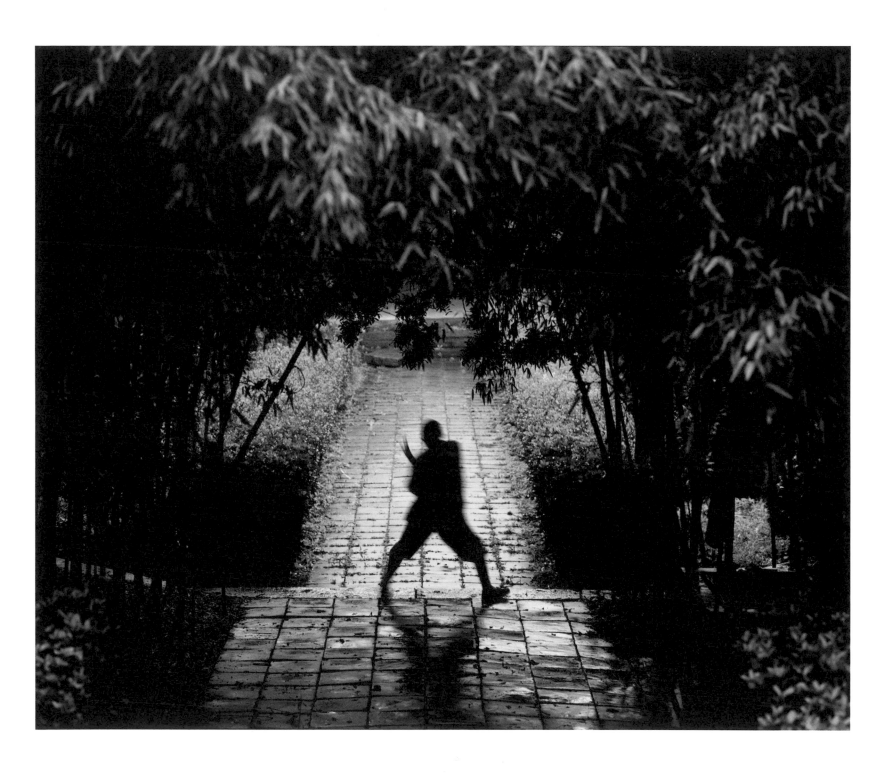

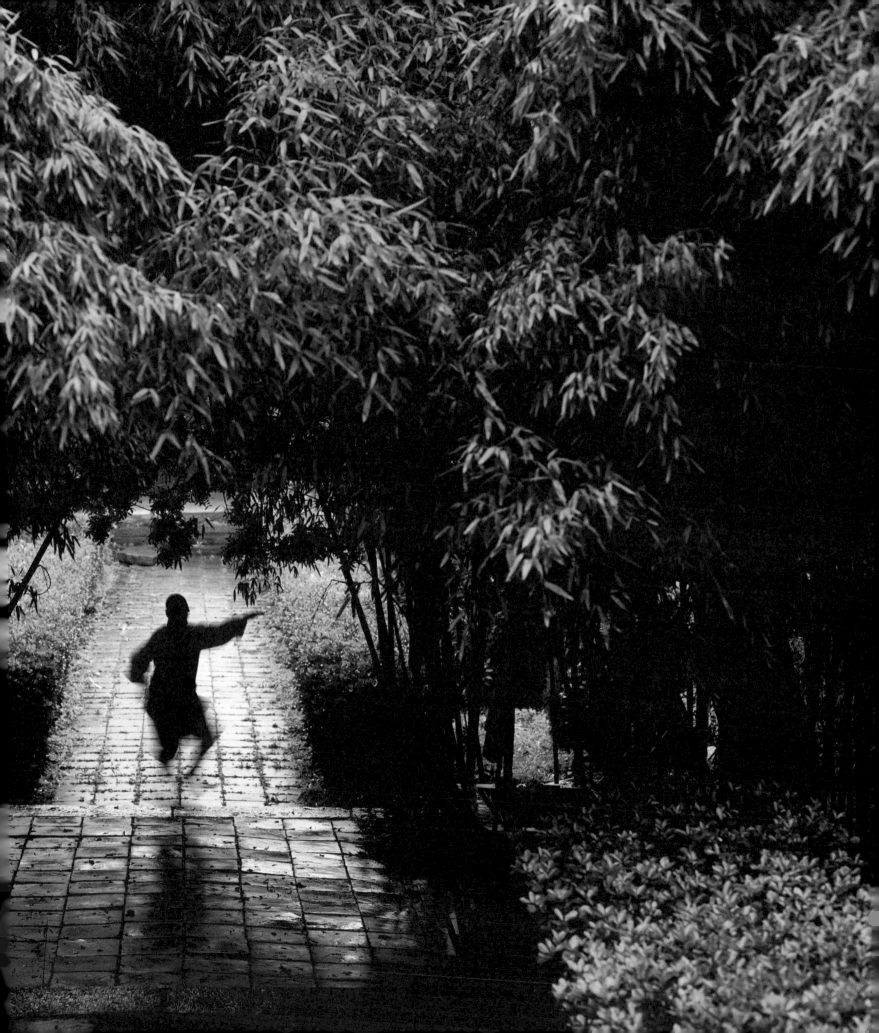

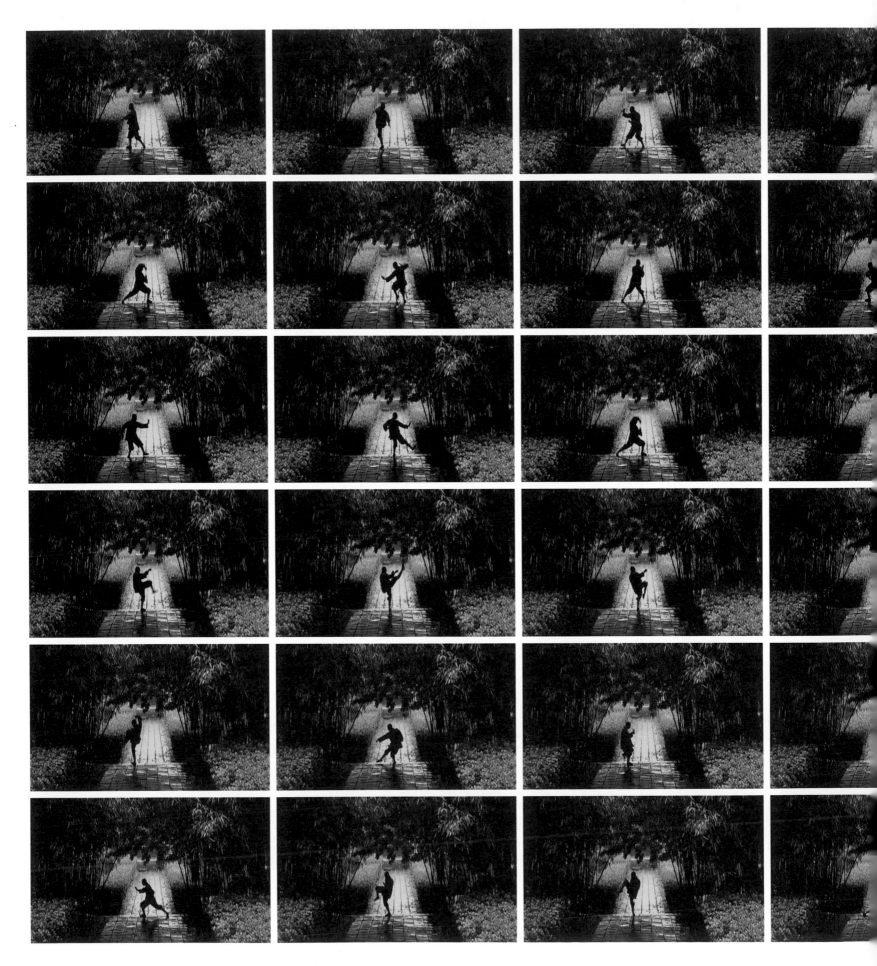

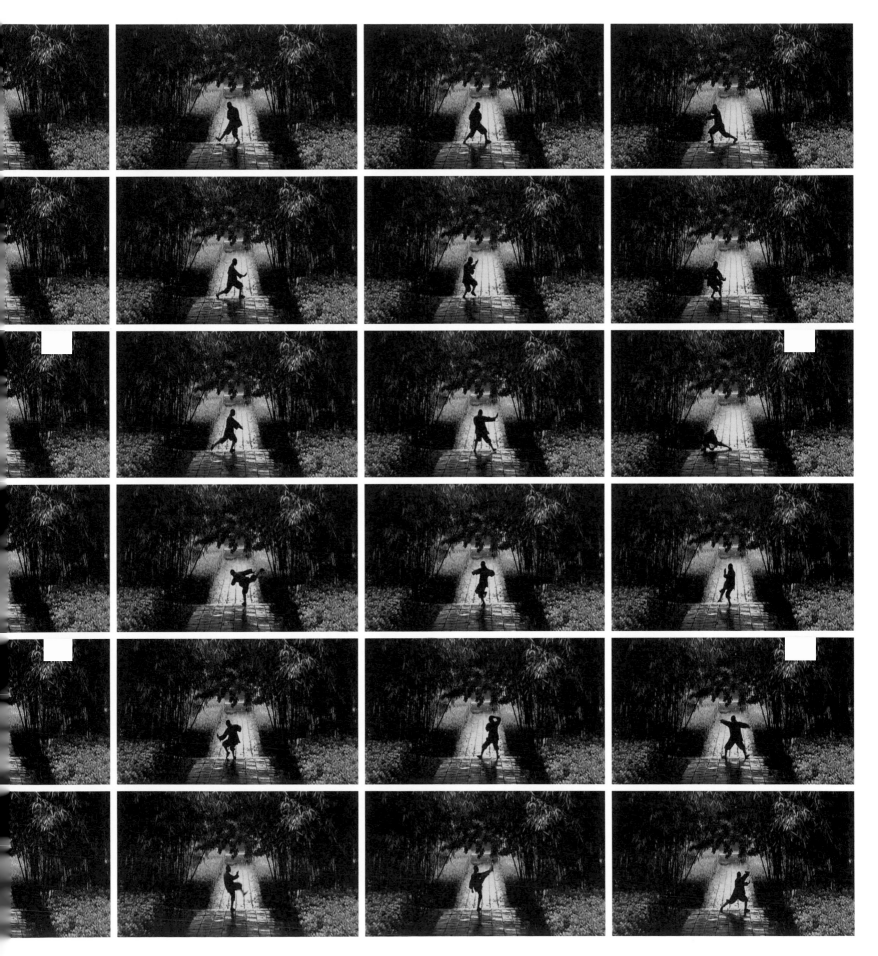

西湖山
陈志姐

杨從元
到剥竹林共游
灣川兵龙来
2002
再次

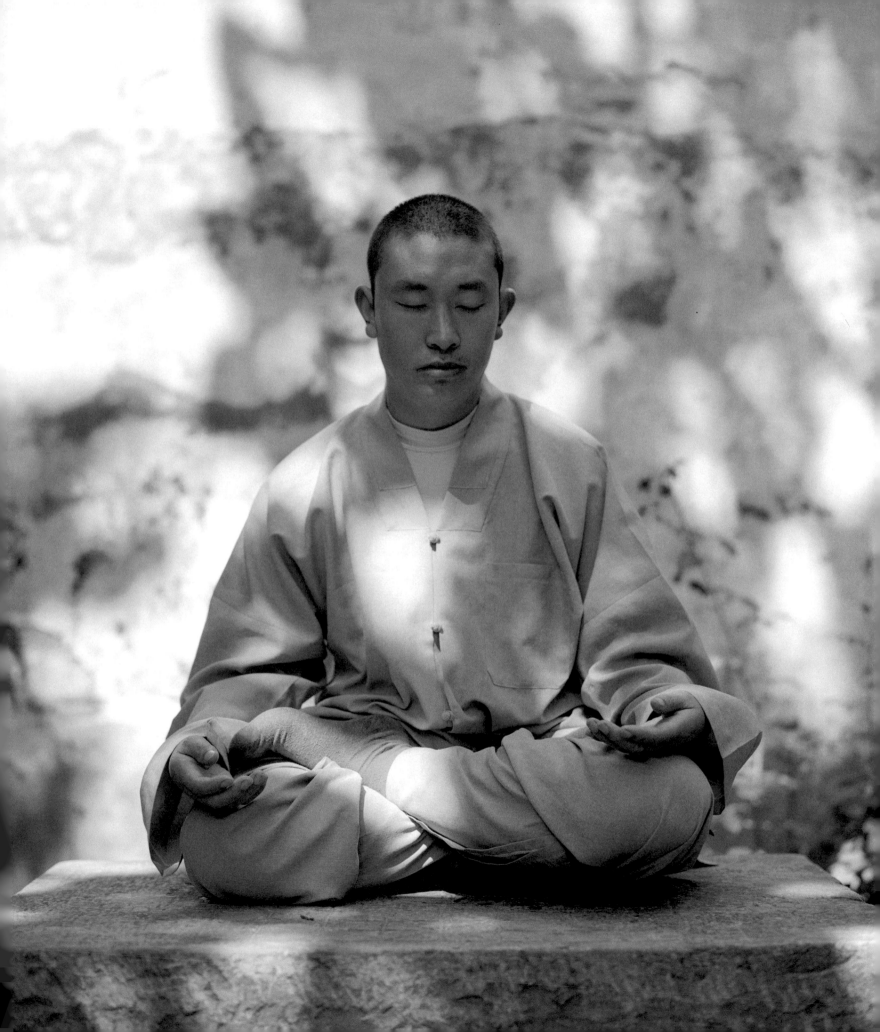

Page 142:
Stalks of bamboo inside the bamboo forest are scarred by tourists who have carved their names into the stem of the plant.

Page 143:
Wenseng monk Shi Yong Ji meditates as part of his daily practice. There are two types of monks: praying (*wenseng*) and martial arts-practicing (*wuseng*).

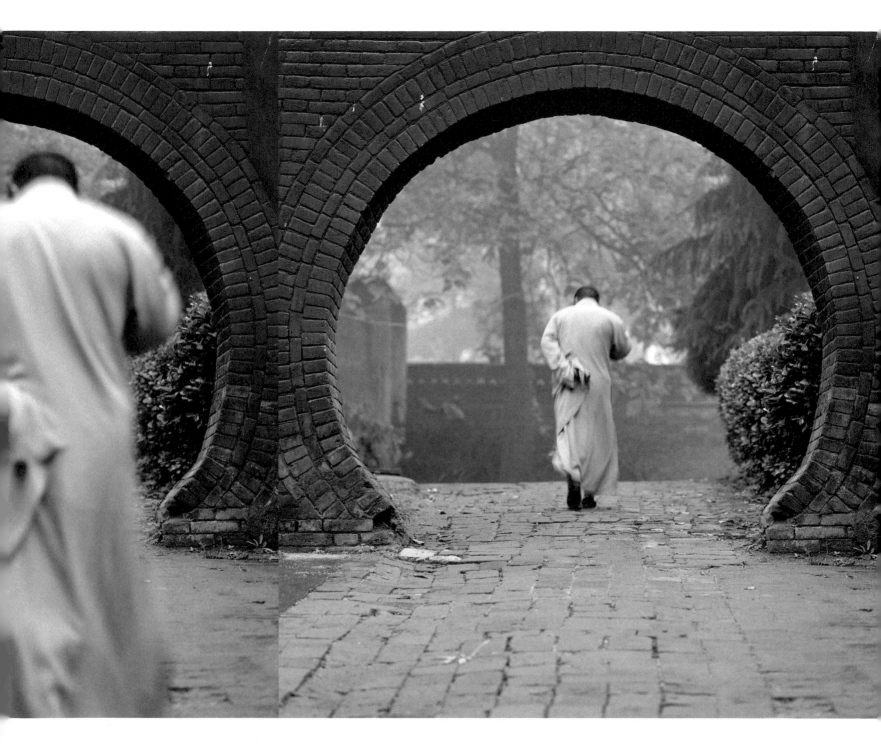

Above:
The gateway leading into the temple from the monks' quarters is a mandala-shaped doorway. There are approximately 160 monks currently living and studying at the Shaolin Temple.

Next spread:
The sun sets over the mountains surrounding the valley of Shaolin.

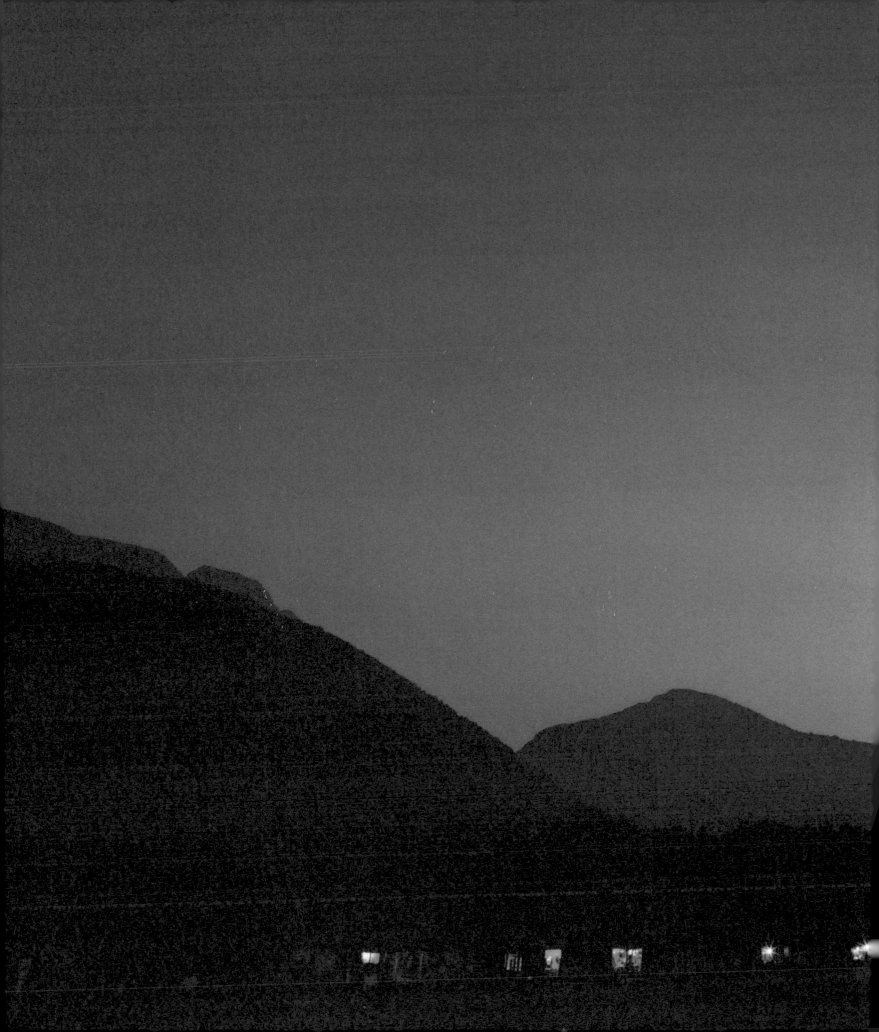

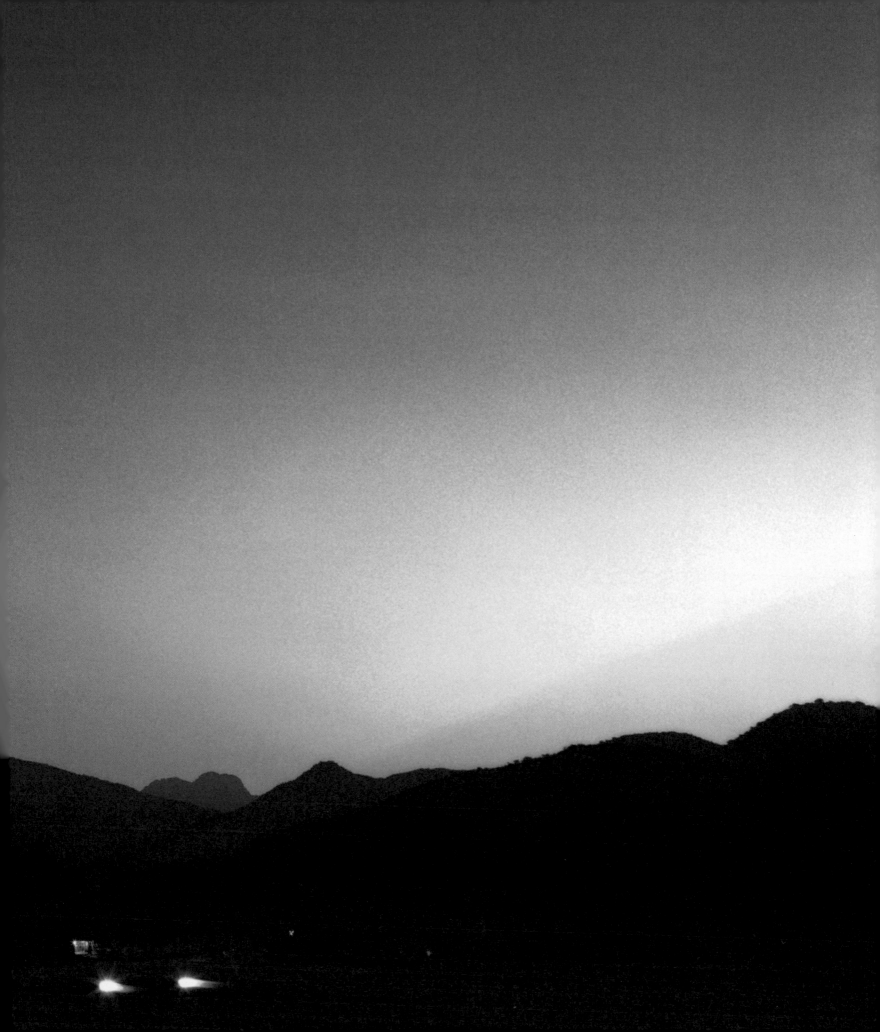

SHAOLIN TEMPLE: BIRTHPLACE OF ZEN

by MATTHEW POLLY

As the birthplace of both Zen Buddhism and the martial arts, the temple of Shaolin is the most significant religious institution in China. As the inspiration for countless chop-socky Hong Kong flicks and the 1970s hit TV show *Kung Fu*, Shaolin has long held a romantic place in the Western heart. Thousands of journalists have traveled to the temple in the past two decades to capture some aspect of Shaolin in print, in photographs, and on film. Having spent the last fifteen years either living at Shaolin or studying its history, I can say with some authority that Justin Guariglia has gone deeper than any of these. But before I explain why this is true, it is important to understand what Shaolin is, and why the Shaolin Temple is so important as a cultural institution.

ZEN AND THE ART OF KUNG FU The Shaolin Temple was built around 492 AD as an isolated mountain monastery in central China. Destiny for Shaolin (which means "young forest") arrived in the form of an Indian Buddhist missionary monk named Damo—Bodhidharma, in Sanskrit. Damo had the radical idea that the key to enlightenment was not merit (i.e., good works) but a dawn-to-dusk practice of sitting meditation, which would erase desire and attachment from the minds of the monks who practiced it. This was the beginning of Zen (*Ch'an*, in Chinese) Buddhism.

Damo soon discovered a problem, however. Days of doing nothing but sitting turned the monks' muscles to mush (a problem familiar to many modern-day office workers). His answer was to introduce a set of eighteen calisthenic exercises called Yi Jin Jing. Given Damo's Indian heritage it is very likely that these exercises were a form of yoga, which is to say, a kind of moving meditation. This point is absolutely crucial; it introduced the idea that action could also be spiritual.

At the same time, China was going through one of the periods of political chaos that have happened every couple of centuries or so in the Middle Kingdom. Being an isolated mountain monastery in one of China's poorest regions, Shaolin was a tempting target for roving bands of marauders, robbers, and warlords with grander aspirations. The first martial monks were probably ex-military guards hired to protect the temple.

While we can never know for sure—the first historical records of the Shaolin Temple were written by acolytes five hundred years later—the best guess is that what became kung fu was a merger between the guards' martial techniques and the Buddhist monks' moving meditation: yoga with attitude. The various fighting techniques were strung together in a structured series of moves, like dance routines. Kung fu, then, is simply Zen meditation in action.

CHINA'S CHAMPIONS Chinese history has always been so tumultuous that no institution has been able to escape its furor, even an isolated monastery hidden deep in the mountain forests. Less than a century after Damo's arrival, the temple of Shaolin, drawn into the contentious political realm, played a role in shaping China's future that would forever cement its monks as folk heroes.

In the sixth century, several factions were vying for control of the empire. One was led by the warlord Wang Shi Chong. To further his cause, he kidnapped the Tang prince, Li Shi Min. That was his first mistake. His second was to ransack the Shaolin Temple. According to the legend, thirteen Shaolin monks (there were probably more) entered his camp, defeated his guards with their superior martial skill, killed Wang Shi Chong, and rescued the prince, who later became the first Tang emperor.

One of Emperor Li Shi Min's first acts was to grant the Shaolin Temple extra land and the monks a special imperial dispensation to eat meat and drink alcohol, making Shaolin the only Buddhist monastery in China that is neither vegetarian nor dry. (Today the monks have a joke: What do you get for extending the life of an emperor? He shortens yours.) The emperor set up for himself a military academy of celibate men, a loyal force unencumbered by the worry and entanglements that hamper warriors with wives and children. Monks who focused on kung fu became known as martial monks (*wuseng*), while those who remained exclusively devoted to Buddhist practice were called cultural monks (*wenseng*).

Over the next thousand-plus years, the Shaolin monks continued to champion the cause of the Chinese people, battling Mongol invaders and Japanese pirates. The temple served as a rebel base against occupying foreign rulers, particularly the Manchus of the Qing dynasty. During this period, Shaolin Temple became an important center for the development of the martial arts, with fighters from across China coming to train, while Shaolin monks traveled and evangelized in other areas. The Shaolin Temple was also the first martial arts franchise. A second Shaolin temple was built in Fujian Province; another was built in western China. Today there are branches of the Shaolin Temple—some official and some not—in New York, London, and San Francisco.

Shaolin's influence also spread to the rest of East Asia. Japanese monks who studied at Shaolin in the twelfth century took its teachings back to their motherland; the impact of this combination of Buddhism and martial practice on Japanese life was dramatic up until the modernization that took place during the Meiji period. One could argue that the Samurai tradition in its combination of Zen and military culture, was one of the most significant offshoots of Shaolin.

Shaolin's culture finally reached the other side of the globe in the 1960s, when Japanese Zen monks arrived in California to promote the detached mind of Zen sitting meditation along with the active meditation of martial arts like archery, swordsmanship, and karate to a New Age audience, reaching its pop-cultural zenith with the TV series *Kung Fu*, starring David Carradine. After fifteen hundred years, America opened its eyes to a profound tradition that was invented in an isolated monastery in the middle of rural China. It wasn't long before some of us who had seen the show *Kung Fu*, or other pop interpretations, started looking for the source.

THE MODERN SHAOLIN TEMPLE Quite unintentionally, I happened to arrive at the Shaolin Temple in September 1992, while the temple was throwing itself a weeklong birthday party to commemorate its fifteen-hundredth anniversary. Shaolin had a right to celebrate: fifteen hundred years of continued existence is almost unprecedented in the history of religious orders, and it is even more impressive given the extreme ups and downs of Shaolin's past. The temple underwent its most harrowing test in the twentieth century; in fact, it barely survived.

The problem, to simplify, was the introduction of firearms into China during the late nineteenth century. Instantly, the self-defense efficacy of a twenty-year master in, say, the double sword, the rope dart, or the three-section staff dropped off the cliff. (God may have made man, but Sam Colt made him equal.) In 1900 the Boxers—members of a Chinese secret society who believed they could harden their bodies through iron kung fu practice to the point where they were impervious to bullets—attacked British soldiers stationed in Beijing. Rarely has the historical conflict between magic and science, mysticism and technology, been so dramatically put to the test with such lopsided results. When the smoke cleared, only the British soldiers remained standing.

One moment the Shaolin martial monks were at the top of the warrior food chain; the next, they were helpless. In the civil wars of the 1920s Shaolin was occupied and the temple was partially burned down by a local warlord. In the early 1940s, it was occupied again and further destroyed, this time by the Japanese. Mao Zedong, who wanted a clean break with China's feudal past and also feared Shaolin because of its historical role as a sanctuary for revolutionaries, banned the practice of kung fu in the 1950s. During the Cultural Revolution (1966–76), Mao's Red Guards sought to finish the job, dragging the few remaining Shaolin monks who had not already fled through the streets for public "criticism" and private floggings.

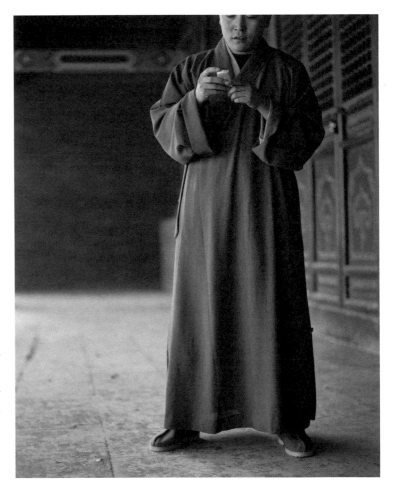

A monk checks a message on his mobile phone.

For all practical purposes Shaolin was on life support for a decade, a comatose wreck. Shaolin was practiced by the few remaining disciples of the temple who lived in the area and passed along their training in secret. The plug might have finally been pulled if it weren't for an emissary from pop culture: the 1981 arrival of Jet Li, an eighteen-year-old actor and martial arts (*wushu*) expert who would later become an international movie star, and who was making his first movie—called, appropriately enough, *Shaolin Temple.*

This movie was the brainchild of Deng Xiaoping's pragmatic reformers. Having inherited a devastated, impoverished nation from Chairman Mao, they needed to generate revenue fast. Since the easiest method for a poor country with a rich cultural history is tourism, the Chinese tourism board invited a Hong Kong production company to make a movie celebrating the famous Shaolin legend of the thirteen monks who rescued the Tang prince.

The impact of the movie, mainland China's first blockbuster, was dramatic. Life started to imitate art. Thousands of young boys ran away from home to become Shaolin monks like Jet Li's character—so many, in fact, that according to the tale I was told, the government had to build extra trains to send most of them back. In addition, tens of thousands of East Asian tourists, for whom Shaolin is one of the most cherished cultural sites, began arriving annually.

Like the phoenix from the ashes, Shaolin was reborn. Tuition from private kung fu students and tourism formed the basis of the village's new economy. Peasants from the surrounding areas gave up their hardscrabble farms to cater to the crowds. Only three Shaolin monks had survived the purges of the Cultural Revolution. But they had many students in the area, some of whom opened private schools to teach young, tuition-paying Chinese students, the best of whom became new monks. Thus was Shaolin's monastic community slowly rebuilt.

The vast majority of the Shaolin monks who arrived at the monastery as preadolescents after seeing Jet Li's movie were in their late teens or early twenties when I came knocking on the temple gates in 1992. As martial artists, they were in their prime. Seeing the potential for profit, in 1989, the Henan Province tourism agency opened an elaborate, by rural Chinese standards, tourism center, complete with a restaurant, a hotel, and a performance hall where the young monks were expected to display their dazzling skill for droves of mostly mainland Chinese tourists. In effect, the Communist Party had turned the Shaolin village into Branson, Missouri. Mainland Chinese tourists were a tightfisted lot with limited resources, however, so the Communist apparatchiks who ran the village quickly decided to take the show on the road, following the well-marked trail laid down by the Shanghai acrobats and the Peking Opera, into Taiwan, Hong Kong, Japan, South Korea, Europe, and America.

Like debutantes awaiting their first ball, the Shaolin monks were eager to strut their stuff. This was their first chance to see the world, to display their hard-earned talents after years spent suffering in ways hard for us to imagine (the Chinese call it *chi ku*—"eating bitter"). But most important, they were working for a higher cause: the promotion of Shaolin kung fu in particular and

Chinese culture in general to a world that had dismissed both for far too long. Nationalism had replaced communism as the country's driving ideology.

The first world, especially Europe, took one look at these fighting Buddhist monks—a paradox worthy of its own koan—and fell in love. To westerners fed on a steady diet of the Hong Kong movie version of Shaolin, these monks—live and in the flesh—were an exotic Oriental dish they could sink their teeth into. The monks filled stadiums in all the major capitals, made the rounds of the major talk shows, and returned home to find the Western media hard on their heels. If you were a TV producer or magazine editor at a sophisticated, internationally oriented media outlet like the BBC, PBS, or *National Geographic,* you sent out a crew to "document" the lives of the Shaolin monks.

Having personally watched and often participated in Polish, German, French, Italian, Japanese, Taiwanese, American, Hungarian—you name it—TV and magazine shoots during Shaolin's first fifteen minutes of modern media fame, I can attest that the term *document* here is used loosely. In the first flush of infatuation, first-world suitors were eager to buy into the mystery, and the Shaolin monks, flattered by the attention, were willing to play into the fantasy. Serious journalists from the most reputable institutions in the world, arriving at the Shaolin Temple to find young monks training much like any other professional athletes—in their jogging outfits, Nike trainers, and Chicago Bulls baseball caps—would ask them to put down their cell phones, shave their heads (it gets cold up in the mountains), and pretend to sleep while hanging from a tree by their necks. Or eat rice while balancing a cup of boiling water on their heads. Or walk down a snowy mountain peak on their hands. Or jump-kick off cliffs so that it looked as if they could fly.

The Shaolin monks could stage these shots because they were fantastic athletes who had willingly endured six hours of brutal training, six days a week, eleven months out of the year, for a decade or longer. But this was not their life. This was "The Shaolin Martial Monks Show"—a clichéd concoction of Hong Kong fantasy and Western Orientalism with little if any relation to past or present life at Shaolin.

JUSTIN GUARIGLIA'S ART My last extended stay at Shaolin ended in 1996. When Justin Guariglia arrived in 1997, two things had changed in the intervening years. Western tastes, bored with staged Shaolin mythology, were finally open to seeing what life was really like for the Shaolin monks and the surrounding community of students and coaches in the village. And China's growing wealth had allowed the temple to attract Buddhist monks and provide them with sinecures, developing the spiritual side of the temple rather than merely focusing on tourist-attracting martial performances.

Justin's early work on Shaolin, found throughout these pages, is a combination of unplanned moments, serene portraiture, and documentation of the monks' unique expertise in the martial arts. Here we see Shaolin monks in repose and in kung fu practice. Seeing Justin's work for the first time brought back a flood of memories. This was how I had seen the monks in between staged shots. His photos captured both a sense of tranquillity and a touch of

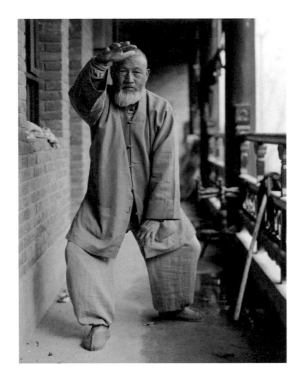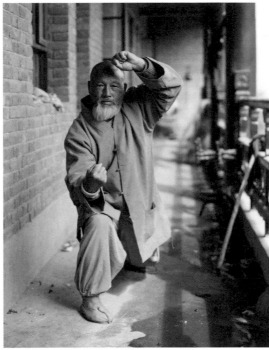

San Yan He, 34th generation, b. 1936

melancholy—life in an isolated village in the middle of rural China has always been a hard one.

More than any other photographer who has focused on Shaolin, Justin possesses an innate sense of what is true about the place and the people there. Where the work of some others represents a kind of drive-by journalism, zipping in and out and thus capturing only surface realities, Justin spent months at a stretch over a period of eight years wandering the village streets, befriending the monks and gaining their confidence. The Chinese are excellent hosts, but like all good hosts they prefer to keep guests in the clean living rooms sipping tea and making small talk, rather than allow them into more private places, with their inevitable messes. It takes time and good faith to build the *guanxi*—"connections"—to earn Chinese trust. I know because it took me half a year, a very lonely six months. As soon as I saw Justin's early photographs, I recognized in them a photographer who had the patience and passion to do the same.

I suspect that the difference between Justin's photographic work and the work of others is that his interest in photography has been driven by personal passion rather than formal training. He first visited China as a student of Mandarin and fell in love with the place; he began taking photos as an excuse to explore. But not until he arrived at Shaolin did he find the subject that would change his life, as it did mine. Without any sense of the strictures of the business or the guiding aesthetics of modern photography, he simply followed where his eyes led him, into the nooks and crannies of one of the most overexposed and misrepresented locales in China.

TEMPLE OF ZEN If Justin had stopped at documentary photos, his work would still be the best of Shaolin's most recent crop of neorealist recorders. But somehow, somewhere in his soul he found a way to unlock and translate to visual form Shaolin's greatest mystery: the relationship between Zen and kung fu. It was through this process that Justin's photographs took the leap from journalism into a true expression of the subject itself. When I first saw his later creations, they took my breath away. They made me rethink what Shaolin meant, a subject I've spent most of my adult life studying.

It took me years to find the proper way to address this subject in several thousand words. But far more impressive is how Justin accomplishes this with his serial imagery. To me, his most eloquent masterpieces are the grids of a single monk performing each movement of one of Shaolin's most traditional forms. By weaving texture into the photo so that it appears to move as you look at it from different perspectives, he has managed the impossible: to capture motion in one image, to make motion meditative, to capture the spirit of Zen in kung fu.

Justin and I have talked at length about what it is about Shaolin as a location that we find so special. Like many who have stayed there for extended periods, we feel a power in the place that we have experienced nowhere else. Justin believes it is the feng shui of the temple's location in the mountains. I'm willing to go further and suggest that centuries of spiritual practice have imbued the area with a soulfulness that touches those who are open to it. Whatever the reason, Justin and I have experienced something there that has inspired the most creative aspects of our own selves.

Matthew Polly is a Princeton graduate, Rhodes scholar, and travel writer for Slate. *He contributes regularly to* Esquire, Playboy, *and the* Nation. *His recent book* American Shaolin, *a memoir of the two years he spent training at the Shaolin Temple, won the Barnes & Noble Discover Great New Writers Award, and Fox Studios is developing it into a feature film. For more information, please visit www.mattpolly.com.*

ACKNOWLEDGMENTS

I would like to thank the following people who supported this project at various stages,
in endless ways, shapes, and forms:

Shi De Chao, Shi Xing Du, Shanli, Meir Shahar, Justin Zhang, Matt Polly,
Keith Bellows, Dawn Drew, and the rest of the staff at *National Geographic Traveler* magazine, Shaun See, Scott McClelland,
Dr. Qing Yeh and San San, Stefen Chow, Juyi Ong, Ed Burtynsky, Zoe Chen, Suzanne, Joe, and Jordan Guariglia, and Christen Cappelluti,
and to all the staff at Aperture who made this book and exhibition possible, especially Lesley Martin, Ellen Harris,
Diana Edkins, Andrea Smith, Rich Hendricks, and Matthew Pimm.

Thanks are also due to Gene Qing and Gigi Oh for their moral support of my project and fastidious fact-checking, and to Howard Hull,
Jeff Whatley, and the entire crew at the National Geographic Photo Lab for their dedication to a superior scan.

Also, special thanks for the kind support of Dan Steinhardt and Epson America, Inc., Dr. Craig "Praying Mantis" Reid, Noah Weinzweig,
Geoff Lieberthal, Sam Chen, Raja Zarith Idris, and Yau Digital,
who helped me bring this project to fruition. Thank you.

Last, but surely not least, many thanks are owed to the abbot, Shi Yong Xin, and all of the Shaolin monks,
for giving me run of the temple during my numerous visits over the years.

This book is dedicated to the living descendants of Dharma; may their spirit and traditions
be carried on for another fifteen hundred years.

Born in 1974 in Livingston, New Jersey, Justin Guariglia lived and worked in Asia for nearly a decade before returning to live in New York City in 2006.
He has worked for the National Geographic Society, *Smithsonian* magazine, and *Newsweek*. Guariglia was nominated for the International Center
of Photography's Young Photographer Infinity Award, received an Eddie Adams Workshop award, and was named by *Photo District News* as one of the top
"30 Young Photographers Under 30." An exhibition of this work will be on view at the Ben Maltz Gallery, Otis College of Art and Design, Los Angeles,
February 2–March 29, 2008, and at the National Geographic Society, Washington, D.C., June 11–September 11, 2008, before traveling internationally.
For additional information on and images by Justin Guariglia, visit www.guariglia-chen.com.